MARINE PAINTING

MARINE PAINTING

in England 1700–1900

David Cordingly

Clarkson N. Potter, Inc./Publisher NEW YORK

DISTRIBUTED BY CROWN PUBLISHERS, INC.

Inquiries should be addressed to Clarkson N. Potter, Inc.,
419 Park Avenue South, New York, N. Y. 10016.
Library of Congress Catalog Card Number: 73-84670
ISBN: 0-517-512297

Printed in Great Britain
First American edition published in 1974 by Clarkson N. Potter, Inc.

CONTENTS

The following collections contain marine paintings or drawings which are mentioned in the text:

Aberdeen Art Gallery and Museum
Art Institute of Chicago, Illinois
Ashmolean Museum, Oxford
Birmingham City Museum and Art Gallery
Brighton Art Gallery and Museum
Bristol City Art Gallery
British Museum, London
Courtauld Institute of Art, London
Ferens Art Gallery, Kingston upon Hull
Fitzwilliam Museum, Cambridge
Foundling Hospital Art Treasures, London
Freer Gallery of Art, Washington, D.C.
Frick Collection, New York
Glasgow City Art Gallery and Museum
Guildhall Art Gallery and Museum, London
Hampton Court Palace, Middlesex
Kenwood House (Iveagh Bequest), London
Lady Lever Art Gallery, Port Sunlight, Cheshire
Laing Art Gallery and Museum, Newcastle upon Tyne
Leeds City Art Gallery
Leicester Museum and Art Gallery
Liverpool City Museums
Manchester City Art Gallery
Museum of Fine Arts, Boston
National Gallery, London
National Gallery, Washington
National Maritime Museum, Greenwich, London
National Museum, Stockholm
Norwich Castle Museum
Petworth House (National Trust), Sussex
Collection of Mr and Mrs Paul Mellon, Upperville, Virginia
Collection of Mr and Mrs F.B.Cockett, London
Queen's Gallery, Buckingham Palace, London
Rijksmuseum, Amsterdam
Royal Academy of Arts, London
Russell-Cotes Art Gallery and Museum, Bournemouth
Sir John Soane's Museum, London
Sterling and Francine Clark Art Institute, Massachusetts
Sunderland Museum and Art Gallery
Tate Gallery, London
Victoria and Albert Museum, London
Walker Art Gallery, Liverpool
Wallace Collection, London
Whitworth Art Gallery, Manchester
York City Art Gallery

for Shirley

PREFACE

The aim of this book is to examine the lives and painting methods of some fifty artists who painted pictures of ships and the sea. The period covered is from the arrival of the van de Veldes in London to the end of the nineteenth century. Not all the artists described were English but, with the exception of the Scotsman McTaggart, all of them worked in England for part of their lives and made a significant contribution to marine art in this country. An effort has been made to trace the development of an English style of marine painting and for this reason considerable space has been devoted to the artists of the Romantic period. Most of these artists were landscape artists and had limited experience of ships but they had a considerable influence on the marine artists who followed them and their beach scenes and seascapes are among the most beautiful of all marine paintings.

I am acutely aware of the number of fine marine painters I have omitted but my intention has been to study a few artists in detail. I have quoted at length from contemporary sources in order to build up a picture of their lives and I have tried to discover the extent of each artist's knowledge of the sea. To have included a higher proportion of the one thousand artists who are known to have painted marine paintings in England would have meant cutting out much of the material about the fifty artists originally chosen, and this I was reluctant to do.

While writing this book I have received help and encouragement from many people. In particular I would like to thank the following who read various

sections of the manuscript and offered valuable advice: Mr M.S.Robinson who read the section on the Dutch marine painters and corrected several errors in my description of the van de Veldes; Dr Marion Spencer, of the Paul Mellon Centre for Studies in British Art, read the section on the Romantic painters; Mr Derek Rogers, Keeper of Art at Brighton Art Gallery and Museum, read the section on the Victorian painters; and Mr F.B.Cockett, FRCS, who owns a fine collection of marine paintings (including part of the Ingram collection), read the section on the eighteenth-century painters. Mr Cockett generously made available to me his notes and supplied a large number of photographs. While acknowledging the help of these people I must of course point out that I am responsible for any errors of fact which may appear in the text.

I would also like to thank the staff of the Department of Pictures at the National Maritime Museum, Greenwich, London, for their hospitality and helpfulness on numerous occasions. Mr John Munday kindly lent me his material on E.W.Cooke. Miss Judy Cockett, formerly Assistant Keeper at the National Maritime Museum, made a number of useful suggestions. I would also like to thank all those who supplied photographs and information about the pictures. It is not possible to thank everyone by name, but Miss Beverly Carter, Secretary of the Paul Mellon Collection in Washington, and Miss Constance Parker at the Royal Academy have been particularly helpful. I owe a special debt of gratitude to Mrs Pauline Chasey who typed the manuscript, and to my wife who has provided continual encouragement and has made many valuable suggestions.

D.C.

Kemp Town, Brighton
January 1973

1 INTRODUCTION

'Many are the obstacles to the attainment of a proficiency in drawing Marine subjects, particularly as it is not only requisite that a person desirous of excelling in this Art should possess a knowledge of the construction of a ship, or of what is denominated Naval Architecture together with the proportion of masts & yards, the width & cut of the sails, &c; but he should likewise be acquainted with Seamanship.' Published in 1805, the *Liber Nauticus* by Dominic and John Thomas Serres was an instruction manual in the art of marine drawing. This extract from the preface of the book is a good introduction to some of the problems which confronted the marine artist in the days of sail.

All branches of painting in the period we are considering required certain basic skills in draughtsmanship, composition and the handling of paint. But in addition to these skills the professional marine artist required a fund of specialized knowledge. He had to be acquainted with the rig and hull form of a variety of sailing vessels from a first-rate man-of-war down to a small cutter. He must be able to differentiate between the ships of the French, Spanish, Dutch and British fleets. He must appreciate the importance of flags and pendants, of naval uniforms and of the armament carried by different classes of ships. He must understand the behaviour of ships in varying wind strengths and on different points of sailing. He must have some knowledge of hull construction. He must be able to depict the way in which a ship settled in the water, and the movement of waves created by a hull of certain shape travelling through the water at a

certain speed. These were only some of the requirements, and the artist who neglected them would be quickly corrected by his patron.

George Chambers went to sea at the age of ten and yet even he could sometimes make mistakes in matters of detail. A letter to him from Admiral Mundy illustrates the accuracy demanded by professional seamen: 'I approve of your drawing of the ship, of the sea and of the land; they are, in my humble opinion, pretty and very spirited: but I must object to the handling of the sails. Why is the foretopsail not set?—no man of war loosens her foretopsail as a signal for sailing—unless she is in charge of a convoy and at anchor. The jib should be eased a third in on the jib boom—it will look more ship-shape in blowing weather. The mizen or spanker need not be loose, which will shew an ensign at the mizen peak, which you should hoist, and blow upwards like your jack at the foretopmast head—these alterations be so good as to make, and then I will pronounce it perfect.'[1]

A knowledge of ships and of seamanship was only one aspect of marine painting however. Equally demanding was a knowledge of the sea. A marine artist must have some understanding of tides and currents. He must be able to show the difference between wind action on shallow estuary waters, and on the deeper waters of the Channel. He must be able to portray waves breaking on a gently shelving beach and waves pounding on outcrops of rock. He must be able to paint reflections on the surface of calm water, or depict the violence of a gale in the Bay of Biscay. Knowledge of this type could only be acquired after years of studying the sea under varied weather conditions.

A gifted artist with a trained eye could, of course, learn much by observing the sea from the shore. Bonington and Constable, for instance, were able to paint certain aspects of the sea with an immediacy and a truthfulness which often eluded the professional marine artists. But it was obviously difficult for a landsman to depict the appearance of a ship in a storm unless he had experienced a gale at first hand. With a few exceptions the greatest painters of sea-pieces—as opposed to painters of harbour scenes and sea shores—were men who had spent several years at sea. Dominic Serres, Nicholas Pocock, George Chambers and Clarkson Stanfield had all been seamen in the Navy or Merchant Service. Charles Brooking was brought up in the dockyards at Deptford and according to Farington 'had been much at sea'. The most notable exception was Turner who in marine painting as in other aspects of art tended to break the rules. More than any other artist he conveyed the power and fury of gale-lashed seas, and yet his experience of the sea appears to have been limited to coastal passages and several Channel crossings.

The *Liber Nauticus* made some attempt to define some aspects of the sea, but the study was in no sense a scientific one, and appears to have been intended mainly as a vehicle for the illustrations of Dominic and John Thomas Serres. The book studied various aspects of the sailing ship in detail, but paid little attention to the sea itself. The section devoted to studies of water, for instance, includes the following passage: 'With respect to waters in a troubled state, everything depends on the variety in the form of the waves; and as there cannot be any rule or proportion laid down for the student, it gives fine scope for the fertility of invention.'[2]

A far more penetrating analysis was attempted by John Ruskin in a section in

Modern Painters entitled 'Of truth of water'. Although he admitted his limited knowledge of optics and the laws governing wave action, he nevertheless conducted a remarkably thorough investigation into the appearance of water under different conditions. Moreover his own drawings and watercolours remind us that he was not simply theorizing about the subject but had a working knowledge of the artist's problems. A single quotation may give some idea of his approach. Writing at some length on the subject of reflections he commented: 'The brighter the objects reflected, the larger the angle at which reflection is visible. It is always to be remembered that, strictly speaking, only light objects are reflected, and that the darker ones are seen only in proportion to the number of rays of light that they can send; so that a dark object comparatively loses its power to affect the surface of water, and the water in the space of a dark reflection is seen partially with the image of the object, and partially transparent. It will be found on observation that under a bank, suppose with dark trees above showing spaces of bright sky, the bright sky is reflected distinctly, and the bottom of the water is in those spaces not seen; but in the dark spaces of reflection we see the bottom of the water, and the colour of that bottom and of the water itself mingles with and modifies that of the colour of the trees casting the dark reflection.'[3]

Ruskin's writings are known to have exerted a considerable influence on the landscape painters of his day, and it is possible that he also had some influence on marine art. John Brett, who painted a number of memorable sea-pieces and beach scenes, was certainly a follower of his teachings.

The use of ship models

We have seen some of the problems confronting the marine artist: in particular the problem of portraying water, and that of accurately depicting a piece of machinery as complicated as a full-rigged ship. To the first difficulty there was no easy solution other than the constant study of the sea under varying weather conditions, but there was an aid which was often employed by marine artists to help them with the drawing of the ship. This was the ship model. It would seem from frequent references to models that they were essential studio props for the marine painter.

In 1706, the translator of Roger de Pile's *Art of Painting* observed that van de Velde the Elder 'for his better information in this way of Painting had a Model of the Mast and Tackle of a Ship always before him, to that nicety and exactness that nothing was wanting in it, nor nothing unproportionable. The Model is still in the hands of his Son.'[4] It is Michael Robinson's contention that the marked improvement in the ship drawing of both the van de Veldes after they came to England may be attributed to their study of models. In the time of Samuel Pepys it was the custom for English shipbuilders to use models as designs for full-sized ships, and so accurate models were readily available.

Some artists accumulated large collections of ship models. Among the effects

in Edward Duncan's studio on his death were, 'a model of a frigate which had belonged to Clarkson Stanfield, a Brixham trawler, ten models of various craft, and of a buoy which had belonged to E.W.Cooke'.[5] John Sell Cotman, whose marine pictures were a side-line rather than his chief occupation, nevertheless had a collection of ship models among his possessions when he sold up the contents of his Norwich House in 1834.[6]

E.W.Cooke made no secret of his dependence on ship models. A splendid photographic portrait of him shows him sitting at his easel with a copy of his *Shipping and craft* in his hand, and a ship model by his side. When he was gathering material for his dramatic painting *The Ramsgate lifeboat going to the aid of an East Indiaman*, he called in at the office of the Lifeboat Institution so that he might draw a model of one of their boats. And from his diary we learn that in 1845 he went to the sale of the pictures and effects of Callcott and bought five model boats to add to his own collection. It is possible that these models were those mentioned by Farington in the entry in his diary on 8 November 1815: 'Mulready called,' he writes. 'He told me that Callcott was now executing a picture for the Marquess of Lansdowne, a whole length canvas, the subject "Boats and Figures".—He has had beautiful models of Boats made & proceeds in collecting the materials for His picture so as to make it as perfect as he can.'[7]

The most interesting reference to models, however, occurs in a letter written by J.C.Schetky to his old friend Admiral George White. It is dated 9 March 1841 and reads: 'Now, my dear George, if you would win my heart entirely, get your sail-maker to make and fit *in all particulars of gear*—a fore-sail, fore-top-sail, and fore-top-gallant sail (not made of cotton, if possible)—for a frigate fifteen feet upon deck. Your carpenter will give you the length of spars and hoist of a 36-gun frigate, and you can soon reduce them to scale. I suppose somewhere about two inches to a foot. I have all masts, yards and rigging, complete and beautiful, but can't get the sails *ship-shape*. I have it not at hand though, else I would send you the measure; but I believe the main-yard something more than four feet. . . . You will perceive at once my object and desire to have this model —it is to place it on my lawn and draw from it, for there are no mast-heads to be seen here at Croydon; and I am much at a loss for details when my ships come large in the foreground.'[8]

Schetky's attention to detail did not succeed in bringing his canvases to life, however, and it is worth noting that Turner had no use for models but relied on his memory and on the lightning scribbles in his pocket sketchbooks.

Origins of marine painting in England

The whole question of the origins of English marine art is a complex one and deserves a book on its own. Unlike the origins of landscape painting the subject has been largely neglected by art historians and considerable research will be required to trace the variety of elements which helped to form an English style of marine painting. However, certain influences can be seen fairly clearly and it would perhaps be helpful to look at some of these.

Firstly it seems clear that the early examples of marine art in England were not paintings. They were carvings, pictures on stained glass, illuminated manuscripts, designs for seals and engravings. Indeed it is not too far-fetched, I believe, to regard some of the scenes in the Bayeux Tapestry as early examples of marine art. The tapestry, which is now considered to be of English workmanship, was probably completed in 1077. The scenes depicting the shipwreck of King Harold on the coast of Normandy and the invasion of William the Conqueror show ships in some detail. The sea is depicted symbolically, and in the most rudimentary manner, by a series of undulating lines arranged in parallel rows.

This method of depicting water was continued with only slight modifications for nearly five centuries. We see it used, for instance in the seals of the south coast ports which are the most well-known representations of ships in the thirteenth and fourteenth centuries. Those of Sandwich (1238) and Dover (1284) are particularly well designed. The crews, the sails, rigging and flags have been cunningly drawn to fill the round shape of the seal. Somewhat more detail is shown on a manuscript illustration of about 1270 which is in the Fitzwilliam Museum (pl. 11). This is a spirited rendering of a sea-battle. A plaice, an eel and other fish swim among the inevitable undulating waves.

By the sixteenth century the drawing of ships had become more sophisticated. The delightful woodcut of the *Ark Royal* which is in the British Museum is a good example of the English preoccupation with flat pattern-making and vigorous curving lines. Also in the British Museum is a manuscript illustration of 1543 which depicts three-masted ships in Dover Harbour.[9] Not only are the ships themselves drawn in some detail, but in the background can be seen the cliffs of Dover and the sweep of coastline curling round to the harbour defences in the foreground. Another view of Dover is presented in the large painting at Hampton Court of *The embarkation of Henry VIII*, which is believed to have been painted around 1540 but is probably by a Netherlandish artist.

A fine example of marine art in the seventeenth century is the well-known engraving of *The sovereign of the seas* by J. Payne (1637). Apart from the meticulous detail of hull and rig, the picture represents a considerable advance because the clouds are portrayed with some realism and the sea has progressed from the undulating line to individually modelled waves with foaming crests blown by a stiff breeze. However, it must be remembered that when this engraving was made there was in existence, across the Channel, a school of marine painting that was reaching maturity. By the 1640s Simon de Vlieger and Jan van Goyen were depicting the ships and waterways of their country with a skill and a sense of atmosphere which was not to be achieved by English artists for nearly one hundred years.

In 1673 the van de Veldes settled in London and from this moment the course of marine art in England underwent a change. Instead of isolated examples of marine art, we see the slow growth of an English school of marine painting. For fifty or sixty years after the arrival of the van de Veldes, the native artists were dominated by the methods of the Dutch school, but gradually certain English characteristics began to emerge. These can be clearly seen in some of the paintings of Samuel Scott, Charles Brooking and John Cleveley the Elder. Before examining these characteristics, however, we must look at the Dutch school and the extraordinary influence which it exerted on English art.

2 THE INSPIRATION
OF HOLLAND:

the van de Veldes

A knowledge of the Dutch marine artists of the seventeenth century is fundamental to a proper understanding of marine art in England. Their methods of composition were imitated by generations of English artists. Their solutions to the problems of portraying light and shadow across the surface of the water, and their manner of rendering skies and reflections inspired countless pictures over the course of nearly two centuries. 'Painters should go to the Dutch School to learn the Art of Painting as they would go to a Grammar School to learn languages,'[1] Sir Joshua Reynolds told his students, and in a letter to Nicholas Pocock he urged him to produce a harmony between the clouds, the sea and the ships in his pictures by painting from one palette, 'as was the practice of Van der Velde'.[2]

By the second half of the eighteenth century a large number of Dutch landscapes and marines had found their way into English collections. Fine examples in Thomas Harvey's collection at Hatton House were admired by Gainsborough and Crome. Farington recorded in 1818 that, following the sale of a painting to Lord Bute, 'pictures by Cuyp were eagerly sought for and many were introduced and sold to advantage'.[3] Exhibitions of Old Masters were frequently held at the British Institution, and when Constable visited one of these exhibitions in 1824 he noted that there were, 'some excellent Dutch pictures, especially some sea-pieces'.[4] Works by van de Cappelle, Backhuizen, van de Velde and de Vlieger were among the pictures in the exhibition.

No doubt the inspiration of Dutch paintings was also partly responsible for

16

1 William van de Velde the Younger
A small Dutch vessel close-hauled in a strong breeze
Oil on canvas, 12⅞ × 15⅞ in./32.5 × 40.5 cm. Signed with initials. 1660s or 1670s
National Gallery, London

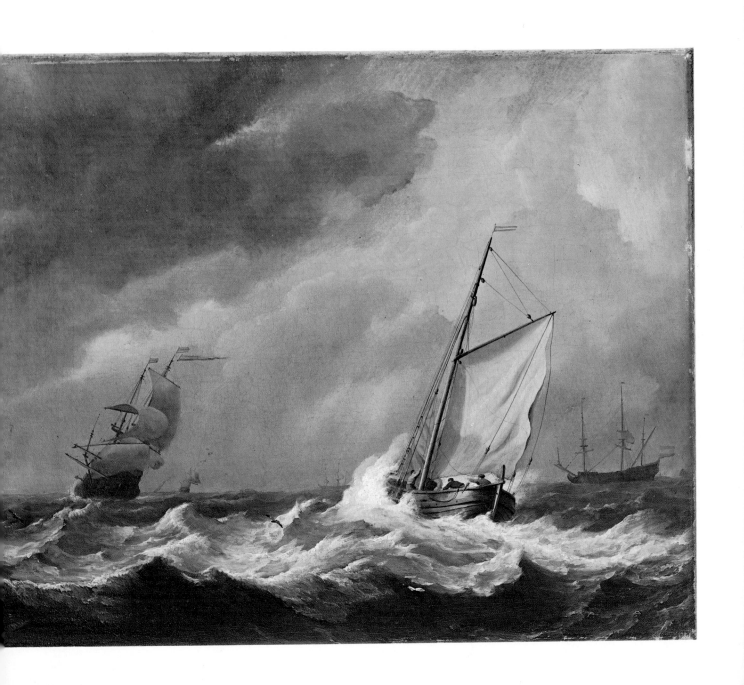

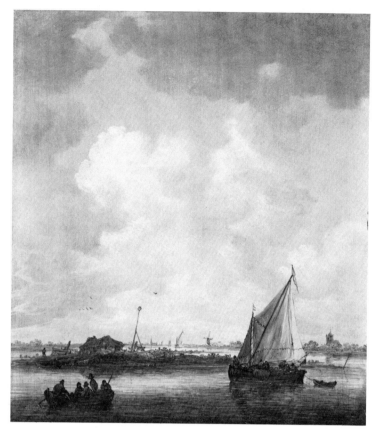

2

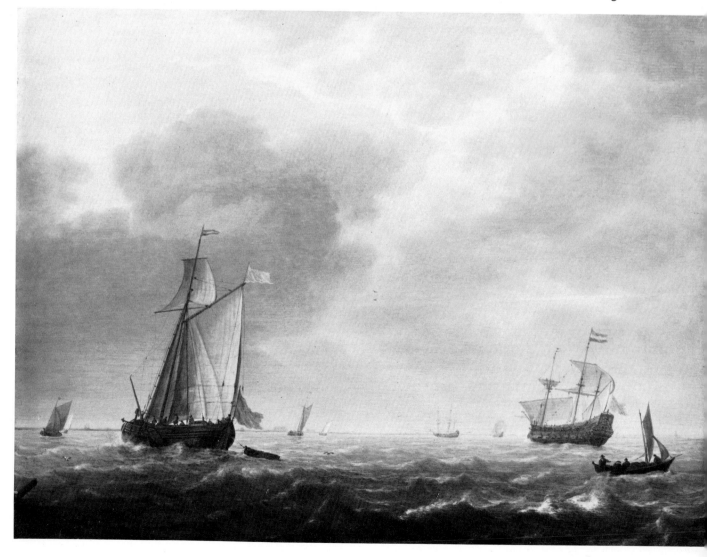

3

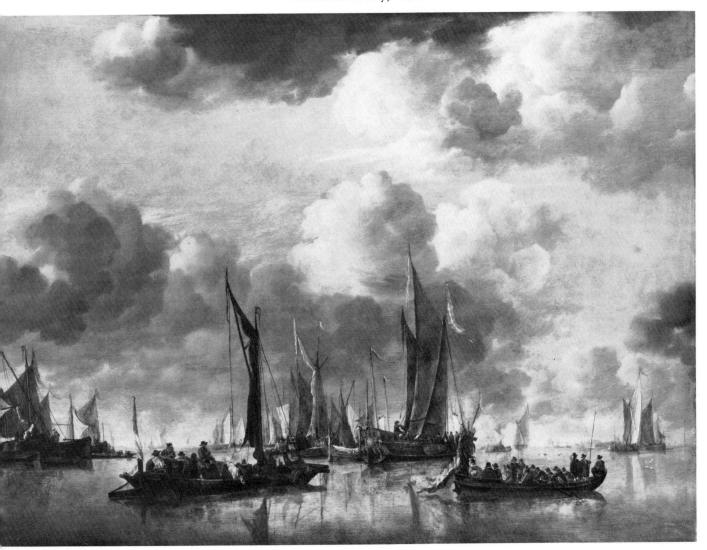

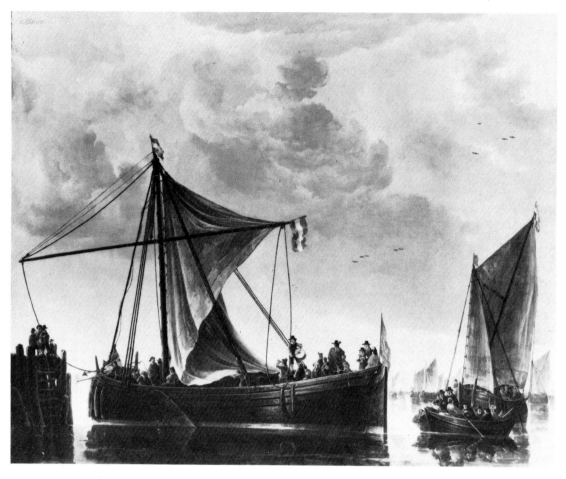

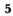

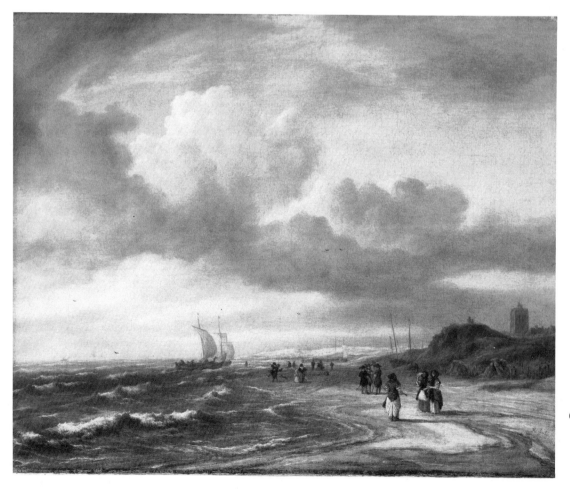

Opposite
5 Aelbert Cuyp
The passage boat
Oil on canvas, 49 × 56¾ in./124.5 × 144 cm. Signed. *c.* 1650
Reproduced by gracious permission of Her Majesty the Queen

6 Jacob van Ruisdael
The shore at Egmond-aan-zee
Oil on canvas, 21⅛ × 26⅛ in./53.5 × 66 cm. Signed with monogram. *c.* 1675
National Gallery, London

7 William van de Velde the Elder
Dutch East Indiaman near the shore
Grisaille, 32 × 44 in./81 × 110 cm. Signed
National Maritime Museum, London

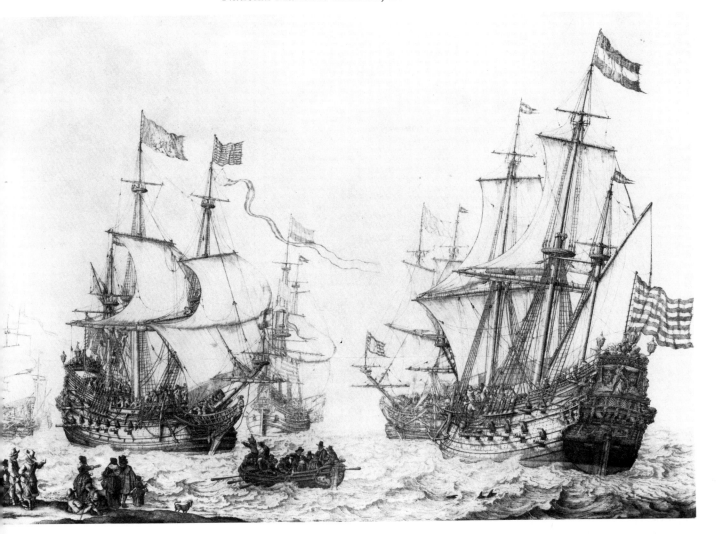

Opposite

9 William van de Velde the Elder
Hull of the Dutch ship Gouden Leeuw from the starboard quarter
Pencil and Indian ink wash, 15⅛ × 26⅛ in./38.5 × 66.5 cm. *c.* 1667
Victoria and Albert Museum, London

10 William van de Velde the Younger
An English ship and a yacht before a light breeze
Pen and brown ink and grey wash, 5½ × 7½ in./14 × 19 cm. *c.* 1700
National Maritime Museum, London

8 William van de Velde the Younger
Boats at low water
Oil on canvas, 12¾ × 14¼ in./32.5 × 36 cm. Signed with initials
Reproduced by permission of the Trustees of the Wallace Collection, London

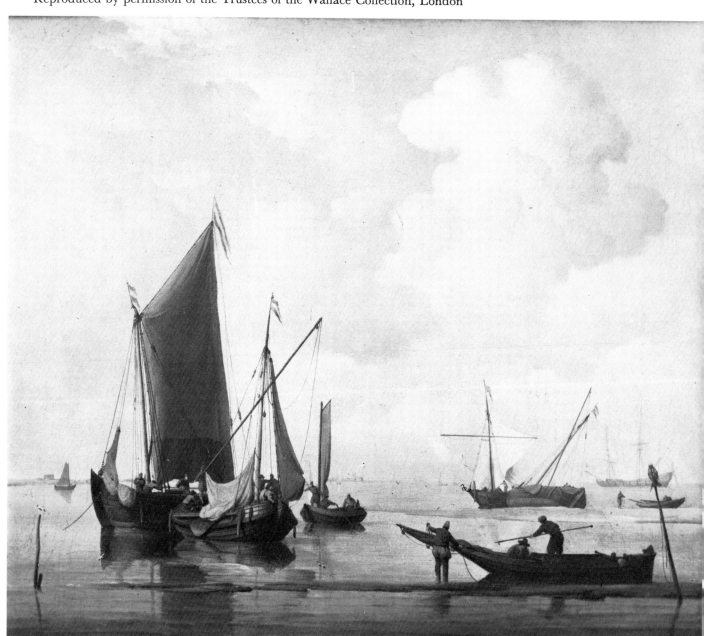

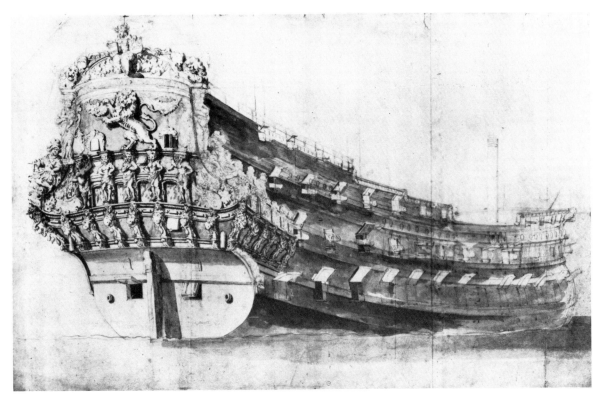

9

Opposite
12 Robert Woodcock
A third-rate getting under way
Oil on canvas. Signed with initials and dated 1726
National Maritime Museum, London

13 J. van de Hagen
Shipping in a fresh breeze
Oil on panel, 26½ × 35 in./67 × 89 cm. Signed with initials
Private collection

11 Anonymous English artist
A sea fight
From a manuscript illustration *c.* 1270 (Marley Add. MS.I, f. 86r)
Reproduced by permission of the Syndics of the Fitzwilliam Museum, Cambridge

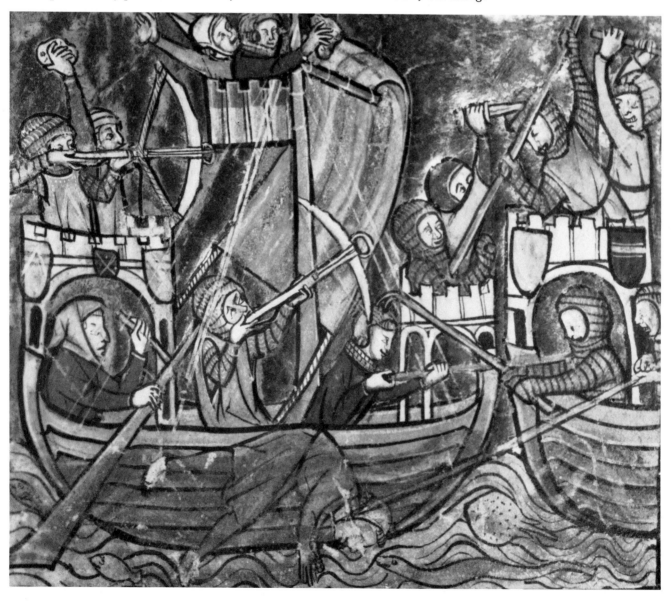

12

13

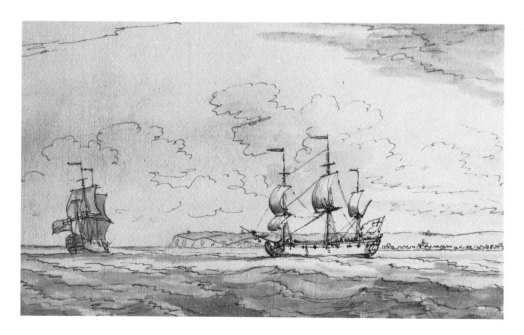

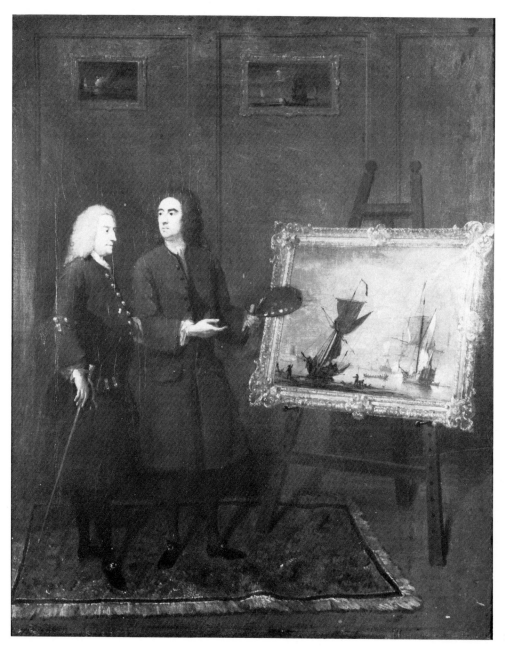

Opposite

14 Peter Monamy
A view of Deal from the sea, South Foreland in the distance
Pen and sepia ink and grey wash, 7½ × 12½ in./19 × 32 cm. Signed and inscribed on the reverse
From the collection of Mr and Mrs F. B. Cockett, London

15 William Hogarth and Peter Monamy
Monamy showing a picture to Mr Walker
The sea piece on the easel was painted by Monamy.
Oil on canvas, 24¾ × 20 in./63 × 51 cm.
From the collection of the Earl of Derby MC, Knowsley, Lancashire

16 Peter Monamy
A calm evening
Oil on canvas, 11½ × 13½ in./29 × 34 cm. Signed
From the collection of Mr and Mrs F. B. Cockett, London

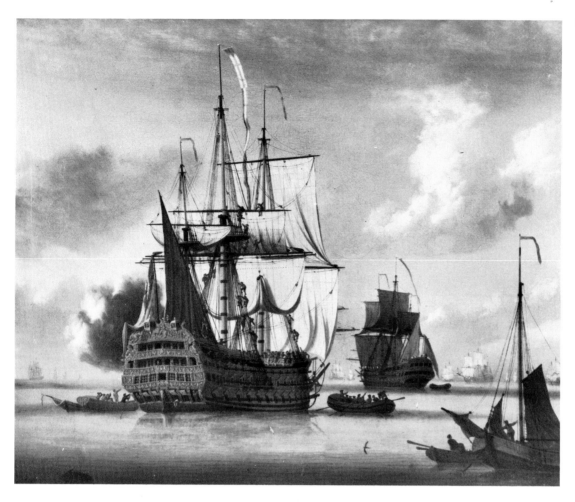

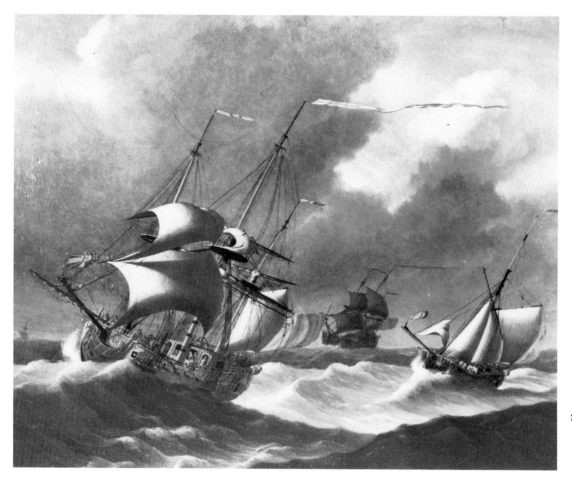

Opposite

17 L. D. Man
The Royal Sovereign
Oil on canvas, 23 × 28 in./58.5 × 71 cm. Signed
From the collection of Mr and Mrs F. B. Cockett, London

18 L. D. Man
The Royal Caroline and the Katherine at sea in a gale
Oil on canvas, 23 × 28 in./58.5 × 71 cm. Signed
From the collection of Mr and Mrs F. B. Cockett, London

19 Jacob Knyff
Dutch fluyt unloading with English Flag
Oil on canvas, 36 × 48 in./91.5 × 122 cm. Signed and dated 1673
National Maritime Museum, London

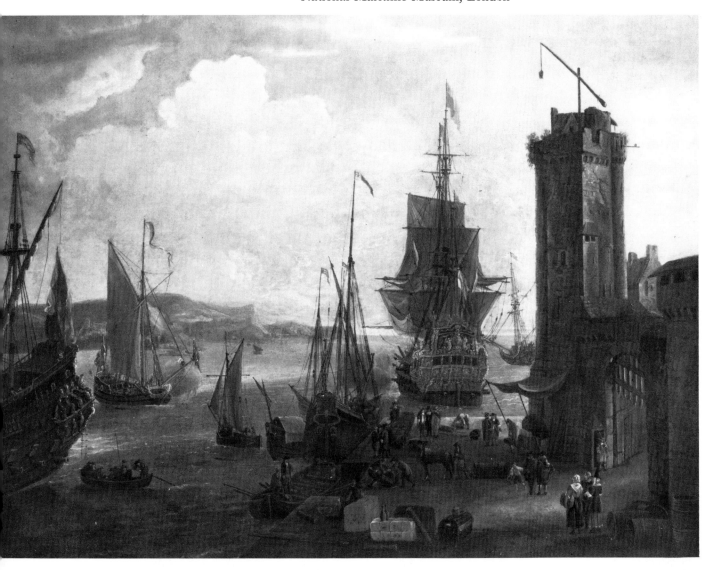

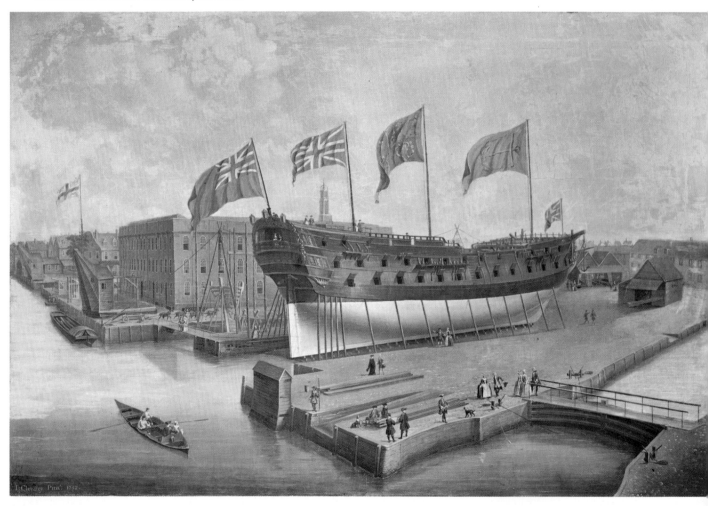

21

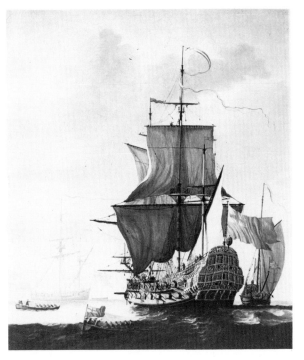

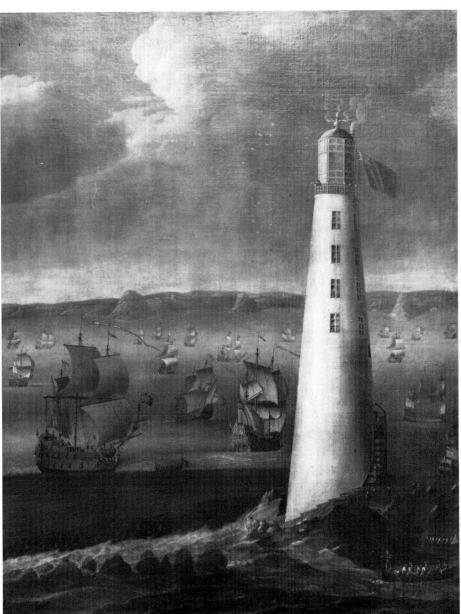

22

23 Samuel Scott
A morning, with a view of Cuckold's Point
Oil on canvas, 20½ × 37¾ in./52 × 96 cm. *c.* 1760
Tate Gallery, London

24 Samuel Scott
A Danish timber bark getting under way
Oil on canvas, 89½ × 86 in./227 × 218.5 cm. Signed and dated 1736
National Maritime Museum, London

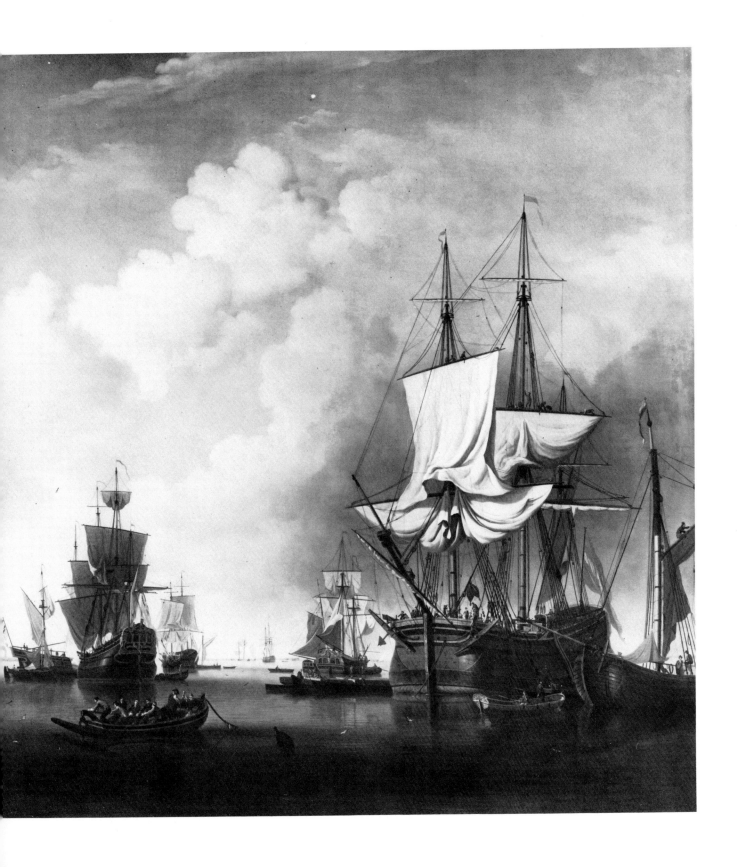

25 Samuel Scott
Old Custom House Quay
Oil on canvas, 63 × 54 in./160 × 137 cm. *c.* 1756
Victoria and Albert Museum, London

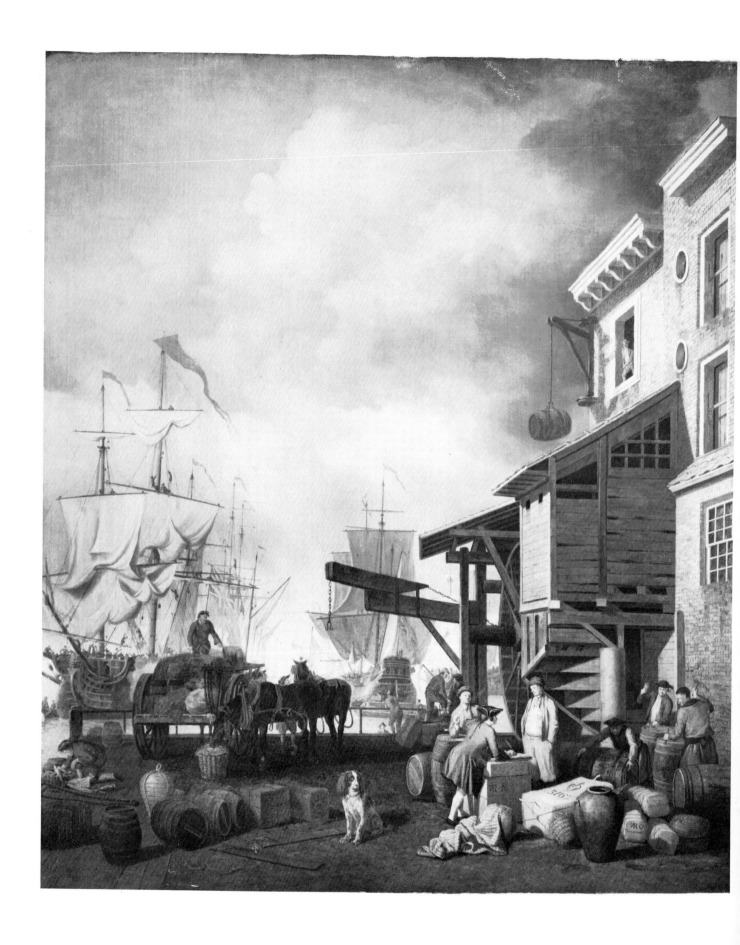

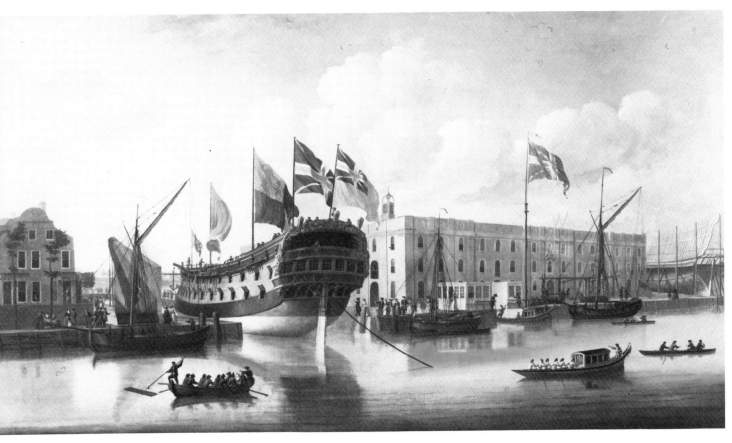

26 John Cleveley the Elder
A ship floated out at Deptford
Oil on canvas, 36 × 62 in./91.5 × 157.5 cm. Signed and dated 1747
National Maritime Museum, London

Overpage
27 John Cleveley the Elder
A view of a shipyard on the Thames
Oil on canvas, 21⅞ × 37½ in./55.5 × 95.5 cm. Signed and dated 1762
Glasgow Museums and Art Galleries

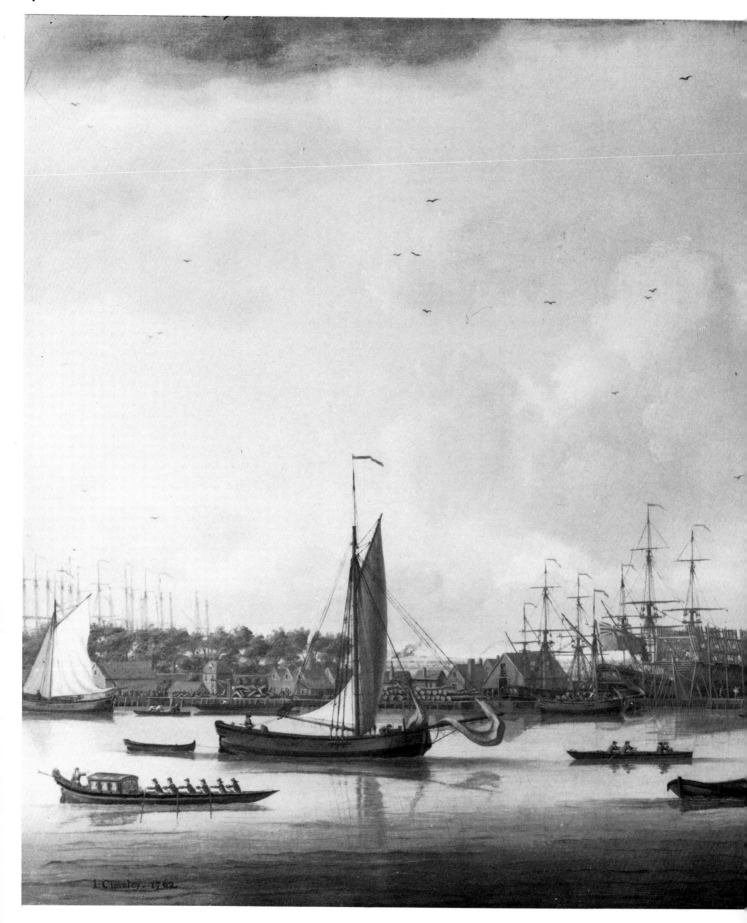

I. Clawley. 1762.

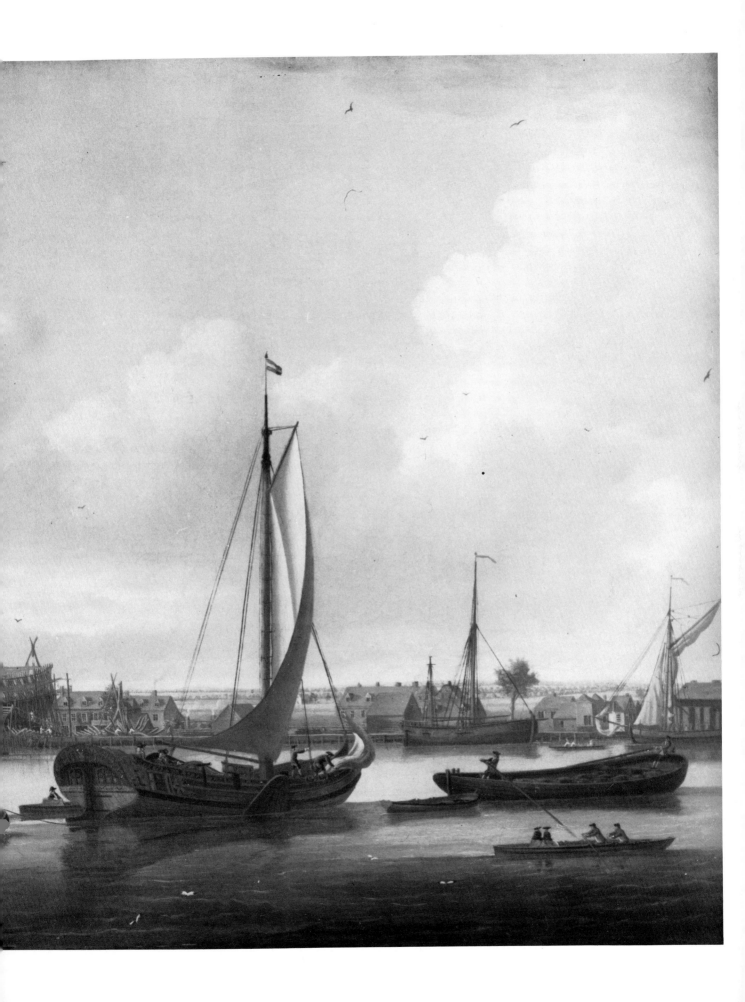

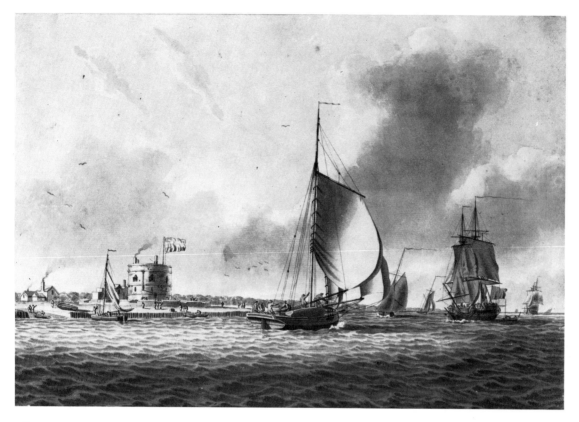

28

29

32 Francis Swaine
 A frigate and a royal yacht at sea
 Oil on canvas, 11 × 16 in./28 × 41 cm. Signed
 From the collection of Mr and Mrs F. B. Cockett, London

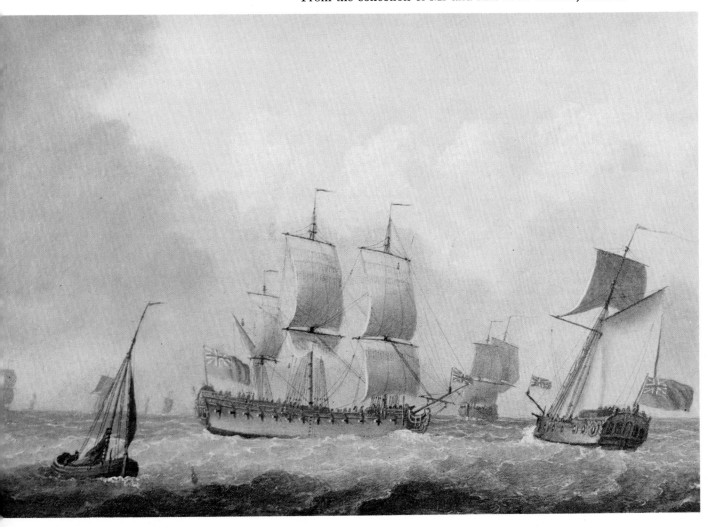

33 Charles Brooking
Men o' war off a coast
Oil on canvas, 35½ × 46⅜ in./90 × 117 cm.
From the collection of Mr and Mrs Paul Mellon, Upperville, Virginia

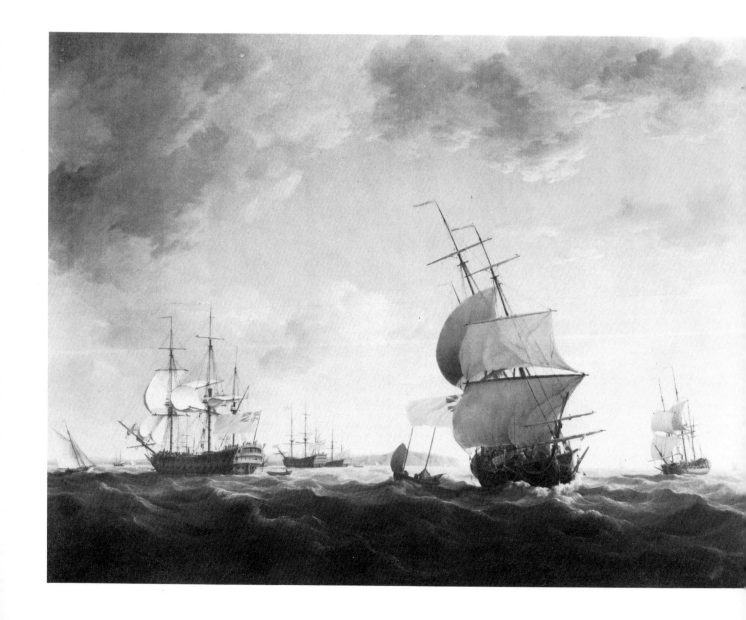

34 Charles Brooking
A vice-admiral of the red and a fleet near a coast
Oil on canvas, 14½ × 22½ in./37 × 57 cm. Signed. 1750s
National Maritime Museum, London

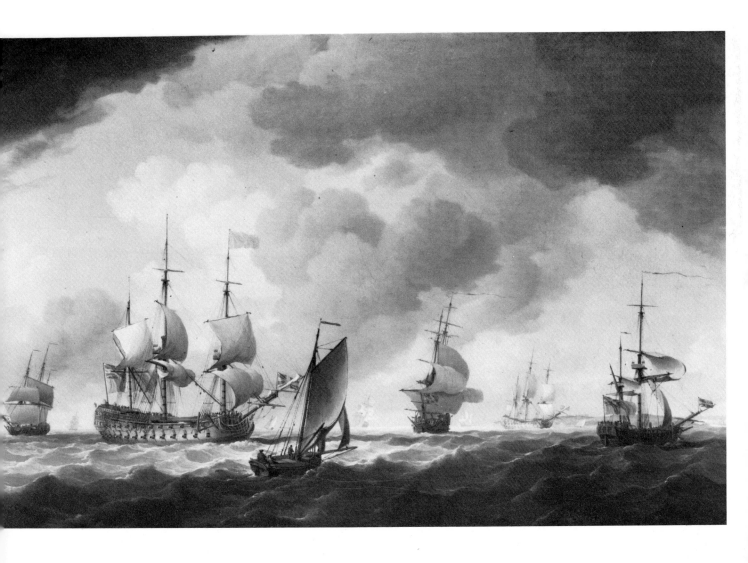

35 Charles Brooking
Fishing smacks becalmed near a shore
Oil on canvas, 10¾ × 33 in./27.5 × 84 cm.
Tate Gallery, London

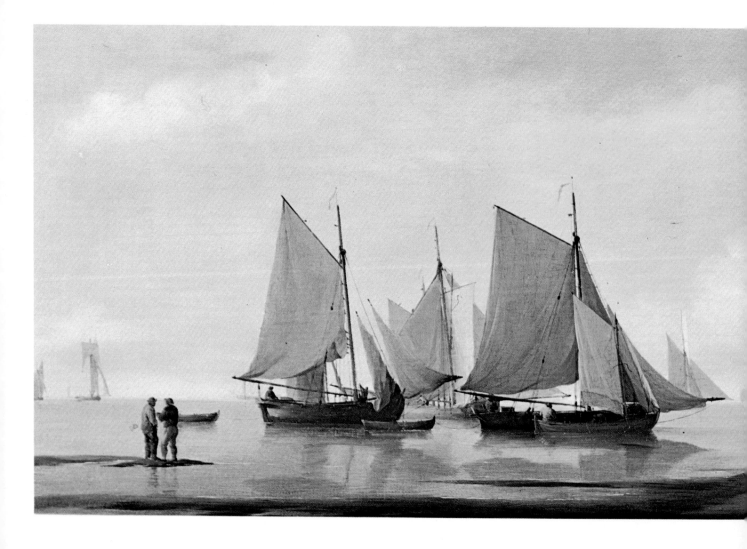

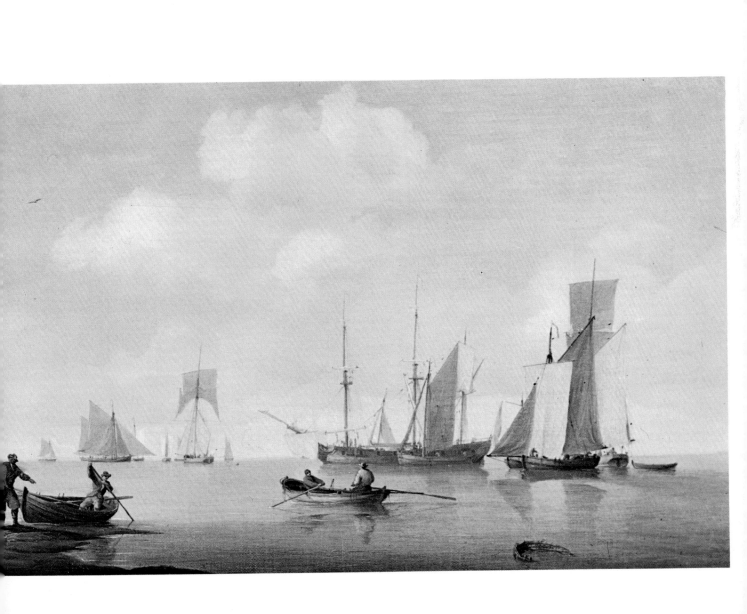

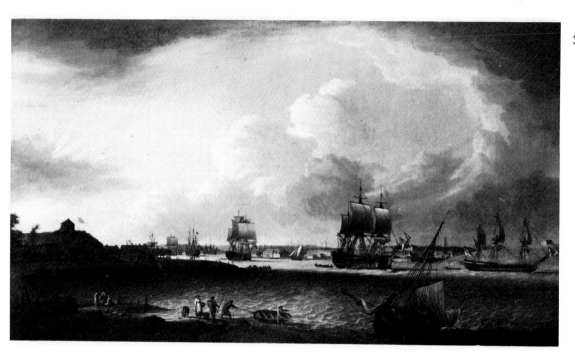

36 Dominic Serres
 Ships at Plymouth (formerly *Ships in the Medway*)
 Oil on canvas, 36 × 62 in./91.5 × 157.5 cm. Signed and dated 1766
 National Maritime Museum, London

37 Dominic Serres
 Two men o' war in a choppy sea
 Oil on panel, 16 × 25 in./40.5 × 63.5 cm. Signed and dated 1770
 From the collection of Mr and Mrs Paul Mellon, Upperville, Virginia

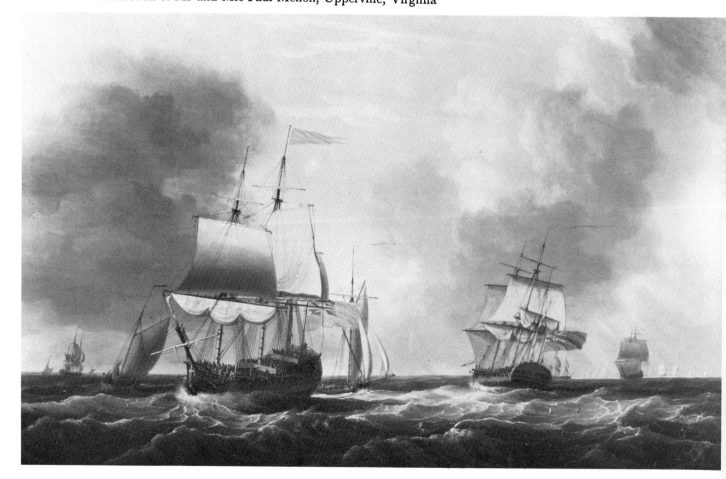

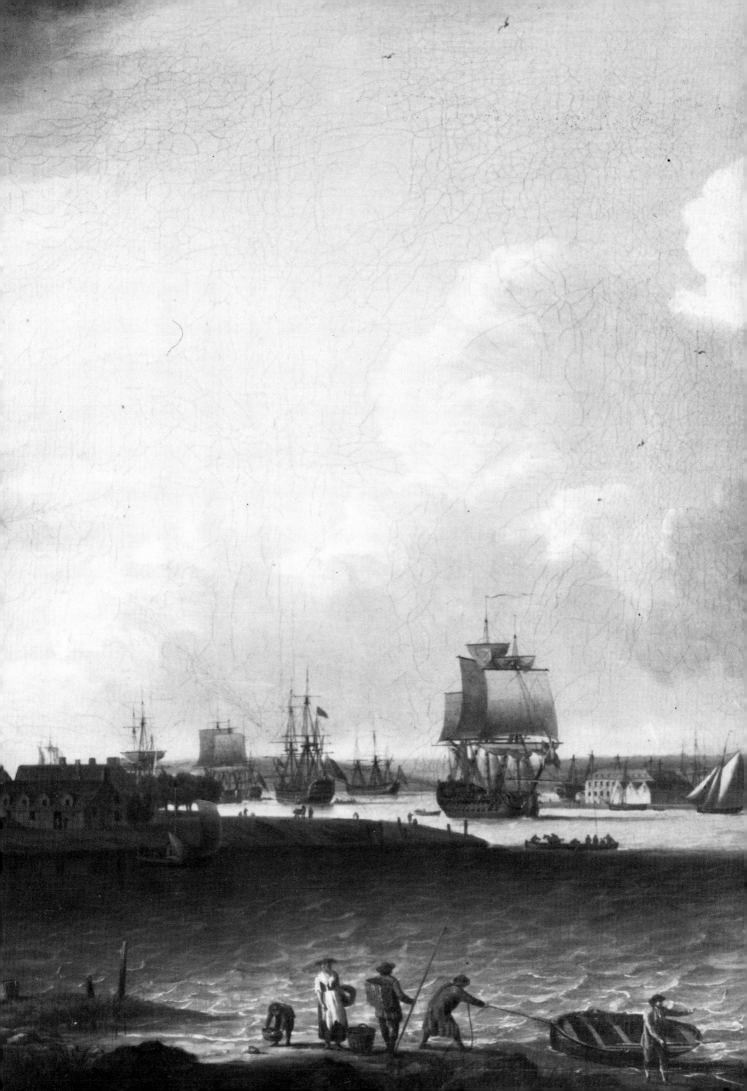

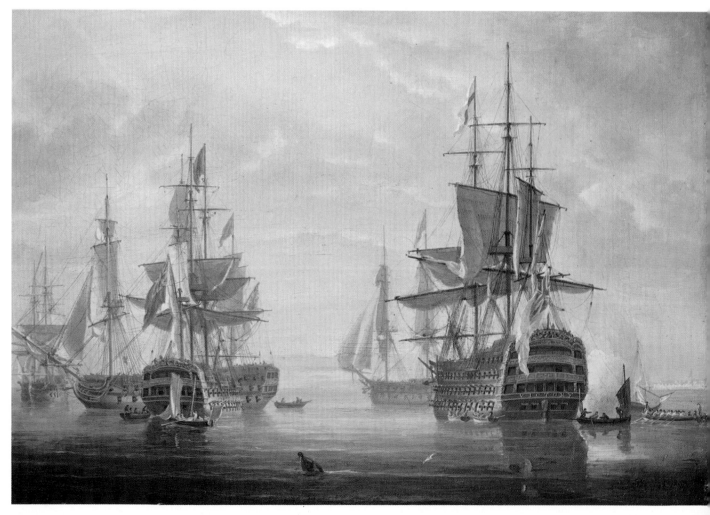

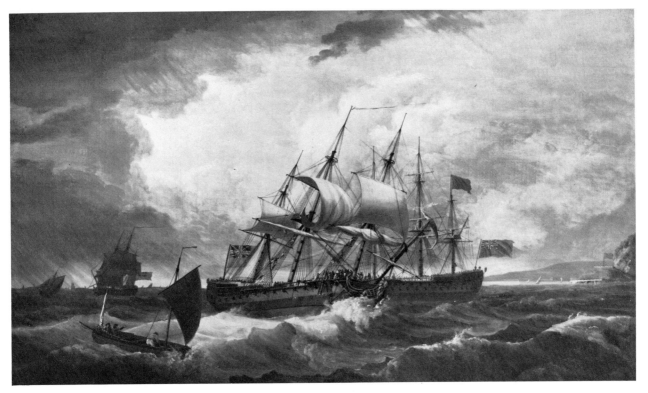

40

41

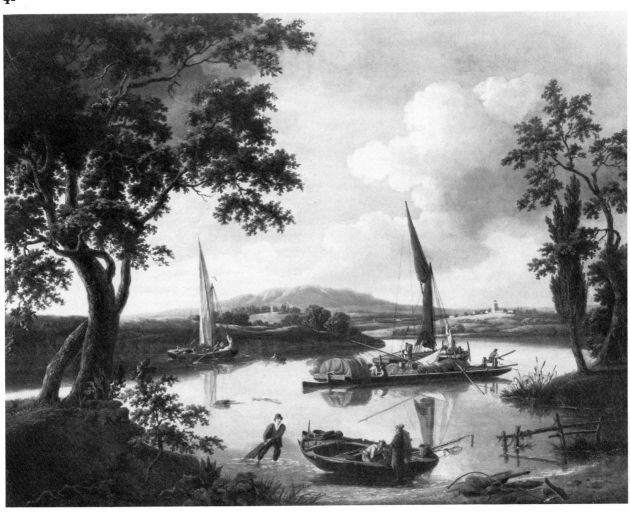

42 Francis Swaine
A lugger close-hauled in a strong breeze
Pen and sepia ink and grey wash, 10⅝ × 16 in./27 × 41 cm. Signed
National Maritime Museum, London

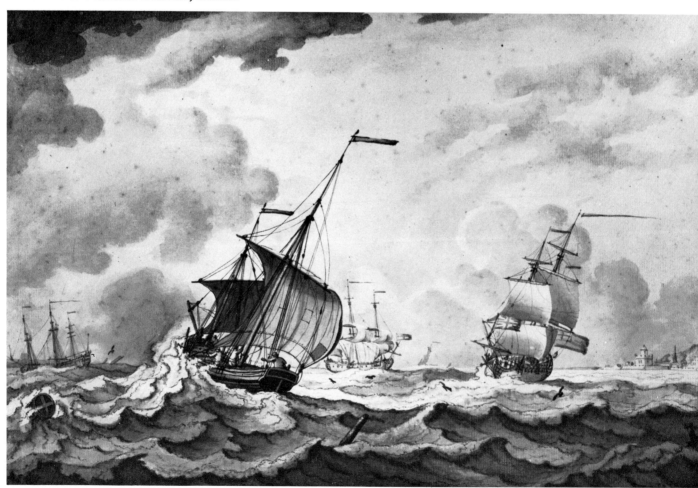

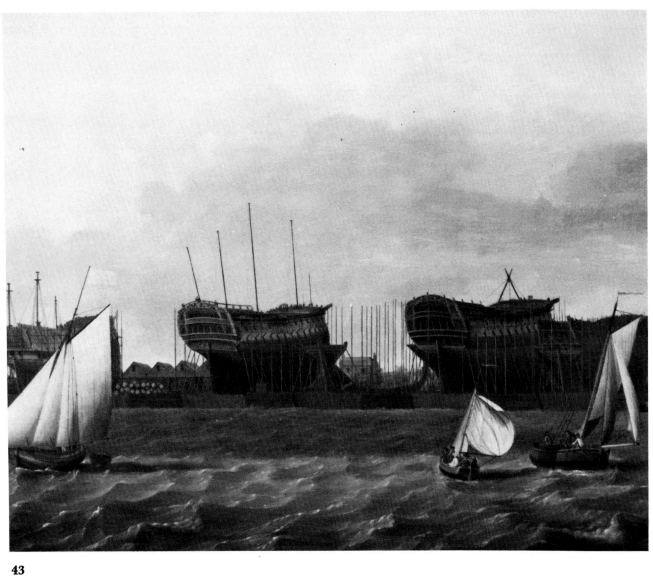

43

44

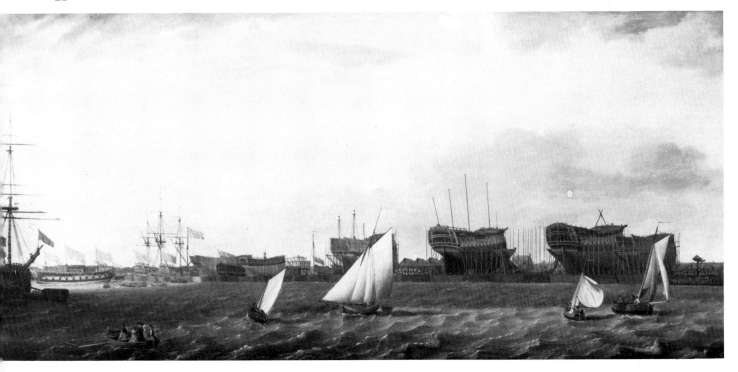

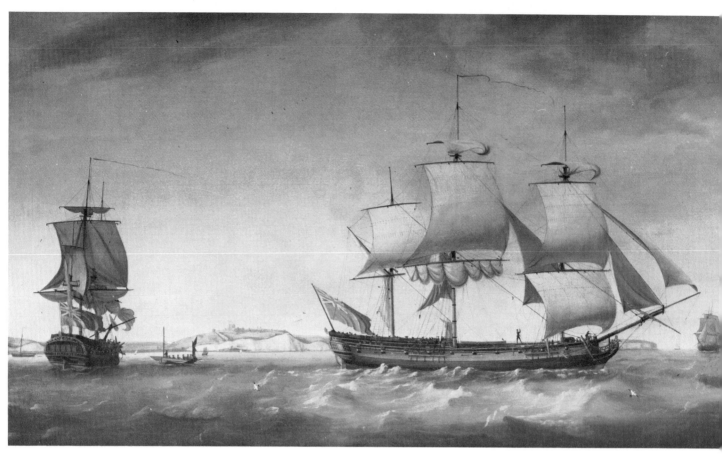

45

46

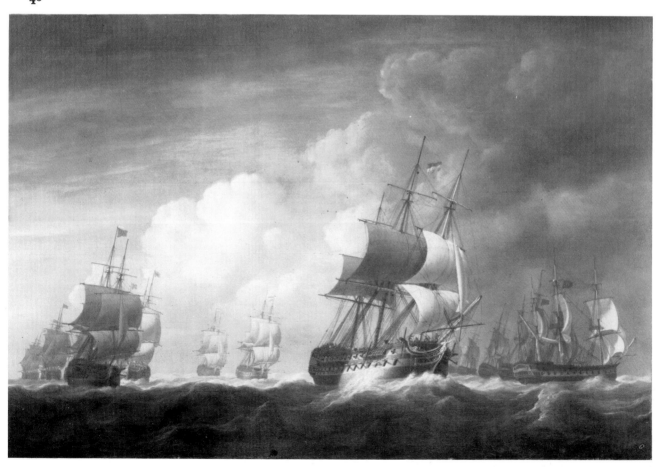

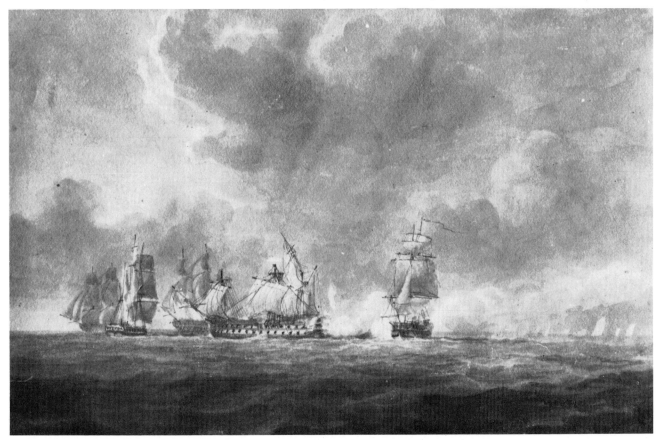

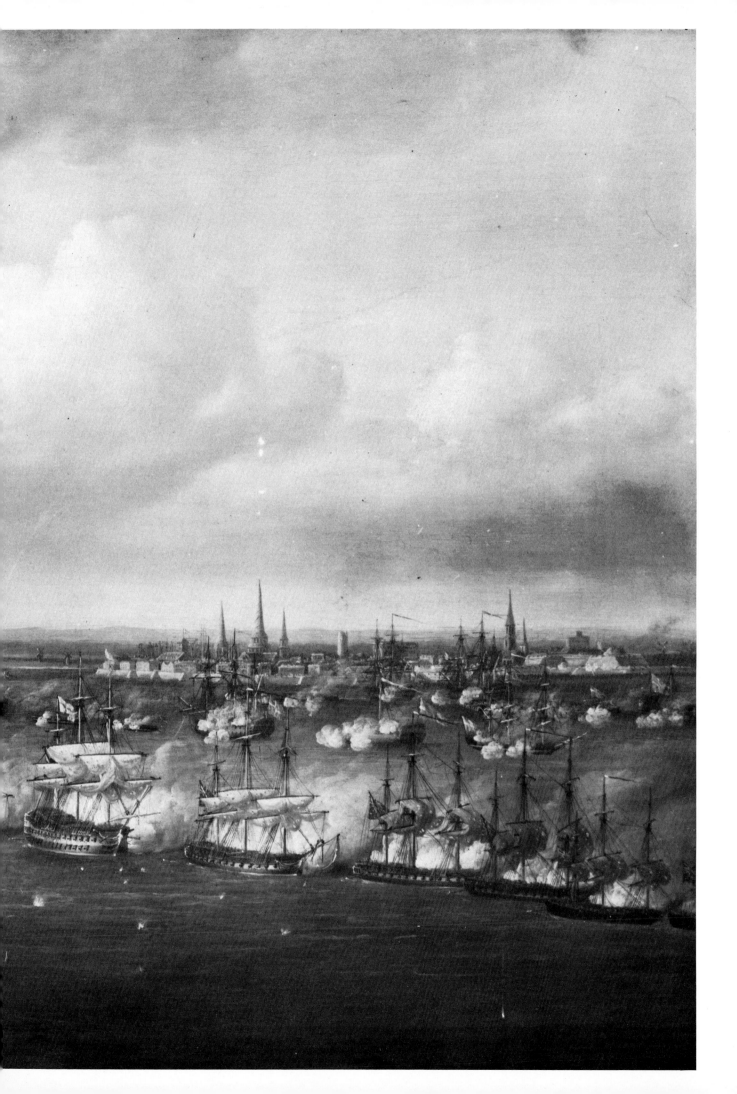

49 William Anderson
Limehouse Reach
Oil on canvas, 12½ × 17 in./32 × 43 cm.
National Maritime Museum, London

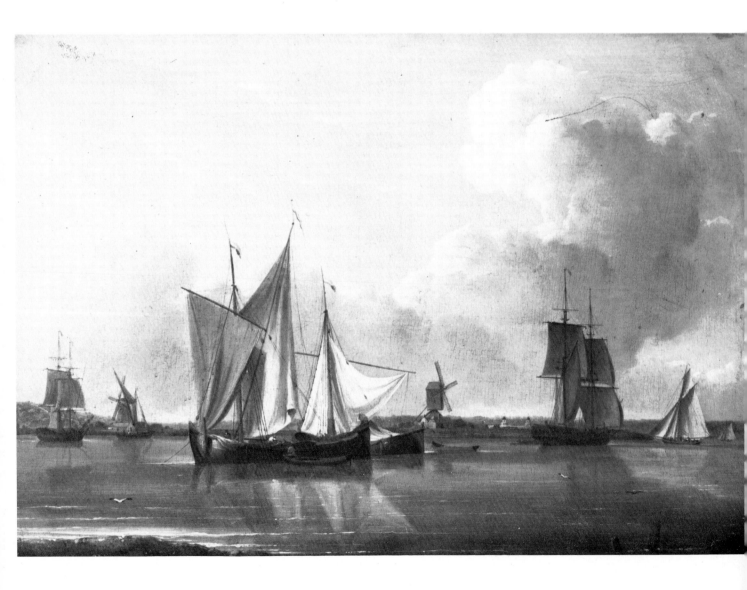

50 William Anderson
Greenwich: return of George IV in the Royal George yacht, 10 August 1822
Oil on canvas, 29½ × 42½ in./75 × 108 cm.
National Maritime Museum, London

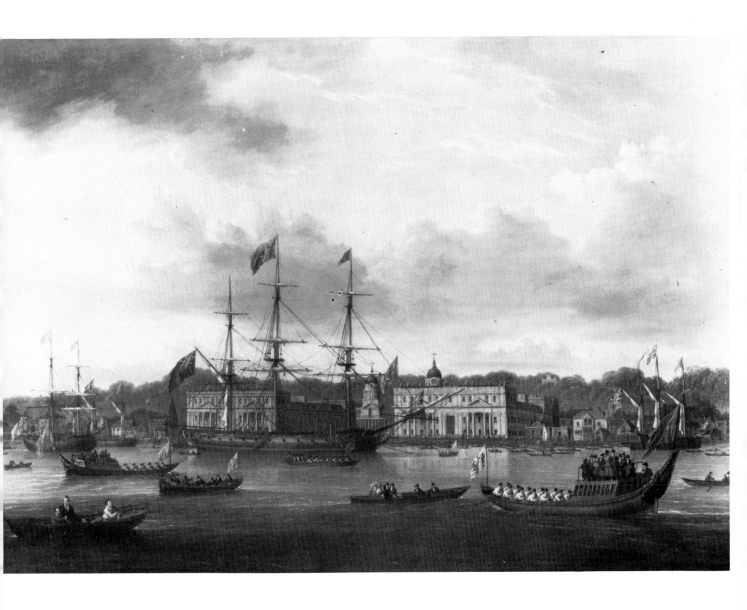

51 Thomas Luny
The wreck of the Dutton, 26 January 1796
The *Dutton* was a troop-carrying ship which was driven ashore at Plymouth during a gale.
The passengers and crew were rescued by the efforts of Captain Pellew who managed to get
lines aboard before she broke up
Oil on canvas, 30 × 44 in./76 × 112 cm. Signed and dated 1821
National Maritime Museum, London

52　Thomas Luny
The Castor and other merchant ships
Oil on canvas, 34 × 50 in./86.5 × 127 cm. Signed and dated 1802
National Maritime Museum, London

53 Thomas Luny
 Shipping off a coast
 Oil on canvas, 19½ × 26 in./49.5 × 66 cm. Signed and dated 1830
 From the collection of Mr William Barnett, Co. Down

54 Thomas Whitcombe
The battle of Camperdown
Oil on canvas, 48 × 72 in./122 × 183 cm. Signed and dated 1798
Tate Gallery, London

55 Robert Salmon
A frigate coming to anchor in the Mersey
Oil on canvas, 19 × 29 in./48.5 × 74 cm. Signed with initials and dated 1802
National Maritime Museum, London

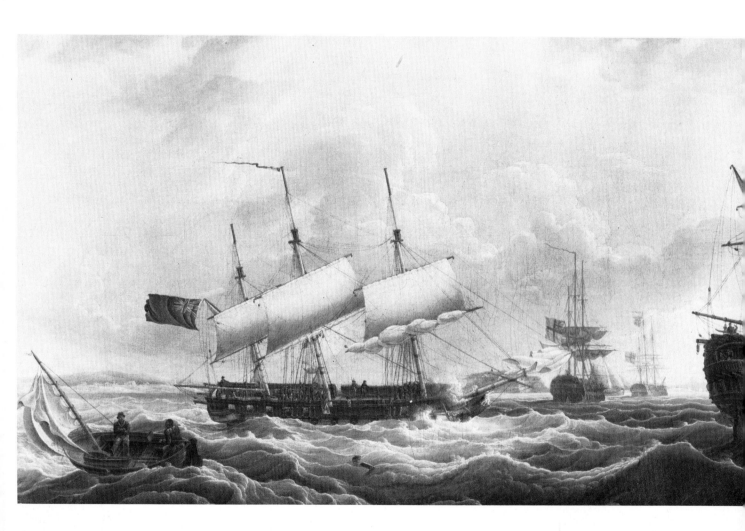

56 Samuel Atkins
A view of the Pool below London Bridge
Watercolour, 14 × 17½ in./35.5 × 44.5 cm. Signed. *c.* 1790
Victoria and Albert Museum, London

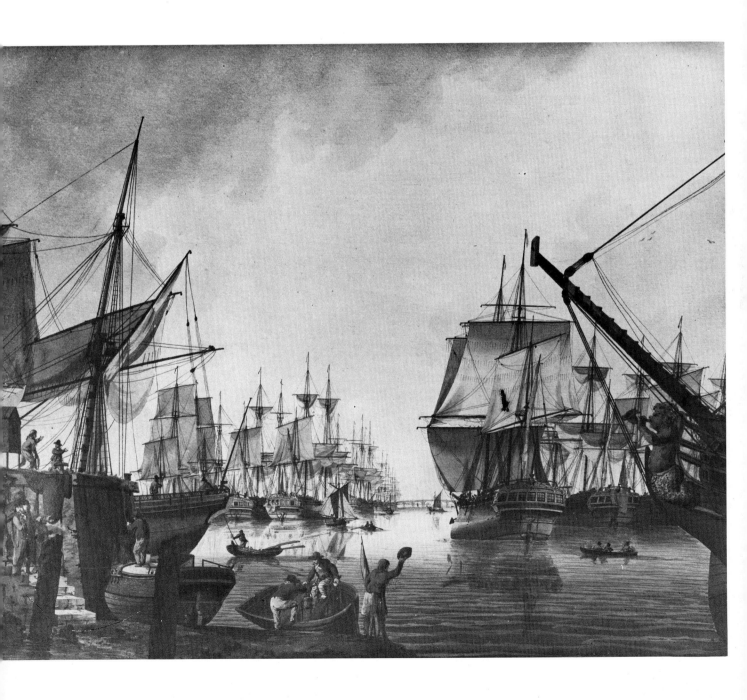

57 Thomas Buttersworth
A naval cutter hove to in the Mediterranean
Oil on canvas, 16½ × 22½ in./42 × 57.5 cm. Signed
From the collection of Mr and Mrs F. B. Cockett, London

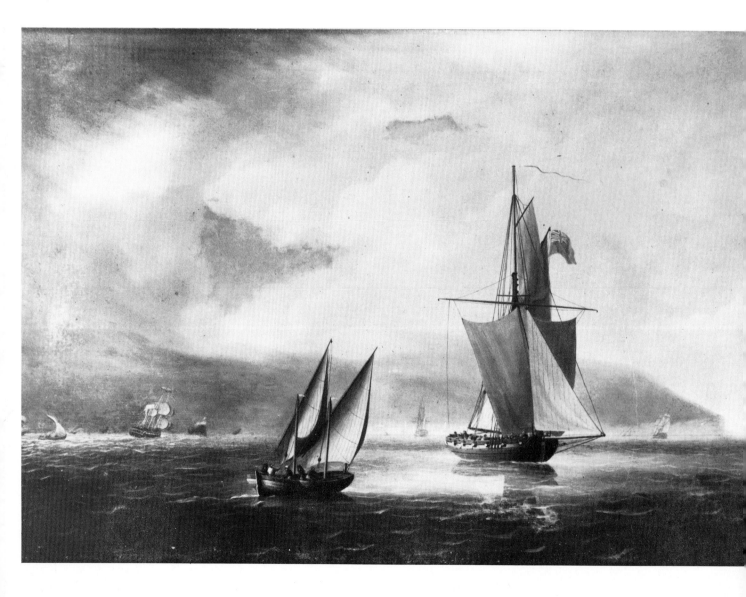

the constant appearance of Dutch craft in the paintings of Scott, Stanfield, E.W.Cooke and so many other English marine artists. The characteristically rounded forms of *boeiers* were a fairly common sight in the Thames Estuary and on the east coast rivers but this fact alone can hardly account for the number of times in which Dutch fishing boats and small merchant vessels were made the subject of marine paintings. Stanfield's *On the Dogger Bank* (pl. 94) and Cooke's Diploma picture *Scheveling pinks running to anchor off Yarmouth* (pl. 112) are typical examples, and it is probable that such pictures were intended to emulate the Dutch masters so admired by these artists.

The marine artist whose work was admired in England above all others was William van de Velde the Younger. This was not due only to his genius as a painter—there were other Dutch artists who shared his gifts for painting ships and the sea. Quite simply, he lived and worked in England for thirty-five years. He was a prolific artist and his work was commissioned by royalty and by many distinguished English patrons. Van de Velde's paintings embodied the lessons he had learnt from Simon de Vlieger and the generations of Dutchmen who had preceded him. He thus provided a direct link between the seventeenth-century marine school of Holland, and men like Monamy, Scott and Brooking who helped to lay the foundations of a school of marine painting in England.

Every English marine artist was familiar with van de Velde's work. Scott, Dominic Serres, Turner and Edward Duncan were among the many who collected his pictures and drawings. Indeed Scott, whose early work was closely based on van de Velde examples, earned himself the immortal jingle:

> Twas late the death of Scot was known
> A painter of the town
> Who for his art was so much fam'd
> The English Vanderveldt was nam'd.[5]

The Reverend William Gilpin, the author of the influential *Essays on the Picturesque*, was charmed by the Dutchman's pictures. 'What beautiful effects does Vandervelt produce from shipping?' he wrote in 1792. 'In the hands of such a master it furnishes almost as beautiful forms as any in the whole circle of picturesque objects?'[6]

Turner was certainly inspired by Dutch paintings in the first half of his life. One of his earliest sea paintings, *Dutch boats in a gale*, was commissioned by the Duke of Bridgewater as a companion piece to van de Velde's *A rising gale*. In this and in several other well-known marines which he painted between 1800 and 1810 he deliberately set out to compete with van de Velde. There is no doubt more than a grain of truth in Thornbury's story which tells how Turner once picked out a mezzotint from a pile of prints and said with emotion, 'Ah! that made me a painter.' The mezzotint was of a picture by van de Velde showing 'a single large vessel running before the wind, and bearing up bravely against the waves'.[7] In the paintings of his middle period Turner was influenced by the golden tones of Cuyp; Ruisdael and van Goyen were other influences. In the 1830s he openly acknowledged his debt to the Dutch school by painting a series of pictures with Dutch subjects. They included *Fishing boats bringing a disabled ship into Port Ruysdael* (the name of the port was fictitious, and was chosen

to honour the Dutch landscape painter), *Helvoetsluys*, and *Tromp at the entrance of the Texel*.

The inspiration which Constable received from the Dutch school is well known and is frequently recorded in his writings. There were also many lesser artists who acknowledged the seventeenth-century painters as their masters. Samuel Walters, a successful painter of ship portraits in the mid-nineteenth century, paid his own tribute by naming his third son Samuel Vandervelde Walters.

Some knowledge of Dutch paintings is therefore essential if we are to appreciate the references made by English artists to their continental predecessors. This is not the place to study the subject in any detail, and scholarly books have been written about the marine painters of the Netherlands. But some of the most distinguished names should be noted.

Two of the earliest painters of ships were Hendrick Cornelisz Vroom (1566–1640) and Adam Willaerts (1577–1664). The men-of-war and the smaller craft in their paintings were always meticulously drawn, but they were also fond of depicting people. The foregrounds of their harbour scenes were usually filled with crowds of onlookers, with much attention paid to their clothes. The colouring of their pictures retained something of the brilliance of manuscript illustrations: emerald green seas and the heraldic colours of flags and pendants were characteristic features.

With Jan Porcellis (*c.* 1584–1632) marine painting entered a different phase. The bright colours of Vroom and Willaerts gave way to more sombre shades and the emphasis shifted from the ships and the people to the sea and the sky. Porcellis particularly influenced the work of Jan van Goyen (1596–1656) and Simon de Vlieger (*c.* 1600–53). Van Goyen's early works were somewhat crowded with incident but he gradually simplified the subject matter and concentrated his attention on cloud-filled skies and effects of the weather. His distinctive palette of olive-browns and silvery-greys, his open brushwork, and his apparently effortless drawing make his work easily recognizable (pl. 2). His landscapes, beach scenes and seascapes were much admired by the English Romantic artists. John Crome owned one of his pictures, and Turner painted a river scene near Antwerp and named it *Van Goyen looking for a subject*.

The greater part of Simon de Vlieger's work consisted of marine paintings and he is an important figure in the context of English marine art because he was the master of van de Velde the Younger. De Vlieger painted with a palette similar to van Goyen's—browns and silver-greys predominating—but his forms were moulded with softer gradations of colour and he did not employ the loose brushwork of van Goyen. There is an attractive little picture by him in the National Gallery in London with a lovely sky and soft grey colouring: it is entitled *A Dutch man-of-war and various vessels in a breeze* (pl. 3). Greenwich has some good examples of his work, and there are of course many fine paintings by him in Dutch museums.

The man who is considered by some authorities to be the greatest of all Dutch marine artists is Jan van de Cappelle (*c.* 1623–79). His paintings are remarkable for their serene atmosphere. He painted numerous pictures of ships and small craft anchored in calm waters. A famous example is *The state barge saluted by the home fleet* which is in the Rijksmuseum. In the National Gallery,

London, there is *A Dutch yacht firing a salute* (pl. 4), with its intricate pattern of sails under billowing cloud formations, and *A river scene with many Dutch vessels becalmed*. In these paintings he achieves an unusual sense of distance, while the clarity of the light and the shimmering reflections are masterly.

Although van de Cappelle was admired by his own countrymen, he appears to have had less influence in England than Aelbert Cuyp (1620–91) and Jacob van Ruisdael (*c.* 1628–82), both of whom painted some memorable river scenes and marines in addition to their better-known landscapes. In 1810 Pasquin wrote in the *Morning Herald*, 'the genius of Mr. Turner is that he has formed a manner of his own; if it partakes of the style of any preceding painter it is Cuyp, whose aerial perspective Mr. Turner seems in some sort to copy.'[8] Pasquin's observation has some truth in it, and received some confirmation from Turner himself a year later: in a lecture at the Royal Academy he praised the work of Cuyp, Paul Potter and Adriaen van de Velde and said that, 'Cuyp to a judgement so truly qualified knew where to blend minutiae in all the golden colour of ambient vapour.'[9] The golden sky tones so characteristic of the Dutchmen's works were emulated by Turner in many paintings, the most spectacular of which was *Dordrecht: the Dort packet-boat from Rotterdam becalmed* (pls. 68, 69 and jacket).

The passage boat (pl. 5) in the English Royal Collection is a striking example of Cuyp's marine painting. The softly glowing sky and limpid reflections are characteristic, but what is outstanding in this picture is the boldness of the composition. He has filled the foreground with the boat and constructed a pattern of diagonals with her mainsail and rigging. This painting, together with the *Shipping near Dordrecht* in the National Gallery at Washington and the Kenwood *View of Dordrecht*, are superb examples of the type of sea painting appropriately known as 'the tranquil marine'. Indeed the work of Cuyp, van de Cappelle and van de Velde in this realm of art has never been equalled.

Ruisdael's marine work was in a different vein. Instead of peaceful sunset scenes he preferred to paint windswept beaches, or choppy seas with fishing boats heeling beneath storm clouds. His *Rough sea* in the Museum of Fine Arts, Boston is a wonderfully atmospheric painting. In this, and several similar pictures he demonstrates his skill in portraying the effect of a stiff breeze on the surface of shallow water. Another marine painting of great power is the *Stormy sea* in the National Museum at Stockholm. Works like these help to explain why Constable should have considered that 'whenever he attempted marine subjects, he is far beyond Vandervelde'.[10]

The shore at Egmond-aan-zee (pl. 6) is typical of Ruisdael's beach scenes. It was this type of picture that was to inspire a host of English variations. The paintings of A.W.Callcott are perhaps the closest in subject matter although some of his contemporaries believed that he lacked the Dutch artist's skill. 'Sir George Beaumont had been today at Kensington & had seen Calcott's pictures,' Farington wrote in his diary on 5 April 1806. 'He spoke of them as being like pictures by Ruysdael, which had been worn down and then worked upon in a fuzzy manner but that there were silver grey skies well imitated & good colour.'[11]

The beach scenes of Ruisdael and his countrymen also influenced the marine painters of the Victorian period. E.W.Cooke and Clarkson Stanfield were

typical of many Englishmen who paid regular visits to Holland and filled their sketch books with drawings. On their return to England they painted pictures of merchant vessels on the Scheldt and the Zuyder Zee, and fishermen launching boats off the beach at Scheveningen and elsewhere.

The colouring of their paintings differed from that of the seventeenth-century masters, but their treatment of clouds, their disposition of light and shade and in particular their grouping of ships often closely resembled the work of the Dutch school.

William van de Velde the Elder c. 1611–1693
William van de Velde the Younger 1633–1707

The powerful influence of William van de Velde the Younger on marine art in England has already been mentioned. Because of this fact, and because he and his father provided a direct link between the Dutch and the English schools of marine painting, the two men deserve more than a passing mention here.

William van de Velde the Elder was born in Leyden around the year 1611. He was the son of a sea captain of Flemish origin. He was married in 1631 and was still living in Leyden when his first son, William van de Velde the Younger, was born in 1633. The family then moved to Amsterdam where the second son, Adriaen van de Velde, was born in 1636. Little is known about the artistic education of the elder van de Velde. His first dated drawing is of 1638, but he must have been working for several years before this. During the 1640s and 1650s he was often at sea, making voyages to the Baltic, and recording sea battles. Large numbers of his sketches have been preserved and they demonstrate the thoroughness with which he approached his subject. It is well documented that he had himself rowed among the men-of-war during battles so that he could make drawings of the action. He was, for instance, present at the Battle of Scheveningen in 1653, and it is interesting to note that in a report of the action which he sent to the Dutch government he described himself as 'Draughtsman to the Fleet'. In 1665 he sailed with de Ruyter's fleet as far north as Bergen, among the Norwegian fiords. He also followed the Dutch fleet in the opening months of the third Anglo-Dutch war, making some seventy drawings before the Battle of Solebay and more during the battle. It was during the course of this war that he and his son emigrated to England and he made drawings of the closing actions of the war from an English vessel.

Several theories have been put forward to explain the emigration of the van de Veldes. The most likely reasons would seem to have been financial necessity, and the difficulty of working as artists in the conditions in Holland at the time. By 1672 when the third Anglo-Dutch war broke out, the country was suffering from a depression. In the same year the French army invaded the Low Countries and occupied Utrecht. In June 1672 Charles II issued a declaration encouraging Dutch people to settle in England, and this resulted in the emigration of a

large number of Dutch families. Van de Velde the Elder had already paid a visit to England in 1661, a year after the Restoration, and he must have formed some idea of the mood of the country then, and the reception he might expect for himself and his work. It may have been a combination of these factors which was responsible for the van de Veldes' decision. The only written evidence we have on the matter is a letter written by Peter Blaeu to Cardinal Leopoldo de' Medici in 1674, in which he said that van de Velde the Elder had decided to seek employment in England and if that failed to travel on to Italy. It seems likely that van de Velde arrived in England early in 1673. His son may have arrived before him because there is at least one picture by him of 1672 which is inscribed 'In London', though it must be remembered that the year in England began in March.

Whatever the exact date of their arrival, there was no doubt about their favourable reception in London. Charles II and his brother the Duke of York took more than an official interest in maritime affairs and they were delighted to welcome the foremost war artists of the day. The king provided them with a studio in the Queen's House at Greenwich and arranged for their salaries to be paid by the Treasurer of the Navy. The warrant of appointment was dated 20 February 1674 and specified 'the Salary of One hundred pounds p. Annm unto William Van de Velde the Elder for taking and making Draughts of sea-fights, and the like Salary of One hundred pounds p. Annm unto William van de Velde the Younger for putting the said Draughts into Colours for our particular use'.

The task of the van de Veldes now was to record naval engagements from the English angle, and this they faithfully did. Indeed the elder van de Velde was still hard at work at the age of eighty, and in 1691 we find that he was at Gravesend making drawings of the departure of some yachts. He died in 1693 and was buried at St James's, Piccadilly.

Although his drawings of ships (pl. 9) and his sketches of naval engagements are of interest to maritime historians, the elder van de Velde's greatest contribution to marine art was his production of *grisailles*. These were pictures carried out with pen and ink on a prepared white surface of canvas or panel. The technique has the appearance of an engraving when it is reproduced, but in fact the pictures were considerably larger than most engravings. Van de Velde was not the originator of *grisailles* but his work in the medium reached a far higher standard than that of any other artist.

The National Maritime Museum at Greenwich has a magnificent collection of van de Velde's *grisailles*. A good example is his *Dutch East Indiaman near the shore* (pl. 7). Close examination reveals an awe-inspiring attention to detail. The individual strands making up the ropes have been drawn, the position of nails along the sides of the hulls has been observed and every intricate carving on sterns and figureheads has been included. And yet in spite of this almost obsessive concern with detail, van de Velde has retained a breadth and freedom in the overall conception. Although the waves are formalized and there is no attempt to introduce atmospheric effects, he has created a vigorous sense of movement. The wind is suggested by the set of the sails, by the faultlessly observed strains and tensions on the rigging and by the fluttering flags and pendants. The groups of ladies and gentlemen on the shore in the foreground—a

favourite device in his pictures—are delightfully drawn, as are the occupants of the rowing boat and the sailors on board the ships. After he came to England he painted also in oils.

William van de Velde the Younger must have had his first lessons in art from his father and he worked in partnership with him for much of his life. Nevertheless his approach to marine painting was very different. He was the true heir to Porcellis, van Goyen and de Vlieger. His ships were drawn with meticulous accuracy but he was also a master of atmospheric effects—indeed it was this quality in his work which so endeared him to the English Romantic artists. He was, moreover, a most versatile painter and was as accomplished at portraying calm inland waters as he was at depicting a fresh breeze in an estuary, or ships running before a gale.

It seems certain that van de Velde was a pupil of Simon de Vlieger although there is doubt about the number of years he studied with him. De Vlieger moved from Amsterdam to Weesp some time between 1648 and March 1650. Van de Velde, who would have been seventeen in 1650, appears to have left his family and gone to live in Weesp as de Vlieger's pupil. The likelihood of this is strengthened by the fact that he became betrothed to a girl from Weesp, although he returned to Amsterdam for the marriage in March 1652. De Vlieger died at Weesp in 1653. Van de Velde was a precocious artist and a period of only two or three years with de Vlieger would have been long enough for him to learn the valuable lessons on which the mature period of Dutch marine painting was founded.

During the 1650s and 1660s van de Velde worked with his father in Amsterdam. Although he does not seem to have made so many voyages with the Dutch fleet as his father, he was present at some of the naval engagements of the Anglo-Dutch wars—his drawings would indicate that he was at the Four Days' Battle off North Foreland in June 1666. Many of his best paintings of this period are in the Rijksmuseum: *The cannon shot* is one of his classic compositions, and was the type of picture that was to be a model for many paintings by Peter Monamy, Samuel Scott and others. Van de Velde has invested the man-of-war with an element of grandeur, and has given a timeless quality to the moment portrayed.

In 1691, father and son moved from Greenwich to Westminster, and this remained their home for the rest of their lives. After the death of his father in 1693, van de Velde continued to act on his own as official war artist to the British navy. His position is made clear in an order to the commanders of the fleet, dated May 1694. It reads: 'Whereas Mr. William Vande Velde is appointed by this Board to goe aboard their Ma^ts Fleet this Summer in ordr. to make from time to time Draughts & Figures or Imitations of what shall pass & happen at Sea by Battle or fight of the Fleet, you are hereby required and directed to cause him the said William Vande Velde & one Servant to be born in victualls only, on Board Such Ship or Ships of ye said fleet as he shall desire to proceed in. . . .'[12]

The Wallace Collection has a fine selection of van de Velde's work including two 'tranquil marines', *Ships in a calm* and *Boats at low water* (pl. 8). The latter is a beautiful painting of this type with soft colouring and a poetic sense of atmosphere. The boats have been grouped with exquisite care, and a complex and harmonious composition has been constructed with the varying angles formed

by masts, spars, sails and posts. The reflections have been painted with an assured touch and even the shallowness of the water in the foreground has been suggested.

The National Gallery in London has sixteen paintings by van de Velde the Younger including one of his best-known tranquil marines, *Dutch vessels close inshore at low tide, with men bathing*, a picture which is remarkable for its clarity of light and brilliance of execution. In a different vein is the lively painting entitled, *A small Dutch vessel close-hauled in a strong breeze, and men-of-war in the distance* (pl. 1). Simon de Vlieger and Jacob van Ruisdael painted similar subjects, but it was van de Velde's renderings of small craft splashing through choppy seas that had the greatest influence on English artists. We come across many variations of this subject during the course of the next two hundred years. George Chambers' *A Dutch boeier in a fresh breeze* (pl. 113) is a typical example. The National Maritime Museum at Greenwich has a very large and representative collection of van de Velde paintings, including a number of battle scenes. There are also some memorable pictures of storms at sea. *The Resolution in a gale* is a vivid portrayal of a man-of-war heeling before gale-force winds. Another dramatic painting is *An English squadron beating to windward*. Van de Velde's method of depicting ships in storm conditions was clearly based on much first-hand observation, and in spite of the volume of his work he rarely became mannered in his technique. Many of the artists who followed him, however, were content to copy the style he had set and we therefore see van de Velde techniques appearing in numerous marine paintings throughout the eighteenth century.

The van de Veldes' drawings are an important part of their work, and the collection at Greenwich, which has been so thoroughly catalogued by M.S. Robinson, provides a valuable insight into the artist's approach to his subject. A large proportion of these drawings are studies of hull and rig details and are, perhaps, of more interest to the marine historian. But the pen and ink sketches in which they recorded movements of the fleet have a quality which will be appreciated by any admirer of drawings. A spirited sketch like van de Velde the Younger's *An English ship and a yacht before a light breeze* has great immediacy and assurance. It is not surprising that Constable should have modelled his style on such drawings when he made a coastal voyage in 1803.

Van de Velde the Younger died at Westminster in April 1707 and was buried alongside his father in St James's, Piccadilly. During the course of his life he had drawn or painted nearly every type of Dutch and English vessel afloat.

3 THE EIGHTEENTH CENTURY:

the formation of an English style

Naval reforms which had begun in the 1660s when Pepys was at the Admiralty, combined with the superiority of British seamanship and the dominating fire-power of her ships, secured Britain an absolute mastery of the seas in Georgian times. And just as the Dutch marine painters had recorded the triumphs of Tromp and de Ruyter in the seventeenth century, so the English artists who succeeded the van de Veldes found a ready market for pictures of the victorious ships of Hawke, Rodney and Jervis.

A second source of commissions was the portrayal of ships of the East India Company. The Company's fortunes reached a peak of prosperity during the course of the eighteenth century. The Government granted them exclusive trading rights in 1711, and by 1748 the value of imports to England (chiefly raw silk, cotton, calico and tea) had reached £1,100,000. Francis Holman and Robert Dodd were among the many artists who painted pictures of the Company's ships.

The marine art of the period provided an invaluable record of merchant shipping and naval achievements. In addition, it is possible to trace through it the development of an English style. The Dutch school exerted an undeniably powerful influence, but a few artists retained their individuality and certain national characteristics began to emerge.

The 'Englishness' of these eighteenth-century painters is not nearly so easy to pin down as is that of the Romantic artists who followed them, but there are a few common factors. The first is in the portrayal of light and atmosphere.

Scott and Brooking in particular show much skill in capturing the vagaries of the English weather: in their paintings the sunlight on the water seems constantly on the move and we are aware that clouds and a sudden shower of rain will follow. A second characteristic is a concentration on the flat surface of the picture. The Dutch were adept at creating the illusion of depth: mirror-calm canals merging into distant sky are a typical feature of their paintings. By contrast, Cleveley's *A ship on the stocks* (pl. 20) shows a delight in flat shapes: ships' hulls, flags and warehouses form strongly marked patterns. Brooking shows the same sense of patterning in his cloud shapes and the way he depicts light and shadow on the surface of sails and craft. A third characteristic is a factual approach to the subject-matter. Instead of placing people in stylized groups and arranging buildings and boats according to traditional rules of harmony, the English artists adopted a more literal approach—which is perhaps epitomized in Scott's *Old Custom House Quay* (pl. 25) by the man with his hands in his pockets surrounded by a clutter of boxes and barrels.

Early marine artists in England

In recent years it has become apparent that there was a flourishing group of marine artists working in London at the time of the van de Veldes. Very little is known about the lives of these artists but signed paintings which have come to light have shown distinct differences in style. As more research is done on this early period (which extends from about 1680 to 1720) new facts will doubtless emerge and only a brief outline of the present state of knowledge can be given here.

These early artists may for convenience be divided into two groups: the van de Velde group and the Sailmaker group. The first group included Cornelis van de Velde who was a son of the younger van de Velde; J. van de Hagen (or der Haagen) whose daughter married Cornelis van de Velde; L.D.Man; and Robert Woodcock. Cornelis is still a somewhat shadowy figure but it is becoming apparent that he was more than a mere copyist of his father's work and may have been a fine painter in his own right. J. van de Hagen worked in the studio of the younger van de Velde and successfully assimilated his style. His best work has a breezy atmosphere and a sense of movement (pl. 13). It is believed that he took to drink and died in penury. L.D.Man (or L.de Man) was an interesting artist with a strongly individual style. A pair of his paintings in a private collection (pls. 17, 18) shows him to have had an equal mastery of the tranquil marine and rough seas. He was particularly adept at painting detail, such as the sailors hauling on the halyards and the gilded decoration on the sterns and bows of his ships. Robert Woodcock (*c.* 1691–1728) was a civil servant who became an artist and painted a great number of copies of van de Velde subjects. Lastly, it is worth mentioning that the elder van de Velde is known to have become a copyist in his later years and painted a number of oil paintings in the style of his son.

The Sailmaker group is more difficult to define and there is still confusion in

attributing the works of these artists. However the chief names were Isaac Sailmaker (c. 1633–1721); Jacob Knyff; H.Vale and R.Vale; and Jan van Beecq. In the past Sailmaker has been credited with paintings by all these artists and has frequently been referred to as the father of English marine painting. It is true that he worked in England for some seventy years but it seems that he was of Dutch origin and came to this country as a boy. He was a pupil of George Geldorp, a German artist who looked after the art collection of Charles I. The best account of Sailmaker is provided by Vertue who wrote: 'This man was imployed to paint for Oliver Cromwell a prospect of the Fleet before Mardyke when it was taken in 1657. Sept. . . . This little man imploy'd himself always in painting views small & great of many sea Ports & Shipps about England, he was a constant labourer in that way tho' not very excellent. his contemporaries the Vander Veldes where too mighty for him to cope with. but he outlivd them & painted to his last. he was born at Scheveling came very young into England. and always liv'd here. & died here at his home near the River side without the Temple Gate. call'd the Kings bench Walks. a profil off his picture painted by young Philips. who since paints conversations.'[1]

Although there are no signed paintings by Sailmaker in existence it has been possible to make attributions on the basis of engravings after his work. *A view of the Eddystone lighthouse* (pl. 22) is one such painting. There seems no reason to question Vertue's comment that he was 'not very excellent'. A number of paintings previously attributed to Sailmaker are now known to be by Jacob Knyff (c. 1638–81). A signed and authenticated painting by this artist in the National Maritime Museum shows him to have had a clearly recognizable style (pl. 19). He was fond of harbour scenes with moored ships, and he usually paid considerable attention to architectural features. His work should not be confused with that of Leonard Knyff (c. 1650–1721), who painted landscapes and views of English country houses.

Nothing is known about H.Vale and R.Vale beyond the existence of their signed paintings, of which there are examples at Greenwich. *The Royal Katherine* by H.Vale is a lively work in which the ships are drawn with impressive accuracy. The most talented artist of this group would seem to have been Jan van Beecq (1638–1722), who worked in Paris before coming to England in about 1714. *Shipping in a calm* (pl. 21) is typical of his work, and there is a fine painting by him at the National Maritime Museum, *The Royal Prince*, with a lovely sky, liquid green waves and closely observed ships.

Peter Monamy c. 1686–1749

Horace Walpole described Peter Monamy as 'a good painter of sea-pieces', and it would be hard to quarrel with this judgement. His oil paintings are distinguished by their pleasant colouring, and by their accurate drawing of ships and small craft. He rarely strained after dramatic effects and was best in peaceful scenes showing ships at anchor. *A calm evening* (pl. 16) is a fine example.

At the present time, facts about Monamy's life are meagre and slightly confusing. The chief source of information has been an entry in Vertue's *Notebooks* which was written in 1749, the year of Monamy's death. According to Vertue, Monamy was born in Jersey, came to London when he was young and became a house painter. By imitating the van de Veldes and by constant practice 'he distinguisht himself and came into reputation'. His understanding of ships caused his pictures to be highly esteemed by seafaring people. During the latter part of his life he lived by the Thames at Westminster, 'for the Conveniency in some measure of viewing the Water & Sky tho' he made many excursions to wards the Coasts & seaports of England to Improve himself from nature'. Vertue concludes: 'Thus having run thro' his Time about 60 years of age being decayd and Infirm some years before his death which happend at his house in Westminster the beginning of Feb.1748/9—leaving many paintings begun and unfinished, his works being done for dealers at moderate prices kept him but in indifferent circumstances to his end.'[2]

Redgrave and most subsequent art historians have given 1670 as the probable date of Monamy's birth. This hardly agrees with Vertue's concluding sentence, however, which would infer that Monamy was born around 1689. A recently discovered entry in the Registers of the Company of Painter Stainers records 'Peter Monamy Son of Peter Monamy of London Merchant bound to William Clarke for Seven Years by Indentures Dated the 3rd September 1696.'[3] On the assumption that he must have been at least ten years old when he was apprenticed, it seems probable that he was born around 1686.

Monamy's association with the Painters Stainers' Company is confirmed by two further entries in the Company's records: in 1703 he is mentioned in the List of Freemen; and in 1726 an entry reads, 'Ordered that Mr. Peter Monamy be admitted upon the Livery in consideration of his haveing presented the Company with a Valuable Seapiece of his Own Painting. . . .'[4] Further facts about his life come from a variety of sources. J.T.Smith in *Nollekens and his Times* mentions that 'Monamy, the famous marine painter, decorated a carriage for the gallant and unfortunate Admiral Byng with ships and naval trophies; and he also painted a portrait of Admiral Vernon's ship, for a famous public house of the day, well known by the sign of the "Porto Bello" remaining until recently, within a few doors worth of the church in St. Martin's Lane.'[5] Horace Walpole noted that Monamy 'received his first rudiments of drawing from a sign and house-painter on London-Bridge'.[6]

Of more general interest, perhaps, than these fragments of information is a painting by Hogarth entitled *Monamy showing a picture to Mr Walker* (pl. 15). Hogarth depicts Monamy, in frock coat with palette in hand, displaying his work to Thomas Walker who was a commissioner of customs and a noted collector of Dutch and Italian pictures. Monamy himself painted the marine picture on the easel.

In addition to his oil paintings (many of which are in the National Maritime Museum), Monamy carried out some attractive pen and wash drawings. His *View of Deal from the sea* (pl. 14) has the fresh, breezy quality that is characteristic of the best of these drawings. The British Museum's *Ships entering a harbour* is another good example. It has an airy freedom and a delicacy of touch that recalls the drawings of the younger van de Velde. Indeed it is a pity that

Monamy's work is always compared with his Dutch predecessor because he inevitably suffers by the comparison. And yet he is an important figure in the history of marine painting in England because, with Samuel Scott, John Cleveley the Elder and Brooking, he helped to lay the foundations of the English marine school.

Samuel Scott 1701/2–1772

Samuel Scott is known today mainly for his views of the Thames and the buildings along the waterfront. Many of these pictures were plainly inspired by the London views of Canaletto. The Venetian painter arrived in England in 1746 when Scott was in his thirties, and he proved very popular with the English connoisseurs. In Scott's *Entrance to the Fleet River* (which is in the Guildhall Art Gallery), Canaletto's influence is immediately apparent. But in his own lifetime, and particularly until Canaletto's arrival caused him to change his subject-matter, Scott was famous as a marine painter. Indeed he was referred to as 'the English van de Velde' and the reference was not inappropriate because he owned a large collection of prints after van de Velde and made several copies of the Dutchman's work. He was not an entirely derivative painter, however, and although he obviously owed a debt to the Dutch marine school, he acquired a distinct style of his own and must be considered an important forerunner of the eighteenth-century group of English marine painters.

Unfortunately, it is possible to discover few of the facts of Scott's life. It is believed that he was born in London and most authorities give the date of his birth as 1710. However this date may be incorrect because William Marlow, who was one of his pupils, told Farington that Scott died at the age of seventy, which would mean that he was born around 1702.[7]

Although his early life is obscure, one event that is well documented is his trip round the Isle of Sheppey in May 1732. With William Hogarth and three other friends he set off in a small sailing boat and spent five days in the region of Gravesend and Sheerness. Some of the sketches which he made *en route* have survived, and he collaborated with Hogarth to produce a set of engravings commemorating the trip. These were of a humorous nature and one of them, entitled *The Embarkation*, shows the reluctant and diminutive figure of Scott being pushed towards their moored boat by the burly Mr Forrest. Hogarth is crawling up the gang-plank on his hands and knees. Forrest's account of the Sheppey trip also tells us that Scott was married by this date—to 'a smart and witty woman'.[8]

Farington's Diary provides further information about the artist. We learn that 'Scott was a warm tempered man but good natured' and that for a thousand pounds he purchased a place as 'Clerk or Deputy Clerk of Accounts to the Stamp Office which produced him £100 a yr.—and obliged him to attend the office 2 hours 3 times a week. In the latter part of his life he sold the place.' We also learn that 'He never was at Sea, except once in a Yatch [sic] which was sent to Helvotsluys to bring George 2nd from Hanover.'[9]

By the end of 1732, Scott had completed a commission for the East India Company. This involved the painting of six views of the Company's various settlements abroad including Fort William in Calcutta, the Cape of Good Hope and St Helena. The buildings in the paintings were carried out by another artist, George Lambert, but Scott was responsible for the sea and the shipping. When completed the paintings were hung in the Court Room of the Company's house in Leadenhall Street. Scott and Lambert later collaborated on another series of pictures which consisted of views of Plymouth and Mount Edgecumbe. The pictures were engraved and published between 1750 and 1755.

In 1749 Scott took on Sawrey Gilpin as a pupil. The boy, who was aged fifteen when he was apprenticed, was the younger brother of the Reverend William Gilpin, the author of the influential essays on the theory of the picturesque. Sawrey seems to have appreciated Scott's teaching because he remained with him till 1758, two years beyond his apprenticeship. It was he who gave Farington most of his information, including the fact that 'Scott prepared his ground of Brown Oker and White, and made water part darker than rest, finished at once.'[10]

Around 1758 Scott took up residence at Twickenham. By this time Canaletto's success had encouraged him to turn from pictures of naval engagements to views of London (although he still occasionally carried out commissions for marine pictures). Most of his London views must be classed as topographical works and fall outside the scope of this book, but two pictures which he painted about 1760 are good examples of river-side scenes with shipping. They are both in the Tate Gallery. *A sunset, with a view of nine elms* is a wonderfully atmospheric rendering of a quiet stretch of the river. Although there is a naïveté about the composition and the drawing, Scott has captured a mood of stillness and peace.

The second picture is *A morning, with a view of Cuckold's Point* (pl. 23). Again there is the soft light and summer tranquillity, but this time there is more activity: the passenger in the stern of the boat grounding on the shore is singing and waving a bottle in the air; beyond, a smack has been beached and three men are breaming the hull—a process that involved burning off the barnacles and treating the planks with molten tar. On the left, beyond the Peter-boat, a ship is being loaded with timber.

The facts about the latter half of Scott's life are almost as scarce as those about his early years. According to Redgrave, he exhibited at Spring Gardens Rooms in 1761. Around this time he went to visit his only daughter at Ludlow and then he retired to Bath, apparently in the hope of curing his gout. He sent in his *View of the Tower of London* to the Royal Academy in 1771. The following year, on 12 October, he died at 7 Chatham Row, Walcot Street, Bath.

Scott's paintings invariably repay a close examination. His practice of recording numerous human incidents gives an added interest to the static details of riverside architecture and shipping. It is a practice which he may have copied from Canaletto, although the figures in Canaletto's paintings seem to have a more decorative purpose. Scott's figures are much more like Hogarth's. There is a homely and often burlesque quality about them.

This quality also extends to some of his purely marine works. *A Danish timber bark getting under way* (pl. 24) is a large painting with a certain grandeur in

its composition and a fine regard for the placing of every ship. A closer look reveals in addition a bustle of human activity. The crew of the boat in the foreground are hauling up an anchor with the aid of a windlass in the bows: the deck of the timber bark is crowded with men heaving on halyards and making ropes fast, while high above them half a dozen sailors are precariously perched on the yard-arms loosening the sails.

An interesting feature of Scott's marine paintings is the fact that he usually avoided the portrayal of ships in rough seas or carrying out complicated nautical manœuvres. This was presumably because—unlike Monamy and Brooking—he had little or no practical knowledge of seamanship. It is believed he often drew his ships from models.

John Cleveley the Elder c. 1712–1777

Although the dockyard scenes of the elder Cleveley are so distinctive, very little is known about him and this has led to some confusion in the past. Authorities have differed over his dates and his work has sometimes been muddled with that of his son John Cleveley the Younger. However, recent research has clarified some points and we now have a few details about his life.

He was born around 1712 and was the son of Samuel Cleveley of Southwark who was a joiner. He was apprenticed to Thomas Miller and he became a ship-wright.[11] At the time of the birth of his twin sons, Robert and John, he and his wife Sarah were living at Kings Yard Row in Deptford. Both these sons became artists. Over a period of some forty years Cleveley painted scenes of shipbuilding and launching ceremonies on the Thames in an attractive style and with a professional regard for nautical detail, but it is not known whether he earned a sufficient livelihood from his painting to enable him to give up his job in the docks. He died in Deptford in 1777. From the record of Administrations at Somerset House for June 1778 we learn that his wife was given charge of his goods and chattels. The entry refers to him as 'John Cleveley late of the Parish of St. Paul Deptford in the County of Kent & Carpenter belonging to His Majesty's Ship the Victory in the pay His Mys Navy'. This interesting piece of information would seem to discount the usual view that he spent all his life in the shipyards, and suggests that he must have spent some time at sea as a ship's carpenter.

The National Maritime Museum has an outstanding collection of some fifteen of his paintings so that, however meagre the facts about his life may be, there is no difficulty in assessing his skill as an artist. His pictures are remarkable for their boldness of approach. In this respect and in his sense of pattern and his obvious delight in such decorative features as the huge flags used in launching ceremonies, Cleveley shows some of the qualities of a naïve painter. This is well illustrated in two delightful paintings of shipbuilding scenes: *A ship on the stocks* (pl. 20) and *A small ship on the stocks*. Another charming dockyard scene is *A ship floated out at Deptford* (pl. 26), which is beautifully composed and

executed. The perspective drawing of the ship's hull is masterly, as is the drawing of the architectural details along the waterfront.

Comparisons have been made between Cleveley's work and that of Canaletto and Samuel Scott. Canaletto was in London in 1746 and he certainly had a strong influence on Scott for several years, but it would be a mistake to overestimate his influence on Cleveley. Obviously their work often shares the same subject-matter because they were both fond of river scenes. There are obvious similarities for instance between Cleveley's *A view of a shipyard on the Thames* (pl. 27) and Canaletto's *Greenwich Hospital*. Both paintings depict small craft plying to and fro across calm water; the oarsmen in the skiffs and barges, and the crews of the sailing boats are carefully observed by both artists; and the viewpoint is similar. On the other hand, Cleveley has adopted a far more matter-of-fact approach: the shipbuilding scene on the far bank (a feature of so many of his pictures) is rendered with extraordinary accuracy. Canaletto has a tendency to romanticize his view and his brilliant brushwork with its characteristic blobs of clear colour gives a sparkle to his painting which Cleveley's thinner brushwork makes no attempt to emulate.

There is, however, a close resemblance between the work of Cleveley and the later work of Samuel Scott. They share the same flat, objective view of the river scenery and they also successfully render the cool softness of the English climate. It is not known whether Cleveley ever met Scott, but he must surely have seen his work. Walpole's belief that Scott was the greatest marine painter 'of this or any age' may have been peculiar to himself, but Scott's paintings were certainly well known in his lifetime.

John Cleveley the younger 1747–1786
Robert Cleveley 1747–1809

Cleveley's twin sons John and Robert both became marine artists. They were born in 1747 and were brought up at Deptford where they each acquired a trade in the shipyards: John became a shipwright and Robert became a caulker. Presumably their father gave them their first lessons in painting, but in addition John Cleveley the Younger received lessons in watercolours from Paul Sandby who was teaching near by in Woolwich.

In 1772 John Cleveley went as draughtsman on a voyage to Iceland organized by Sir Joseph Banks. On his return his drawings were awarded a premium by the Society of Arts. Two years later he was appointed draughtsman to Lord Mulgrave's expedition to the north polar seas. One of the meticulous water-colours which he painted of the voyage is in the National Maritime Museum: some of the crew are depicted playing leapfrog on the ice while an officer, accompanied by a sailor with a plank, goes off in search of food (presumably the plank was to save them in the event of their falling through the ice). Another watercolour which shows his skill in this medium is *Frigate and Dutch fishing*

boats off the Isle of Wight which is in the Victoria and Albert Museum. He died in London in 1786. Redgrave considered that his drawings were 'finished with much skill and taste, spirited in execution, and in colour almost in advance of his day'.

Robert Cleveley, who outlived his twin brother by twenty-three years, became well known for his paintings of naval battles. *The Battle of St Vincent* (pl. 29) is a good example. He was appointed marine painter to the Prince of Wales and marine draughtsman to the Duke of Clarence. His portrait was painted by Beechey and engraved by Freeman. He died in 1809 as the result of a fall from the cliffs at Dover.

Both John and Robert Cleveley exhibited regularly at the Royal Academy and at the Free Society. Details are recorded in Graves' Dictionary: the entries for John Cleveley and his father cannot be accepted as authoritative, however, as there has evidently been confusion between their work.

The third son of Cleveley the Elder was James, who is known to have served under Captain Cook for a period. The sketches which he made on one of the voyages were worked up into finished drawings by John Cleveley the Younger.

Charles Brooking 1723–1759

Although Brooking is now generally regarded as the most gifted, and possibly the greatest, of all English marine artists, very little is known about his life. Dayes, Edwards and Redgrave provide us with brief glimpses of a sick man whose life was a struggle against poverty. We know that he suffered from tuberculosis and that 'injudicious medical advice, given to remove a perpetual headache'[12] was a contributory cause of his death at the age of thirty-six. We know that he was brought up in the dockyards at Deptford, and that for much of his life he was in the hands of an unscrupulous dealer who owned a shop near Leicester Square; we also know a little about his relationship with the Foundling Hospital and its Treasurer, Taylor White. But we know almost nothing about his experience of ships and the sea beyond Farington's remark that 'He had been much at sea.'[13] Whether he was in the navy or the merchant service, how many years he was at sea and where he travelled to, we can only guess by examining his paintings.

Edward Dayes considered that Brooking would have been one of the finest marine painters of all time, 'had he lived',[14] and a number of other writers have bemoaned the fact that he died so young. This fact should be put into perspective however. Bonington for instance died at the age of twenty-six and although he was more fortunate in his friends and upbringing than Brooking, he produced enough pictures in a working life of barely eight years to earn a secure place in the history of English painting. George Chambers, the Victorian marine painter, came from a poor family in Whitby and yet when he died at the age of thirty-seven he had secured the patronage of royalty and admirals and had earned a

revered place among his fellow artists. And Brooking himself painted enough pictures of outstanding quality to prove his true worth.

It should be pointed out that Brooking's paintings do not reproduce well. They rely for their impact on a clarity of colour and a subtlety of tone that is invariably lost in a reproduction. Moreover his subjects are rarely dramatic, and although his ships are always beautifully placed on the canvas he avoided spectacular devices in his compositions. When reduced to the size of book illustrations, his paintings sometimes appear rather ordinary, and could be mistaken for the work of several other eighteenth-century painters. What is remarkable about the original canvases is their sparkle and their astonishing sense of atmosphere. He shares with Constable the ability to fill a picture with a fresh breeze— a breeze which whips up waves, tightens ropes, puffs out sails and heels over ships and small boats. He has perfectly mastered the play of sunlight and shadow across the surface of the water, and his liquid green seas are alive with movement. It must be remembered, too, that he was working some fifty or sixty years before the painters of the Romantic Movement began to concentrate on the portrayal of light and atmosphere in their landscapes. Indeed Basil Taylor considers that 'only Wilson and Gainsborough can be regarded as his superiors before 1760 in the treatment of nature'.[15] His *Ships in a light breeze* (pls. 30, 31 and back of jacket) was, in fact, painted nearly eighty years before Constable's oil sketches of Brighton beach.

It is believed that Brooking's father was employed as a painter and decorator at Greenwich Hospital between 1729 and 1736, and it therefore seems likely that Brooking, who was born in 1723, learnt the technical side of his art by assisting his father. Apart from this, and Edwards' much quoted sentence that Brooking 'Had been bred in some department of the dock-yard at Deptford',[16] his life is totally obscure until 1740. We then have the evidence of two small paintings to show that he had begun to specialize in marine subjects and had acquired basic technical skills in oil painting at a fairly early age. The paintings are companion panels and both depict night scenes. One shows a bomb-ketch off a fort, and the other depicts a ship on fire and is signed 'C.Brooking, pinxit, aged 17 years'.

At the age of twenty-nine, he was commissioned by John Ellis to illustrate a book on marine biology entitled *The Natural History of the Corallines*. That he had acquired a considerable reputation by this time is evident from the words of Ellis who wrote in August 1752, 'Went to the Island of Sheppey on the coast of Kent; and took with me Mr. Brooking, a celebrated Painter of Sea pieces, to make proper Drawings for me.'[17] However celebrated he might have been, it appears that he derived little benefit from his talents until he was discovered by the Treasurer of the Foundling Hospital. The circumstances of his discovery are worth quoting at length because we have so little contemporary evidence about him and Edward Edwards, who tells the story in his *Anecdotes of Painters*, received his information from Dominic Serres, who knew Brooking well: 'Many of the artists of that time worked for the shops, and Brooking, like the rest, painted much for a person who lived in Castle Street, Leicester Square, not far from the Mews, who coloured prints, and dealt in pictures, which he exposed at his shop window.

'A gentleman, who sometimes passed the shop, being struck with the merits of some sea pieces, which were by the hand of this artist, desired to know his

name; but his enquiries were not answered agreeably to his wishes; he was only told, that if he pleased they could procure any that he might require from the same painter.

'Brooking was accustomed to write his name upon his pictures, which mark was as constantly obliterated by the shopkeeper before he placed them in his window; it however happened that the artist carried home a piece, on which his name was inscribed, while the master was not at home; and the wife, who received it, placed it in the window, without effacing the signature. Luckily the gentleman passed by before this picture was removed, and discovered the name of the painter whose work he so justly admired.

'He immediately advertised for the artist to meet him at a certain wholesale linen-draper's in the city. To this invitation Brooking at first paid no regard; but seeing it repeated with assurances of benefit to the person to whom it was addressed, he prudently attended, and had an interview with the gentleman who from that time became his friend and patron: unfortunately the artist did not live long enough to gratify the wishes of his benefactor, or to receive any great benefit from his patronage.'[18]

Edwards' last sentence is not entirely true because Brooking lived for five years after his meeting with Taylor White and derived considerable benefit from his patronage. The Foundling Hospital had a fine collection of paintings by Scott, Hogarth, Wilson, Monamy and others, and was the first place in London to display the work of living painters to the public. The patronage of its Treasurer therefore brought Brooking financial reward as well as contact with other leading artists and a place to exhibit his work.

One of his first commissions for the Hospital was an enormous painting of *The British fleet at sea*. It was approximately ten foot long and six foot high and was consequently painted on the spot and not in Brooking's studio. According to the records of the Foundling Hospital it was commissioned in February 1754 to match a sea piece by Monamy of similar size.[19] Brooking completed the painting in eighteen days. Two other versions of the same subject are in existence. One of them is in the National Maritime Museum and is entitled *A vice-admiral of the red and a fleet near a coast* (pl. 34). It is a small painting of the same proportions as the Foundling Hospital picture and similar composition, and was possibly a preliminary sketch for it. It is a brilliant example of Brooking's work, sparkling in colour, full of delicate detail and yet free and vigorous in execution. The other version is in the Tate Gallery and is of long, narrow proportions. Like the other two paintings it depicts a 70-gun ship as the focal point of the picture but the other vessels have been rearranged to fit into the longer shape.

In June 1754 Brooking was elected a Governor and Guardian of the Foundling Hospital, and we may assume that his last years were not spent in such obscurity and financial hardship as his earlier life. We have very few facts to go on, however. His name appears among the list of painters present at a dinner held at the Foundling Hospital in November 1757, but in spite of the additional contacts he made through his friendship with Taylor White, it seems that when he died in March 1759 he left his wife and children in great poverty.

Dominic Serres 1722–1793
John Thomas Serres 1759–1825

Dominic Serres and his eldest son John Thomas were both prolific artists and were leading exponents of the English marine school during the second half of the eighteenth century. Dominic was a native of France, but he spent his entire working life as an artist in England, and became a distinguished member of the artistic establishment in London. In addition to their output of oil-paintings and watercolours, father and son combined their specialist knowledge to write and illustrate an interesting manual of instruction for marine artists entitled the *Liber Nauticus*.

Dominic Serres was born in 1722 at Auch in Gascony and may have been the nephew of the Archbishop of Rheims. His parents wanted him to go into the church but he ran away from home and made his way to Spain. There he joined the crew of a ship bound for South America. Starting as a common sailor, he worked his way up through the ranks and eventually became master of a trading vessel. According to one authority, it was while trading to the Havannah that Serres 'was taken prisoner by a British frigate and brought to this country about 1758. After his release he married and lived for a time in Northamptonshire.'[20] The date that he arrived in England is critical because it determines the length of time that he knew Brooking. Since Brooking died in London in March 1759, it seems likely that Serres was brought to England considerably earlier than 1758. Indeed according to Redgrave, Serres was taken prisoner 'during the war of 1752',[21] although there is no indication when he came to London.

There seems little doubt, however, that Serres was strongly influenced by Brooking's work. He shows the same regard for subtle atmospheric effects and he has a similar mastery of the passage of sunlight and shadow across the surface of the water. His drawing of waves is never stereotyped and as would be expected of an ex-seaman he shows an equal regard for the drawing of ships, clearly shown in *Two men o' war in a choppy sea* (pl. 37). He sometimes repeats certain compositional devices of Brooking in the grouping of ships and the angle from which the vessels are viewed. The similarities would seem to confirm Edward Edwards' statement that Serres knew Brooking well, and if he was not his pupil in the strict sense of the word, then he certainly received advice from him and made a study of the Deptford artist's work.

Serres made good progress in the ten years following his arrival in London. In 1765 he became a member of the Incorporated Society of Artists and in 1768 he was chosen to be one of the foundation members of the Royal Academy—a particularly impressive achievement in view of his foreign birth and his late start as a professional artist. During the course of the next thirty years he showed 108 paintings at the Royal Academy, twenty-one paintings at the Free Society and eight works at the Incorporated Society of Artists. In 1784, Serres' friend Paul Sandby wrote to James Gandon: 'But Dom is grown a very great man, has been to Paris, seen the grand exhibition, dined with the King's architect, and is going to paint for the Grand Monarque. Alas! poor Paton, hide your diminished head, your topsails are lowered.'[22]

Towards the end of his life, Serres was appointed marine painter to George III, and in 1792 he succeeded Wilton as Librarian to the Royal Academy. Redgrave points out that he was well qualified for this post because 'he spoke English with fluency, was a good Latin and Italian scholar, and was tolerably well versed in French, Spanish and Portuguese'.[23]

We know very little about Dominic Serres' domestic life. He married during his stay in Northamptonshire, and his eldest son John Thomas was born in London in December 1759. He had one other son, Dominic (who also became a marine painter), and four daughters. During the latter part of his life Serres lived at St Georges's Row overlooking Hyde Park. He died on 6 November 1793 at the age of seventy-one and was buried at St Marylebone Old Church.

There is a portrait miniature of Dominic Serres in the National Portrait Gallery. It was painted by Philip Jean and exhibited at the Royal Academy in 1788. It is a half-length portrait and shows Serres seated in a chair before a canvas, putting the finishing touches to a painting of ships. In spite of its small size the portrait gives the impression of being a good likeness and it depicts a man in his mid-sixties with bony, aristocratic features, a long aquiline nose and shrewd dark eyes.

Dominic Serres is well represented in the National Maritime Museum and in the English Royal Collection. His *Ships at Plymouth* (pl. 36) is a good example of one of his more serene works. The figures in the foreground and the soft light in the middle distance are reminiscent of Samuel Scott's Thames scenes. The picture has indeed a very English character about it and could certainly not be mistaken for a Dutch marine scene. In a different mood is the painting of *The Battle of Quiberon Bay*. The painting of naval engagements provided many problems for the marine artist, but by the dramatic rendering of the clouds and lighting Serres has brought the scene to life.

John Thomas Serres was brought up in London and was taught painting by his father. He became a drawing master and was for a time employed in this capacity at the Chelsea Naval School. Apart from various official commissions he continued to teach pupils throughout his life.

In 1789 he spent several months travelling on the Continent. His biographer tells us that in Paris he assisted in the demolition of the Bastille 'to the delight of the excited people'.[24] He visited Marseilles and at Leghorn he called on the British Consul—he had been provided with a letter of introduction from Sir Joshua Reynolds. He travelled on to Pisa and Florence, and spent five months in Rome. On his return to England he married one of his former pupils, Miss Olivia Wilmot, whose father was a house painter and a tenant of the Earl of Warwick. The couple had a child, and on the death of his father in 1793, Serres succeeded him as marine painter to the King. He was also appointed draughtsman to the Admiralty.

Serres' duties involved visits to the fleet, which at this period was engaged in the blockade of the French and Spanish coasts. In the summer of 1800, he was ordered out on government service and sailed in HMS *Clyde* to make drawings of the harbours between Brest and Corunna. He was paid £100 a month while engaged on this work, and received every assistance from the Navy.

Before he had set off on government service, Serres' marriage had begun to break down. On his return he discovered that his wife had been living a life of

wild extravagance, and Serres was charged with bankruptcy. The remaining years of his life were something of a nightmare. His wife was constantly unfaithful to him and produced two illegitimate children. She also caused a scandal by claiming to be the legitimate daughter of the Duke of Cumberland. Serres found himself out of the Royal favour and when he painted four pictures of the King's visit to Scotland in 1822, his approaches to the Court were ignored and he was compelled to auction the pictures for a total of £20. He separated from his wife and tried to find some peace out of London (he stayed in Edinburgh for a time) but his wife continued to plague him and set about selling every picture of his which she could lay her hands on.

Serres continued to exhibit his paintings at the Royal Academy and the British Institution, but he was constantly pursued by creditors. He became seriously ill and developed a tumour on his left side. Just before Christmas in 1825 he was committed to prison for debt, and he died on 28 December.

John Thomas Serres did not have his father's natural gifts as a painter and his pictures sometimes suffer from a straining after dramatic effects. He was fond of painting stormy scenes, of which a typical example is *The lighthouse with Bay of Dublin* in the Victoria and Albert Museum. Another lively scene is *Ships in a rough sea* (pl. 40) at Greenwich: the highly finished treatment of the man-of-war in the centre is in contrast to the looser brushwork with which he has suggested the clouds and the waves. A charming painting of a different type is *The Thames at Shillingford* (pl. 41), in which he again pays great attention to the drawing of the individual craft. In the foreground is a Thames Peter-boat (the wet-well amidships for storing the fish can be clearly seen); in the centre of the composition is a haybarge with lowered mast, and beyond it is a sprit-sailed Thames barge. Serres has achieved here something of the intense local feeling which we find in John Crome's pictures of the Norfolk rivers.

J.T.Serres was also an accomplished watercolourist. His picture of the *Battle of Cape St Vincent* (in the National Maritime Museum) has more value as a historical record than as a work of art, but there is an attractive watercolour in the British Museum[25] which depicts a tranquil scene on the Thames Estuary.

Francis Swaine fl. *1761–1782*

Like a number of talented marine artists working in the eighteenth century, Francis Swaine seems to have lived a life of comparative obscurity. He remains a shadowy figure to us today, and although it is clear from his paintings that his knowledge of ships was considerable, little is known of his practical experience of the sea.

The few facts that are known about Swaine's life may be stated briefly. He exhibited at the Free Society of Artists from 1761 until his death, and he also exhibited a number of works at the Incorporated Society of Artists. In 1764 and 1765 he was awarded the Society of Arts' medal for sea-pieces. For many

years he lived at Stretton Ground, Westminster,[26] and he died at Chelsea in 1782. At some period in his life he may have been a messenger in the Navy Office. His date of birth is not known.

Redgrave and others mention that he was an imitator of the Dutch masters and according to F.Gordon Roe[27] the art dealers of the day sold his work as 'English Van de Veldes'. The confusion of his work with a number of other artists may account for Swaine's receiving less attention than he deserves. It is true that he seldom achieved the mastery of light and atmosphere which characterizes Brooking's work and his drawings of ships lack the accomplishment of Dominic Serres', but his best work proves him to have been a skilful artist. The suggestion has been made, mainly on sytlistic grounds, that Swaine was a pupil of Monamy. The subject-matter of their work is often similar, and confirmation of a link between the artists would seem to be provided by the fact that Francis Swaine had a son named Monamy Swaine.

Francis Swaine is at his best in fresh, breezy pictures such as *A frigate and a royal yacht at sea* (pl. 32). In paintings of this type he demonstrates a lightness of touch and a most attractive colour sense. His calm scenes are, to my mind, less successful and often appear derivative. *A yacht becalmed near a shore* in the National Maritime Museum has a rather stilted air about it, and both the composition and such details as the fishermen with their nets show a decidedly Dutch influence. His pen and wash drawings are often very fine, and have something of the spirited freedom of van de Velde's drawings. *A lugger close-hauled in a strong breeze* (pl. 42) is a lively work, with the vessels closely observed. The waves are less well drawn, and are rather hard in execution. There are obvious similarities between the style of this drawing and that of some of Monamy's drawings such as his *View of Deal from the sea* (pl. 14).

Francis Holman fl. *1767–1790*

It is surprising that so little should be known about Francis Holman. It is obvious from his paintings that he was a gifted artist, and we know that he exhibited at the Royal Academy every year from 1774 to 1784. And yet all the standard authorities repeat the same meagre facts: that he was of a Cornish family, resided at Shadwell and Wapping and painted pictures of storms and seafights. Redgrave also adds that he 'enjoyed a contemporary reputation'. Graves lists two addresses from which Holman sent in his paintings: 'Johnson Street, Old Gravel Lane, St. Georges' and 'Fawdon Fields, Old Gravel Lane, St. Georges'.[28] In addition it seems that Thomas Luny may have been his pupil for a time.

A painting such as *London: Blackwall Yard* (pls. 43, 44) shows that Holman had a command of atmosphere and a knowledge of shipping comparable with Anderson, Francis Swaine and Dominic Serres. The small craft in the foreground are beautifully drawn, and there is something very English about the

composition and the meticulous detail with which he has recorded the ships being built on the stocks. Holman was particularly successful at portraying the surface of the water. His light, feathery touch suggests movement and transparency. In *London: Blackwall Yard* he depicts one of those typical days on the Thames when a stiff breeze whips up a series of short, steep waves, while in *An English brig with four captured American vessels* he portrays the longer waves of more open waters. Both these paintings are in the National Maritime Museum. The Paul Mellon Collection has a typical example of Holman's work entitled *The frigate Surprise off Great Yarmouth*, and there are many other fine examples, such as *The Trelawney, East Indiaman* (pl. 45), in private collections.

Nicholas Pocock 1741–1821

Nicholas Pocock has always been a favourite artist of marine historians. Although he did not take up painting as a profession until he was forty, he lived to a great age and his working life spanned the period of the Napoleonic Wars. He was able to record, either at first hand or from eye-witness accounts, all the major naval battles from the West Indian campaigns of Rodney and Hood to Nelson's victories around the turn of the century. He was moreover a professional seaman of considerable experience: he was given command of his first ship at the age of twenty-seven and between 1768 and 1778 commanded six ships in all, during which time he made many voyages across the Atlantic. Since he not only painted naval battles but also made a series of panoramic views of the principal naval dockyards, and produced pictures of merchant ships and harbour scenes, his work has great value for its historical content as well as its nautical accuracy.

But in addition to the fascinating record he has given us of Britain's navy at the time of her greatest achievements, he had a natural gift for painting. (As far as we know he was entirely self-taught.) His pictures often have the naïve simplicity that is so charming a feature of the elder Cleveley's work, and even when portraying the events in a sea battle he invariably chose a viewpoint which placed the ships in the most satisfying composition. Occasionally, as in the beautiful painting of *Nelson's flagships* (pl. 39), he introduced a poetic note and filled the canvas with a soft light and a sense of atmosphere worthy of Cuyp or van der Velde the Younger.

Pocock was born at Bristol on 2 May 1741. His father was a merchant of the city, and a friend of Richard Champion, a prosperous shipowner and the maker of Bristol Porcelain. Nicholas was apprenticed in the shipbuilding yards of Champion, and when his father died, he became responsible for supporting his mother and two brothers. In 1768 Champion appointed him to the command of the barque *Lloyd* and Pocock sailed her from Bristol to South Carolina. Sarah Champion, the shipowner's sister, described him around this time and we get a glimpse of a modest and sensible young man who was valued as a friend by his

employer: 'In the intervals, when he was not at sea he spent much of his time at my brother's and never seemed happy but when there. Having a fine taste for drawing, he sometimes talked of giving up the sea. Although not highly educated, he was a stranger to that failing too often attendant on want of mental culture for I have generally remarked that ignorance and conceit usually accompany each other, but this Captain Pocock's good sense and diffidence preserved him from.'[29]

For ten years, Pocock confined his 'taste for drawing' to illustrations in his ships' logbooks. Some of these are in the National Maritime Museum and from their pages we can see how he acquired a thorough grounding in drawing ships from every angle and in all conditions. On each page are two or three delicate drawings in pen and wash of his own ship, or passing vessels, and he continued this practice in every ship he commanded. After the *Lloyd* he captained the *Betsy*, a three-masted ship of some 300 tons which he sailed to Cadiz and Minorca. In 1776 he was in command of the snow *Minerva* and took her across the Atlantic to St Kitts. But around 1778 he made the decision to concentrate on painting, and he was present during Rodney's West Indian campaigns as a war artist, though whether in an official or unofficial capacity is uncertain. What we do know is that in 1780 he took up oil painting for the first time and sent a picture to the Royal Academy exhibition. To his amazement he received a letter from no less a person than Sir Joshua Reynolds which began: 'Dear Sir, Your picture came too late for the exhibition. It is much beyond what I expected from a first essay in oil colours' (see Appendix). The letter went on to give him much friendly and practical advice on painting seas and skies and on how to produce a harmony of colour in his work. Greatly encouraged by this, and by the commissions of high-ranking officers, Pocock settled down to his new career as a marine painter. One of his oil paintings and three watercolours were hung in the Royal Academy exhibition of 1782 and during the course of the next thirty years he exhibited regularly and showed altogether sixty-three oil paintings and fifty watercolours.

In the same year that he submitted his first painting to the Royal Academy, Pocock also got married. His wife was Anne Evans, a Bristol girl, and she bore him seven sons and two daughters. They began their married life in Bristol, but in 1789 they moved to London and took a house at 12 Great George Street, Westminster. Here they entertained the naval officers who were Pocock's friends and patrons, and also such celebrities as Sarah Siddons and the Kembles. His domestic life did not prevent him going to sea occasionally, and from his detailed notes and sketches it seems evident that he was an eye-witness of the campaign which culminated in Lord Howe's victory of 'The Glorious First of June'. When he was not present himself during a particular engagement he was able to use his practical knowledge to reconstruct authentic pictures of events from accounts given to him by his naval friends.

In 1805 Pocock became one of the founder members of the Old Water-Colour Society and contributed twenty-eight drawings to its first exhibition. He was offered the Presidency of the Society but declined. In 1817 he suffered some form of paralysis and left London for Bath where he took up residence at 36 St James Parade. He died at Maidenhead on 19 March 1821 at the age of seventy-nine and was buried at Cookham.

Pocock's work was popular in his lifetime, and as he painted a large number of pictures, many of which are now on display in the National Maritime Museum, we can see why he achieved such a high reputation. He shows the same meticulous attention to detail that E.W.Cooke was to display a hundred years later, but he has a more sensitive feeling for colour. Particularly characteristic of his work are large panoramic views in which the ships are seen from a height and arranged in order of battle: *The Battle of Copenhagen* (pl. 48) is a good example of this type. In similar panoramic views of dockyards at Chatham, Portsmouth and Plymouth he gives us a minutely detailed picture of the places which serviced the ships of the Royal Navy. Not all his paintings show tiny ships disposed on a turquoise sea. His painting of *Ships of the East India Company* (pl. 44) is a marine painting of the more traditional type. He shows a dramatic use of light and shade as the ships surge through heavy seas. Perhaps his masterpiece is *Nelson's flagships* (pl. 39). This is a small picture which was painted in 1807. Pocock has grouped together five of the ships in which Nelson distinguished himself. (In spite of the title, two of the ships, the *Agamemnon* and the *Captain*, were not Nelson's flagships.) They are shown at anchor on a calm day at Spithead, their sails drying in the sun. The peaceful scene is scarcely disturbed by the activity of small craft around the men-of-war. To the stern of the *Victory*, the helmsman of a small boat gives directions to a man in the bows who is hoisting the lugsail, and various rowing boats ferry members of the crew or sightseers to and from the shore.

In addition to his oil paintings, Pocock painted a large number of watercolours of naval engagements (pl. 47), harbour views and coastal scenes. There are good examples of these in the British Museum, the Victoria and Albert Museum and in Bristol City Art Gallery.

William Anderson 1757–1837

William Anderson was fond of depicting ships and small craft in the peaceful setting of a river or harbour. He usually worked on a small scale and his finest work has a delicate touch and a wonderful sense of atmosphere. Very little is known about his life, which may, perhaps, be explained by Edward Dayes' observation that, 'As a man he was singularly modest; and as an artist, the last to speak of his own merits.'[30]

He was born in Scotland in 1757 and was a shipwright by trade. Nothing is known of his artistic education but he came south to London and in 1787 he exhibited for the first time at the Royal Academy. He continued to exhibit nearly every year until 1814. During the course of the next twenty years he exhibited there on five occasions, the last being in 1834 when he submitted *Lord Howe's fleet off Spithead*. He also exhibited at the Incorporated Society of Artists, at the British Institution and at the Suffolk Street Galleries. He seems to have spent most of his working life in London, and it is known that he was a friend of Julius Caesar Ibbotson. He may also have worked in Hull for a time.

He painted a large picture of the Battle of the Nile in Trinity House, Hull, and his paintings were frequently exhibited at local art exhibitions. The marine painter, John Ward of Hull, was an earnest student of his work and is known to have made at least three copies of Anderson's pictures.[31]

In the Victoria and Albert Museum there is a sketchbook by Anderson containing drawings in pencil and in pen and ink of small merchant vessels. The sketches, which are meticulously careful studies of figureheads, sterns, rigging and so on, provide ample proof of the preparation which must have gone into his paintings of shipping. Laird Clowes published an interesting article on the contents of this sketchbook in the *Mariner's Mirror*. He points out that the sketches were made between 1792 and 1794 and were probably 'studies made while the ships were building and fitting out, in preparation for the builders' pictures which were then popular'.[32]

In 1800 William Ellis issued a set of aquatints after a series of paintings of the Battle of the Nile by Anderson. It seems that Anderson based his compositions on pencil sketches made by Colonel Walter Fawkes who witnessed the action.

The only records which I can find of Anderson's addresses in London are those noted by Graves. In 1793 for instance his address is given as 44 Bell Street, Lisson Green; in 1820 he moved to 45 Chapel Street, Lisson Grove; and in 1833 he was at 2 Hamilton Terrace, St John's Wood. He died on 27 May 1837.

The National Maritime Museum has an interesting selection of his work: *Limehouse Reach* (pl. 49) is very typical of his style and depicts a tranquil river scene; *Greenwich: return of George IV, 1822* (pl. 50) has a sparkling brilliance of colour and a mastery of brushwork that recalls Canaletto's similar view of Greenwich; *Capture of Martinique, 22 March 1794* and *Troops embarking near Greenwich* are more lively scenes and show that he was able to introduce figures into his marine paintings with conviction. Anderson also had considerable mastery in the medium of watercolours and there are many fine examples in private collections. Iolo Williams observed that, 'His colours are pretty, the detail of his ships is (I am told) accurate, and his drawings, calm in spirit, are often delightfully diffused with light.'[33]

Other writers on Anderson have been generous in their praise, none more so than Edward Dayes. His *Professional Sketches* was published in 1805 when Anderson was forty-eight. 'His style of colouring is clear and bright,' he wrote, 'and his aerial perspective is well understood. The handling is clear, firm and decisive: but of his works, the smaller are by far the best: some of them are of the very first degree of eminence.' Sir Geoffrey Calender, writing more than a hundred years later, provides a more critical but perhaps a fairer summing up: 'In his most characteristic work Anderson displays an airy quality and a soft sense of colour reminiscent of van de Capelle. His work is unequal. He is at his best when portraying ships in light airs, but in some of his drawings he develops a hardness comparable with that found in the later work of Pocock.'[34]

Thomas Luny 1759–1837

Thomas Luny was an ex-naval man who retired to Devon in 1810 and spent the last twenty-seven years of his life being pushed around Teignmouth in a bath-chair. He suffered from rheumatoid arthritis which paralysed his lower limbs and caused his fingers to curl in on his palms, but this unfortunate disease did little to lessen his prolific output of paintings. Contemporary observers have left us with a vivid picture of the old man being wheeled out to the sea-front each day. There he set up his easel and sketched in the outlines of a painting with his brush gripped in his fists and held at arm's length. He had a fair and somewhat florid complexion, we are told; he would seldom be drawn into conversation, but was 'of kindly nature, and pleasant in his manner with children'.[35]

Although his years of retirement are well documented, we know much less about his early years. He was born in London in 1759 and he served in the Royal Navy, apparently as a purser. At some time during the earlier part of his life he was a pupil of the marine painter Francis Holman. (In 1777 and 1778 he sent some paintings to the Society of Artists' Exhibitions and gave as his address: 'Mr. Holman's, St. George's, Middlesex'.) In 1777 and 1778 he exhibited some pictures at the Society of Artists and in 1780 he exhibited *A privateer cutter* at the Royal Academy. He continued to exhibit occasionally at the Academy until 1793. It is believed that he was at sea for the next seventeen years because during this period he only showed one painting, *The Battle of the Nile*, which was exhibited at the Academy in 1802. Most authorities agree that at some time during his naval career he served under Captain Tobin, a son-in-law of Nelson. When paralysis forced Luny to retire from the navy he took up residence at Teignmouth and was joined there by Tobin, who was himself an amateur artist. By this time Tobin had achieved the rank of admiral and the two of them spent much time together discussing subjects for pictures and painting.

Teignmouth proved to be a profitable residence for a marine artist because, in addition to Tobin, there were a number of naval officers in the town who were glad to commission pictures from Luny. They included Admiral Wight, Sir Edward Pellew, and two captains with the names of Brine and Spratt. Soon he had made enough money to move out of Oak Tree House, which was his first house in the town, and to build himself his own house in Teign Street. It was called Luny House and was close to the quayside of the inner harbour. A fascinating record has been left to us by a Mr Hutchinson who at the age of eight or nine was taken by his uncle to see Luny's paintings: 'We were shown up into his studio or painting-room, and this I can recall to memory pretty well. The fire-place, I think, was in the wall opposite the door where we entered; but it was nearly hidden behind stools, portfolios, canvas on frames &c. On the floor, round the walls, and on a few chairs, were a number of paintings in all states of progress and finish. One, just sketched out, a first draft of a storm, on a chair near the right-hand corner of the room, I thought was too white, with a superabundance of froth and foam, and my uncle remarked it too.'

After examining some of the other pictures—mostly local views of the harbour and coast—he turned his attention to the artist.

'Luny himself sat at a table between the fireplace and window, the light coming in on his left side, and his back turned somewhat towards the door. He and my uncle exchanged greetings when we entered. He was not, however, disposed to talk; but went on with his work, leaving us to look about and examine anything we liked. . . . He was at work on a picture about 20 inches wide by 15 inches high, some eight or ten inches on the table, supported on a small easel, with a palette or slab for his colours between him and the canvas, or towards his right, with brushes, bottles &c. close by. But what surprised me most was, he had no hands. His wrists ended not in two fists, but in two egg-shaped lumps, and he held his long-handled brush between these two lumps, which I clearly saw, as he had no gloves.'[36] The boy did not realize, of course, that rheumatoid arthritis had caused the fingers of Luny's hands to become deformed.

Luny must have been a man of great determination because there is evidence that he continued to paint to within a few years of his death. In June 1837 an exhibition of 130 of his paintings was held at a gallery in Bond Street. The critic on the *Literary Gazette and Journal* wrote a favourable account of the exhibition and mentioned that, 'Mr. Luny is, we understand, seventy-eight years of age, and it has only been within the last two years that he has relinquished his palette.'[37] Pointing out that his skies were full of variety and his shipping was nautically correct, the critic urged the Naval Club to purchase Luny's five pictures of the naval victories of 1836.

Luny died on 30 September 1837 and was buried at West Teignmouth churchyard. He left most of his estate of £14,000 to his niece Elizabeth Haswill.[38]

Although there are some good examples of his work at Greenwich, many of Luny's paintings are in private collections and they frequently come up for auction. His painting is uneven in quality and the work of the middle period of his life is generally considered to be his finest. His early paintings tend to be too meticulous and his later work inevitably suffered at times from his bad health. Luny's best work is distinguished by fluid brushwork and attractive colouring with lovely green seas and skies of a pearly transparency. His ships are always well drawn, but he was less successful at depicting the sea. Too often he resorted to a rather lifeless rendering of the waves and he seemed unable to capture the liquid quality of water. One of his most accomplished works is *The wreck of the Dutton* (pl. 51), which is in the National Maritime Museum. It is dated 1821. It depicts the fate of the transport ship *Dutton* which was driven ashore at Plymouth during a gale on 26 January 1796. The men on board were rescued by the efforts of Captain Pellew who managed to get lines aboard. The painting of shipwrecks was to become a favourite theme for artists in the Romantic period, but Luny's knowledge of ships and the sea puts this picture in a class above the often conventionalized versions of artists who were landsmen.

Luny was a skilled practitioner at ship portraits, and Greenwich has some examples of his work in this genre, notably *The Hindustan* and *The Castor and other merchant ships* (pl. 52). A lively painting from his later period is *Shipping off a coast* (pl. 53).

Thomas Whitcombe c. 1752–1827

Whitcombe was a prolific artist who painted ship portraits, sea battles, views of harbours (mostly on the south coast of England) and dramatic pictures of ships in stormy weather. Between the years 1783 and 1824 he exhibited a total of fifty-six marine paintings at the Royal Academy. His pictures frequently appear in the sale rooms and usually fetch high prices. He has, however, received surprisingly scant attention in previous histories of English marine painting—possibly because so little is known about him.

He was born in London around 1752, but nothing is known of his background or artistic education. He was in Bristol in 1787, toured Wales in 1789 and in 1813 he was in Devon painting scenes around Plymouth Harbour. However it seems likely that most of his working life was spent in London. Graves' 'Royal Academy Exhibitors' lists nine separate addresses from which he sent in his pictures. From 1790 to 1795 the address given is 24 Bridges Street, Covent Garden; from 1796 to 1807 he was at various addresses in central London; and from 1810 onwards his addresses were in Clarendon Road or Clarendon Square.

The National Maritime Museum has twenty-nine of his pictures, and there is a good example of his work in the Tate Gallery entitled *The Battle of Camperdown* (pl. 54). There can be no doubting Whitcombe's ability to draw ships, and one must assume that a man who devoted his entire life to marine painting had some practical experience of the sea. Although he showed no great originality in his compositions, his pictures invariably have an atmospheric unity—his ships are in their element and respond correctly to the force and direction of the wind. He makes good use of strongly patterned cloud forms and his seas are usually full of movement.

Robert Salmon 1775–1843(?)

An entry in the records of the parish of St James, Whitehaven, Cumberland, indicates that Robert Salomon, son of Francis Salomon, was baptized on 5 November 1775. It seems likely that this refers to the marine artist, who signed his early paintings 'Salomon'. We know little about his life until the year 1802 when he exhibited at the Royal Academy. From 1806 to 1811 he was working in Liverpool, and from 1812 to 1822 he was in Scotland, where he was based in Greenock. He was back in Liverpool in 1827 and in June 1828 he set sail for America. His marine paintings found many admirers in Boston where he had a studio at the end of Marine Railway Wharf overlooking the harbour. Boston Public Library has his diaries from 1828 to 1841, but the last year or so of Salmon's life is something of a mystery. It is known that he returned to Europe, however, and he probably died around 1843.

Salmon had an attractive and most characteristic technique. His waves were stylized in form and he had an easily recognizable method of painting gentle ripples, choppy waves and rough seas. Some of his pictures have a visionary quality about them (one is occasionally reminded of Caspar David Friedrich). He frequently filled his tranquil scenes with a golden light and was fond of portraying all the details of a busy harbour. His ships were always beautifully drawn. The *Boston Daily Advertiser* considered that 'his views are always correct, seeming like the present reality of the thing represented'.

Among the paintings by Salmon in the National Maritime Museum are *A frigate coming to anchor in the Mersey* (pl. 55), and several splendid ship portraits such as *The Warley, East Indiaman*, which is dated 1804 and depicts the ship in three positions. There are many fine paintings in the Walker Art Gallery, Liverpool, and some magnificent examples of his work in Boston collections including the famous *Wharves of Boston*, and *View of Boston from the mouth of the River Charles*. The American art historian John Wilmerding has written an authoritative account of this interesting artist's life and work.[39]

Samuel Atkins fl. 1787–1808

Samuel Atkins is best known for watercolours in which the ships are drawn with a delicate precision. Very little is known about his life beyond the fact that he appears to have been at sea in the 1790s and visited the West Indies and the coast of China. We do know that he exhibited eighteen marine pictures at the Royal Academy between 1787 and 1808 and that the paintings were all sent in from London addresses (from the Strand in 1787, the Haymarket in 1792 and Pall Mall in 1796). We also know that in 1788 he issued an advertisement which read:

'MARINE DRAWING taught in an easy, pleasing and expeditious manner by S. Atkins No. 78, Corner of Salisbury-street, Strand, where specimens may be seen every day (Sundays excepted) from ten till four during the exhibition at the Royal Academy. N.B. Schools attended.'[40]

The Victoria and Albert Museum has an excellent example of his work entitled *View of the Pool below London Bridge* (pl. 56). Clearly, he was not good at drawing figures, and the brushwork is rather stiff, but on the other hand the picture is beautifully composed and a close examination of the moored ships reveals a most sensitive portrayal of detail with a fine pen. Indeed it is the technical accuracy of his shipping which is the chief delight of Atkins' work because his rendering of both calm water and rough sea tends to be conventional in the extreme.

Atkins' work is fairly rare, but the Victoria and Albert Museum has three watercolours in addition to the one illustrated, and there are pictures by him in the British Museum, the Ashmolean Museum and the Whitworth Art Gallery, Manchester.

Thomas Buttersworth fl. 1798–1830

The work of Thomas Buttersworth is of considerable interest in the United States because, together with Robert Salmon, he provided a link between the English marine school and the emerging American school of marine painting. As far as is known he never visited America, but he painted several pictures of American naval engagements during the war of 1812, and aquatints of his work by Joseph Jeakes brought him some popularity among American collectors.[41] It is also believed that he was the grandfather of James Buttersworth who was born in the Isle of Wight, settled in America around 1850 and became famous for his fine paintings of clipper ships.[42]

Thomas Buttersworth was working in England between about 1798 and 1830. It seems likely that he was a sailor, as some of his watercolours in the collection at Greenwich are mounted on sheets from an eighteenth-century signal book. It is also known that he was appointed marine painter to the East India Company. He exhibited at the Royal Academy in 1813 a single picture entitled *The Ville de Paris, Admiral Earl St Vincent, lying-to for a pilot off the mouth of the Tagus*. It was sent in from 18 Golden Lane, Kennington.

Buttersworth had a characteristic palette of blue-greys and green-greys. Most of his paintings tend to be dark in tone with overcast skies and murky seas (pl. 57). Much of his work is in private collections in the United States. The National Maritime Museum at Greenwich has some fifteen of his pictures including ship portraits, naval engagements and two well-known paintings of the battle of Trafalgar.

4 THE ROMANTIC MOVEMENT:

a new approach to the sea

The artists we have so far considered were mostly specialists in marine painting and their ship portraits and pictures of sea battles were usually commissioned by merchant seamen or naval officers. Towards the end of the eighteenth century, however, a number of talented artists who were primarily landscape painters turned to the sea as a source of inspiration, and found a market for their work among people who had no professional interest in ships.

Hitherto the landscape painters had filled their pictures with rounded hills and tranquil lakes, with classical temples, carefully composed clumps of trees and grazing cattle or deer. Looking to the river estuaries and harbours, they now found picturesque qualities in groups of fishing boats at their moorings; dinghies, capstans, anchors and fishing nets provided suitable material for foregrounds; masts and sails supplied the vertical features needed in their compositions. The sea itself gave them an opportunity to portray man's struggle against the elements, and they painted storms and shipwrecks to show the power of nature's forces rather than to illustrate actual events.

Of course some of these artists had no practical experience of the sea and it was inevitable that they should sometimes depict ships in impossible positions. But this shortcoming should not be exaggerated. The sea was much closer to people's lives in 1800 than it is today. Until the introduction of good roads, it was common to make journeys of any length by boat along the coast. The threat of invasion from the Continent and continuous naval warfare kept people aware of their dependence on the fleet. The spectacular successes of

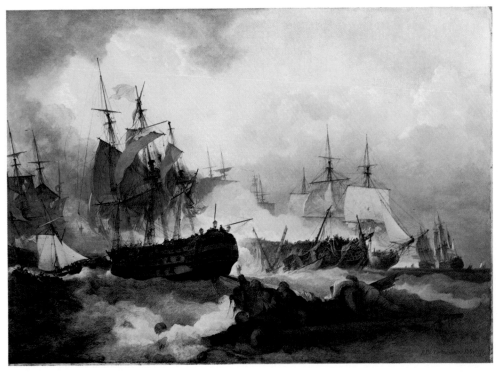

58　P. J. de Loutherbourg
The Battle of Camperdown 1799
Admiral Duncan's flagship *Venerable* has just fired a broadside at the Dutch ship *Vryheid*.
Oil on canvas, 60 × 84¼ in./152.5 × 214 cm. Signed and dated 1799
Tate Gallery, London

59　A. W. Callcott
A sea-piece
Oil on canvas, 45½ × 66½ in./115.5 × 169 cm. Exhibited British Institute 1845
From the Petworth Collection, Sussex

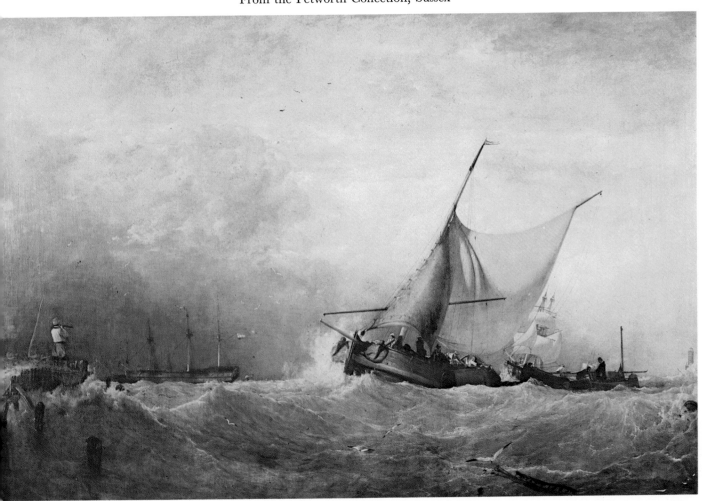

60

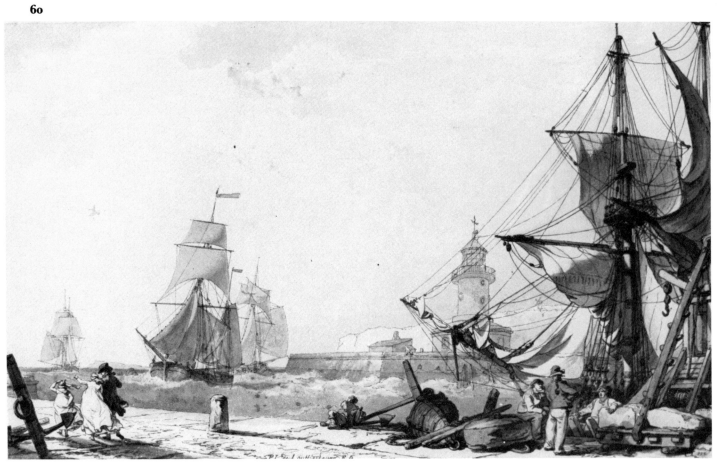

61

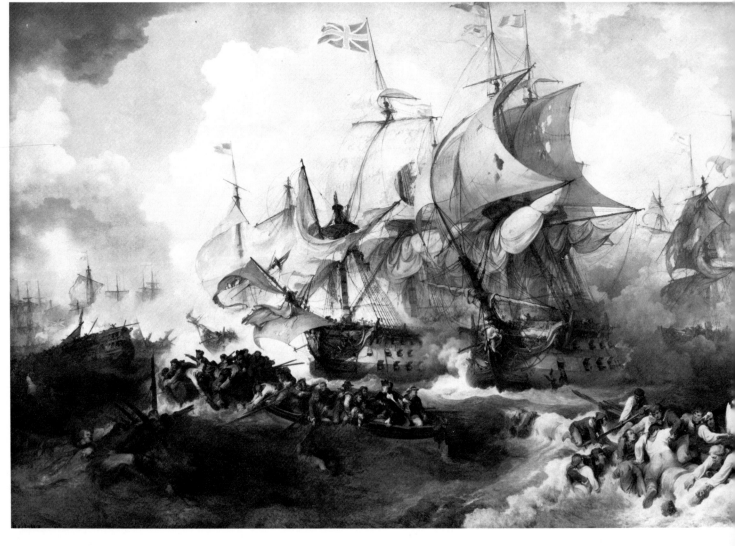

Opposite

60 P. J. de Loutherbourg
Harbour scene
Watercolour, 11¼ × 18¾ in./28.5 × 47.5 cm. Signed
Courtauld Institute, London

61 P. J. de Loutherbourg
The battle of the Glorious First of June
Oil on canvas, 105 × 147 in./267 × 373.5 cm. Signed and dated 1795
National Maritime Museum, London

62 William Daniell
Lighthouse on the South Stack, Holyhead
One of the illustrations from *A Voyage round Great Britain*
Aquatint, 6⅜ × 9⅜ in./16 × 23.5 cm. 1815
Author's collection

63

64

63 William Daniell
Egg-boats off Macao
Oil on canvas, 28 × 36 in./71 × 91.5 cm.
Leicester Museum and Art Gallery

64 J. M. W. Turner
Fishermen on a lee shore
Oil on canvas, 36 × 48 in./91.5 × 122 cm. Exhibited Royal Academy 1802
Greater London Council as Trustees of the Iveagh Bequest

65 J. M. W. Turner
The shipwreck: fishing boats endeavouring to rescue the crew
Oil on canvas, 67½ × 95 in./171.5 × 241.5 cm. Exhibited Turner's gallery 1805
Tate Gallery, London

66 J. M. W. Turner
The Battle of Trafalgar as seen from the mizen starboard shrouds of the Victory
Oil on canvas, 67¼ × 94 in./171 × 238.5 cm. Exhibited Turner's gallery
1806 (unfinished), Royal Academy 1808
Tate Gallery, London

65

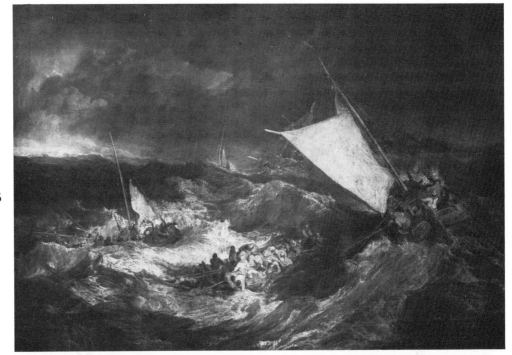

66

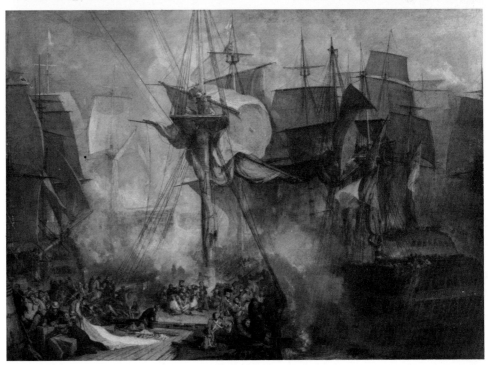

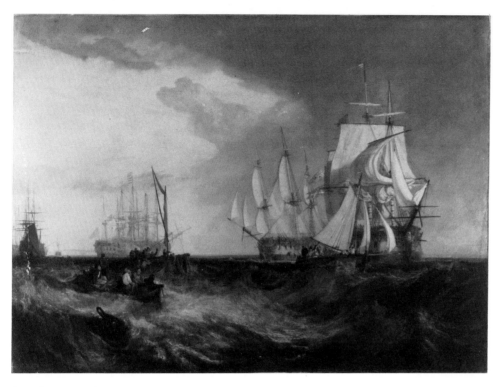

69 *Opposite*
J. M. W. Turner
*Dordrecht: the
Dort packet-boat
from Rotterdam
becalmed* (detail)

67 J. M. W. Turner
Spithead: two captured Danish ships entering Portsmouth Harbour, 1807
The leading ship under sail is the *Denmark*. She is flying the Red Ensign above the flag of
the Danish Navy. Behind her is the *Three Crowns*.
Oil on canvas, 67½ × 92 in./171.5 × 233.5 cm. Exhibited Turner's gallery 1808, Royal
Academy 1809
Tate Gallery, London

68 J. M. W. Turner
Dordrecht: the Dort packet-boat from Rotterdam becalmed
Oil on canvas, 62 × 92 in./157.5 × 233.5 cm. Exhibited Royal Academy 1818
From the collection of Mr and Mrs Paul Mellon, Upperville, Virginia

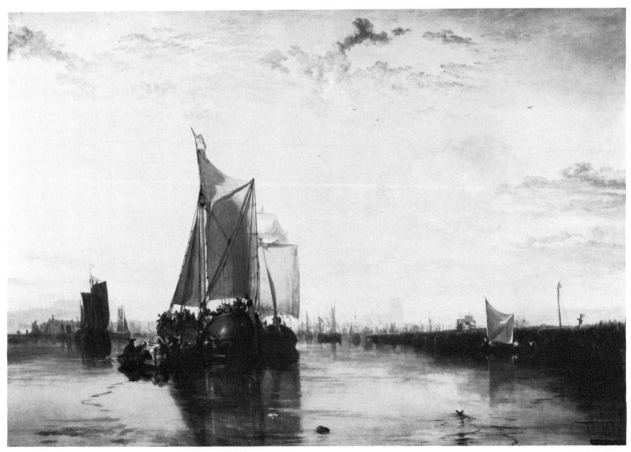

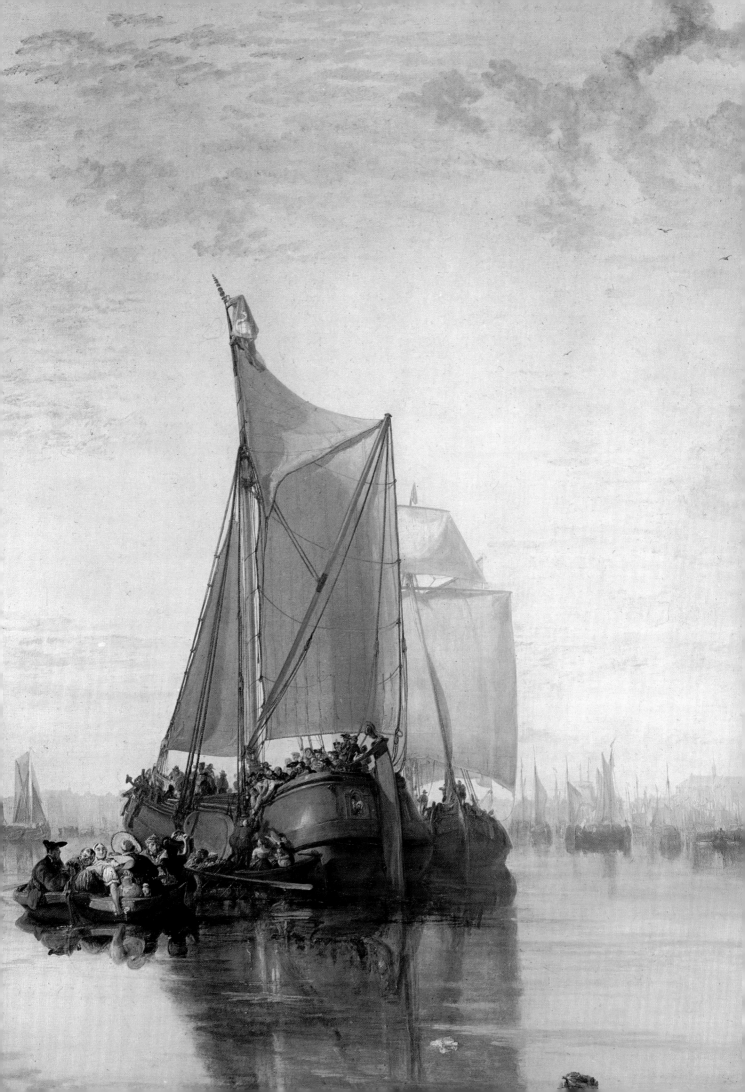

70 J. M. W. Turner
Rockets and blue lights (close at hand) to warn steam-boats of shoal water
Oil on canvas, 35 × 48 in./89 × 102 cm. Exhibited Royal Academy 1840
Sterling and Francine Clark Institute, Williamstown, Massachusetts

71 John Constable
Rough sea, Weymouth (?)
Oil on canvas, 8⅞ × 21⅞ in./22.5 × 55.5 cm. Probably painted at Weymouth in 1816
From the collection of Mr and Mrs Paul Mellon, Upperville, Virginia

72　John Constable
Shipping in the Thames
Pencil, grey wash and watercolour, 7½ × 12⅜ in./19.5 × 31.5 cm. 1803
Victoria and Albert Museum, London

73　John Constable
Hove Beach
Oil on paper laid on canvas, 12½ × 19½ in./31.5 × 49.5 cm.
Victoria and Albert Museum, London

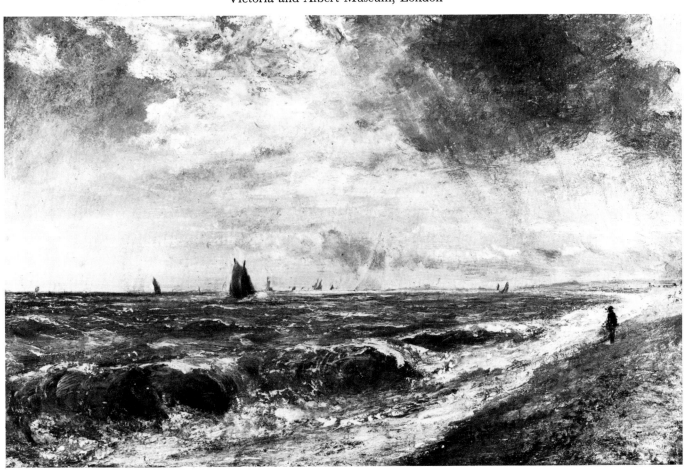

74 John Sell Cotman
The Mars riding at anchor off Cromer
Watercolour, 12 × 8⅝ in./30.5 × 22 cm. *c.* 1807
City of Norwich Museums

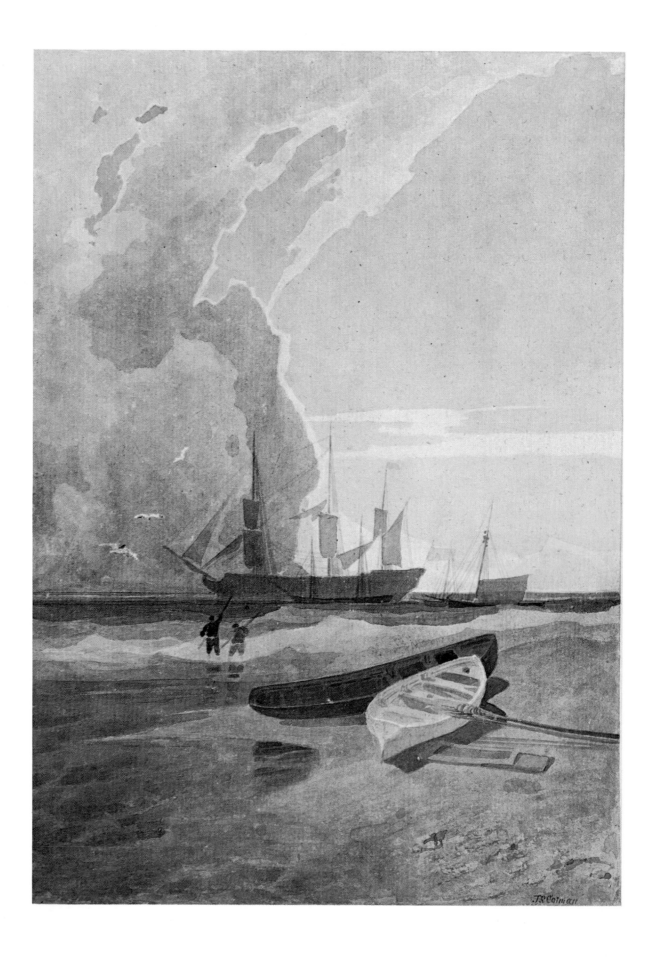

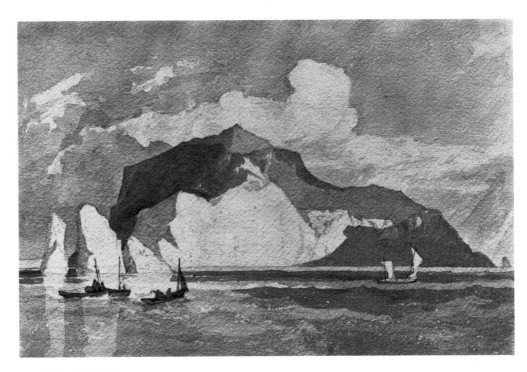

75 John Sell Cotman
The Needles
Watercolour, 8¼ × 12¾ in./21 × 32.5 cm.
City of Norwich Museums

76 John Sell Cotman
Galliot off Yarmouth
Watercolour, 14½ × 21 in./37 × 53.5 cm.
City of Norwich Museums

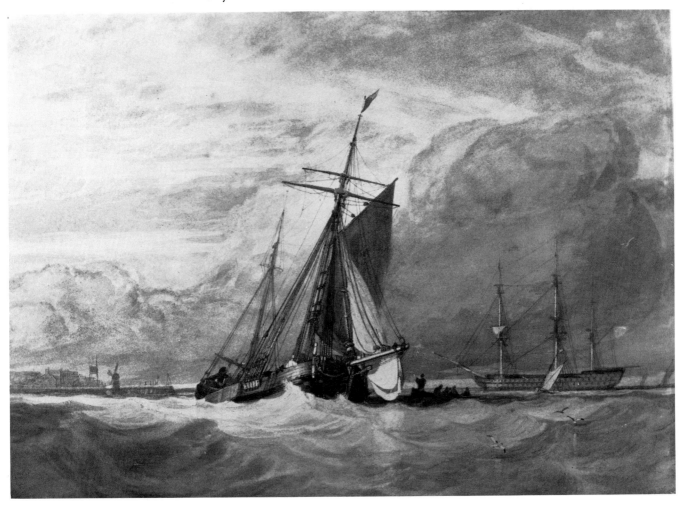

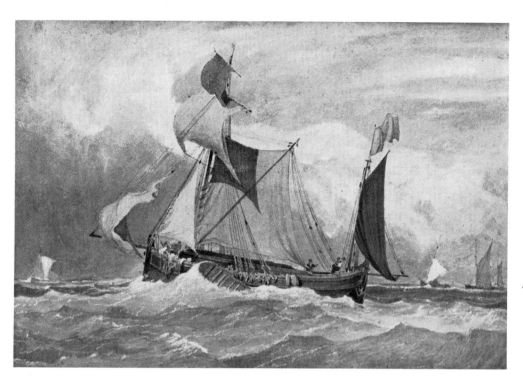

77 Miles Edmund Cotman
The squall
Watercolour,
8¾ × 12 in./
22 × 30.5 cm.
City of Norwich Museums

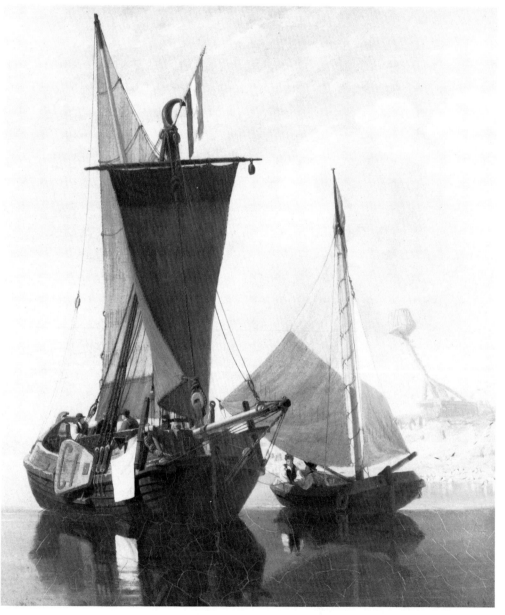

78 Miles Edmund Cotman
Boats on the Medway
Oil on canvas,
21⅜ × 19½ in./
55 × 49.5 cm.
City of Norwich Museums

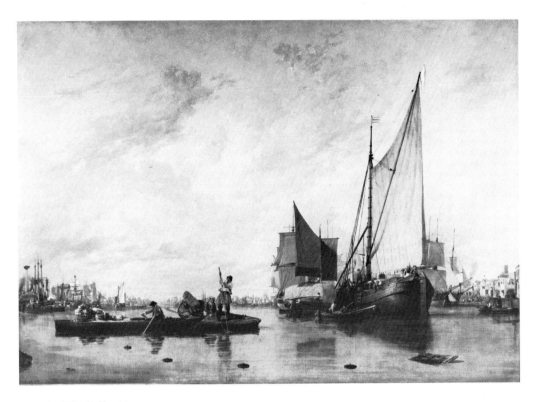

79 A. W. Callcott
 The Pool of London
 Oil on canvas, 60⅜ × 87 in./153.5 × 221 cm. Signed with initials. Exhibited Royal
 Academy 1816
 From the collection of the Earl of Shelburne, Bowood, Wiltshire

80 A. W. Callcott
 A brisk gale: a Dutch East Indiaman landing passengers
 Oil on canvas, 26¼ × 41 in./67 × 104 cm. Exhibited Royal Academy 1830
 Victoria and Albert Museum, London

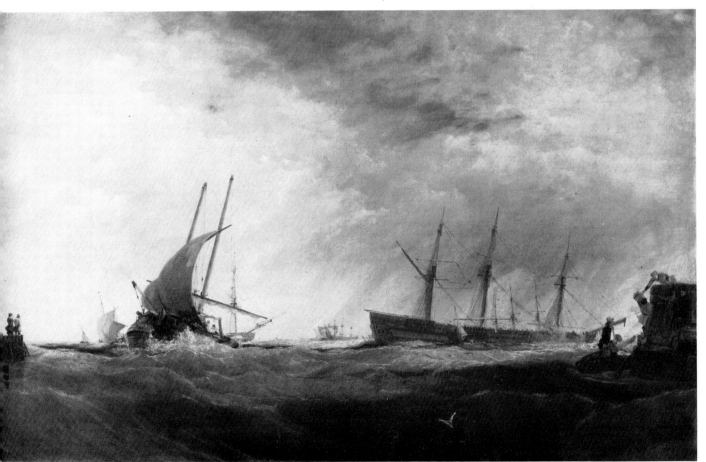

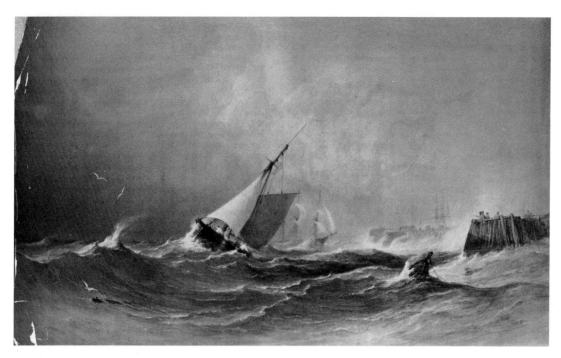

81 A. V. Copley Fielding
Bridlington Harbour
Watercolour, 18½ × 30¾ in./47 × 78 cm. Signed and dated 1837
Reproduced by permission of the Trustees of the Wallace Collection, London

82 A. V. Copley Fielding
Fishing smacks: storm coming on
Watercolour, 16 × 23½ in./41 × 59.5 cm. Signed and dated 1843
Lady Lever Art Gallery, Port Sunlight

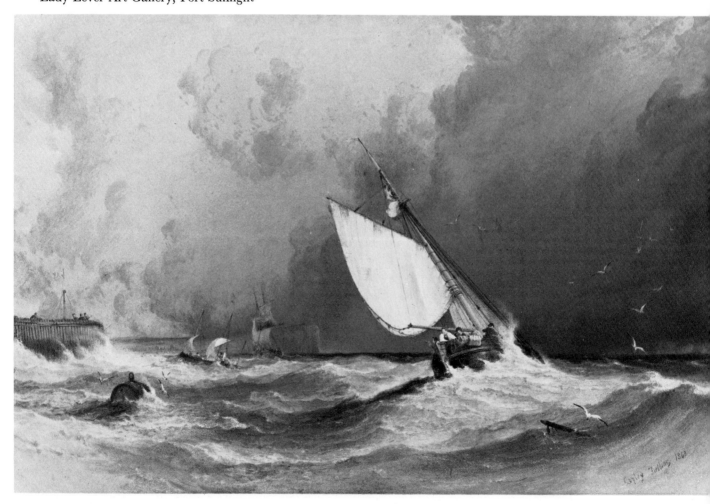

83 Charles Bentley
Fécamp, Normandy
Watercolour, 8⅝ × 14⅛ in./
22 × 36 cm.
Art Gallery and Museums, Brighton

84 R. P. Bonington
Coast scene with shipping
Watercolour, 5¼ × 7¼ in./
13.5 × 18.5 cm. Signed with initials
and dated 1828
Art Gallery and Museum, Aberdeen

85 R. P. Bonington
Coast scene in Picardy
Oil on canvas, 26⅛ × 39 in./
66.5 × 99 cm. Signed. 1826
Ferens Art Gallery, Kingston upon
Hull

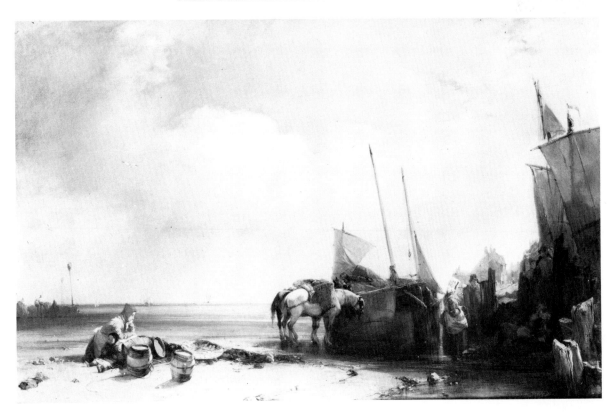

86 R. P. Bonington
Fishing boats in a calm
Oil on board, stuck on canvas, 14⅛ × 12⅛ in./36 × 31 cm. *c.* 1824-5
Walker Art Gallery, Liverpool

Jervis, Hood and Nelson were commemorated not only in paint but also in pottery, porcelain and numerous other art forms and are evidence of a nation-wide pride in Britain's ships and her seamen.

It should also be remembered that a large proportion of the population was dependent on the sea for a living, and storms and shipwrecks were as much a part of people's lives then as are road accidents and air disasters today. In the circumstances it is not surprising to discover that many of the landscape artists described in this chapter had close dealings with the sea at various points in their lives. It is also clear from studying their notebooks that all of them went to great pains to record the rigging and hull details of the ships and craft which they put into their pictures.

The greatest contribution of this generation of sea painters was not the accuracy of their rendering of ships, however, but their portrayal of atmospheric effects. We have seen this skill anticipated in the work of Charles Brooking and it reached its fulfilment in the beach scenes of Constable, the mist-filled calms and turbulent storms of Turner and the sparkling coast sketches of Bonington.

Philip James de Loutherbourg 1740–1812

More than most branches of art in England, marine painting has been influenced and enriched by the work of foreigners. One of the most interesting of these was Philip James de Loutherbourg. He received his artistic education on the Continent and did not settle in England until he was in his early thirties. It is hardly surprising, therefore, that his work is so different from that of most English marine painters. There is a certain harshness in his colouring which is very different from the soft colours and more subtle tones of the English Romantic painters who followed him. He was, however, an imaginative artist and a most accomplished draughtsman. His portrayals of shipwrecks and the great naval battles of the wars against Revolutionary France are among the most dramatic pictures of their kind.

De Loutherbourg was born at Strasbourg on 31 October 1740. He received his first lessons in art from his father who practised as a miniature painter, and he then studied under Carl Vanloo and Francesco Casanova in Paris. He became a member of the French Academy at an unusually young age and exhibited landscapes, portraits, battle-pieces and marines at the Paris Salon. After travels in Germany, Switzerland and Italy he came to England in 1771 and took a house at 45 Titchfield Street in London.

He first exhibited at the Royal Academy in 1772 and continued to be a regular exhibitor all his life. He was made an A.R.A. in 1780 and a full Academician in 1781. The violent sense of drama which he so often introduced into his canvases impressed David Garrick, who appointed him chief designer at the Drury Lane Theatre. He was paid a salary of £500 and worked with Garrick for several years. From all accounts his stage sets were popular and the fortunes of the theatre reached a high point during this period.

In 1781 de Loutherbourg devised and exhibited a moving panorama which he called an Eidophusikon. By means of gauze and changing lights he depicted different effects of weather on such scenes as 'The Bay of Naples', 'Storm and Shipwreck at Sea' and 'The Rising of the Moon contrasted with an Effect of Fire on the Mediterranean'. Both Reynolds and Gainsborough were among the crowds who visited it, and the latter was so impressed that he made a miniature version of his own. Gainsborough painted de Loutherbourg's portrait. It now hangs in the Dulwich Art Gallery, and it shows him to have been a most handsome man with aquiline nose and strongly moulded features.

In his later years de Loutherbourg became absorbed in such pursuits as faith healing and the search for the philosophers' stone. He died on 11 March 1812, aged seventy-one, at Hammersmith Terrace. He was buried in Chiswick Churchyard and no less a man than Sir John Soane designed his monument.

Most writers on de Loutherbourg have stressed his reliance on imagination at the expense of accurate observation. As Ellis Waterhouse bluntly puts it, 'He could paint anything he liked out of his head but was too lazy to refer back to nature.'[1] It is certainly true that the grouping of his figures and his rendering of waves and lighting effects is often unreal and theatrical. On the other hand he took great pains over many details. His drawing of ships is most accurate, and Commander Robinson has pointed out that 'the changes in naval uniform from 1794 to 1812 can be traced in Loutherbourg's pictures, and for this reason they are worth careful study'.[2]

The masterpiece of his marine works is the very large canvas in the National Maritime Museum, *The battle of the Glorious First of June* (pl. 61). Heroic in conception, it is a fine example of the Romantic artist's view of naval warfare. It anticipates Turner's *Battle of Trafalgar* of 1823 by some thirty years and it is interesting to speculate how much Turner may have been influenced by it. *The Battle of Trafalgar* (which was commissioned by George IV) was hung as a companion work to *The First of June* in one of the State Rooms at St James's Palace and so it seems probable that Turner, who was never able to resist a challenge, did his best to outdo the earlier work. Although the two paintings are different in technique and colouring, they have many similarities: the struggling sailors in the foreground, the histrionic gestures of the officers, the clouds of smoke and billowing sails and above all the restless sense of movement pervading the composition.

Two other battle scenes by de Loutherbourg are in the Tate Gallery: *The Battle of Camperdown 1797* (pl. 58) which is a very exciting composition with a mass of closely observed detail; and *The Battle of the Nile 1798*, an over-dramatic picture dominated by a lurid orange glow of fire.

Another popular theme among artists of the Romantic Movement was the shipwreck, and de Loutherbourg's *Survivors of a shipwreck attacked by robbers* is a good example of this type. Earlier marine painters from Backhuisen to Brooking had painted storms at sea, but their accounts had been essentially factual. To a new generation inspired by Falconer's celebrated poem 'The Shipwreck', and influenced by the popular shipwreck pictures of the French artist Joseph Vernet, the theme gave them an opportunity to glorify the violence of nature. It was a theme which admirably suited de Loutherbourg's style and he painted several variations on it. *The Wreckers* in York City Art Gallery is another example.

Not all de Loutherbourg's marine pictures were of storms or battles, however. He also painted coastal scenes with more tranquil subjects, such as *Sea-piece* in the Victoria and Albert Museum; and some of his watercolours, like his *Harbour scene* (pl. 60), have a charm and delicacy of touch that belie the tempestuous nature of his more famous works.

William Daniell 1769–1837

The aquatints of William Daniell in the eight volumes of *A Voyage Round Great Britain* would be sufficient in themselves to secure him a place in the history of English marine art. However it is often forgotten that, in addition to his aquatints and his landscape paintings, Daniell made a speciality of marine paintings. Following his election to full membership of the Royal Academy he exhibited three paintings of naval engagements: *The English Fleet at Trafalgar*, the *Battle of Trafalgar* and *The Battle of the Nile* and four years later the British Institution awarded him a prize of £100 for his sketch of the Battle of Trafalgar. Daniell was not a professional marine artist, however, in the sense that Stanfield and E.W.Cooke were, but he had some experience of deep-sea sailing and had observed a gale off the Cape of Good Hope when he was a passenger on board a ship of the East India Company.

He was born in 1769 at Kingston-on-Thames. When his father died in 1779 he was taken into the care of his uncle Thomas Daniell, R.A. He went to stay with his uncle in London and was taught the rudiments of painting and engraving. In 1784 Thomas Daniell set off for India and he took William along with him to assist in the work of drawing views of oriental scenery. The Daniells travelled on the East Indiaman *Atlas* and visited China before sailing on to Calcutta.

For the next ten years they journeyed all round India, making drawings which were later to be worked up into engravings. The return voyage was also made via China, and they reached England in September 1794.

They settled at 37 Howland Street, Fitzroy Square, and immediately embarked on the engravings of *Oriental Scenery* which was published in six volumes between 1795 and 1808. William Daniell later told Farington that 'the great facility which He had acquired in executing Aqua-tinta was obtained by the most severe application for Seven years together after He arrived in England from India—He said He had worked from 6 in the morning till 12 at night.'[3] Although both the Daniells worked on the engravings it was William who proved the more talented in the medium, and he developed a new and more subtle technique than had been used hitherto. He later applied the same technique to the plates of *A Voyage Round Great Britain*. His method was to employ 'at least two colours—warm grey and pale sepia, later adding a pale blue-grey. These tints imitated the foundation washes or "dead-colouring" which were normally used in watercolours at this period, and when the print was "stained" or tinted with watercolour, the imitation of the original was exact.'[4]

In addition to his work on *Oriental Scenery*, William Daniell began to make a

name for himself with his oil paintings. He first exhibited at the Royal Academy in 1795 and became a regular exhibitor. (Between 1795 and 1838 he showed no fewer than 168 pictures at the Academy.) The majority of these works were of a topographical nature, but marines frequently appeared among them, particularly during the 1820s. A good example was *An East Indiaman in a gale off the Cape of Good Hope*, which illustrated an event he had witnessed. The picture vividly portrays the size of waves which can be encountered in southern latitudes. Daniell was particularly fond of painting rough seas and was adept at capturing the surge and movement of the water. The delightful painting of *Egg-boats off Macao* (pl. 63) shows that he was also expert at depicting the liquid and transparent qualities of waves lapping against the boats' sides.

Daniell's oil painting was carried out in the intervals between his engraving work and his tours round the British coast. For in 1813 he had begun work on *A Voyage Round Great Britain*. The preparation of this work occupied twelve years of his life: the first volume was published in 1814 and the complete set of eight volumes contained 308 coloured aquatint plates engraved by Daniell from drawings he had made during the summer months. Richard Ayton wrote the text for the first two volumes, but Daniell himself wrote the text for the remaining volumes. Although most of the plates depict boats and harbours and the sea breaking on rocky shores or beaches, the journey round Britain was not, in fact, a voyage because most of it was undertaken on foot or on horseback. Sometimes it was necessary to take a boat out to an offshore island—Daniell and Ayton were rowed out to the Longships lighthouse, for instance, by the local boatmen —but most of the views were taken from the cliffs looking down at the sea. Daniell seems to have relied on pencil sketches made on the spot and rarely made notes about colours.

By 1825 Daniell had visited nearly every headland, beach and seaside town in Britain. He had travelled thousands of miles and visited lochs and estuaries as well as remote Scottish islands. The resulting aquatint plates provide a fascinating record of Britain's coastline in the early nineteenth century. The technique of the aquatints is always accomplished and the colouring is beautifully restrained with soft greys and browns predominating. As Martin Hardie has written, 'Daniell excels in suggesting the warm haze that hangs over a summer sea, or sunlight playing on the roofs of a fishing village, or rugged cliffs where sea-gulls swoop in circling flight.'[5]

The plates do vary in artistic merit, however. A particularly fine example is the *Lighthouse on the South Stack, Holyhead* (pl. 62). In this as in many of the plates he shows a refreshing boldness in the composition, combined with a delicate treatment of details such as the tiny ships on the far horizon and the scattered flocks of sea-birds. The sombre tones of sea and cliffs are enlivened by carefully placed highlights: the sunlight on the jib and staysail of the gaff cutter in the foreground, and the red hat of a member of the crew in the bows. But other plates, particularly some of the east coast and south coast views have a tendency to be dull and lifeless and one wonders whether he was finding difficulty in sustaining his interest as he worked on the later volumes.

The remaining twelve years of Daniell's life were spent in painting, continuing his travels (he visited Ireland in 1828 and later France) and in carrying out other sets of engravings. He died at sixty-eight on 16 August 1837.

J.M.W.Turner 1775–1851

It is not easy to set out Turner's achievements as a marine painter in the space of a few pages. He was one of the most prolific of all artists and the portrayal of marine subjects was a major preoccupation of his life. Over one hundred of his oil paintings depict seascapes, coastal views or river scenes with boats, and a high proportion of his 20,000 watercolours and drawings depict similar subjects. Moreover his sea-pieces have always been the subject of controversy. There are some who argue that he was the greatest of all marine artists and far outshone van de Velde and van de Cappelle in the range and power of his work. There are others who regard his marine paintings with suspicion and believe that his influence on the course of English marine art was wholly detrimental.

Criticism of Turner's work is of course nothing new, and when paintings like *Calais Pier* and the 1823 version of *The Battle of Trafalgar* were first exhibited they were subjected to savage criticism from seamen and art connoisseurs alike. However, such criticism did nothing to stem the admiration of many contemporary artists, and it is probably true to say that there was no marine painter working in England from 1805 onward (the date when Turner's *Shipwreck* was exhibited) who was not aware of his sea paintings. The pages of Farington's diary are littered with comments to this effect. We learn, for instance, that William Daniell 'like most of the younger artists of his time . . . was an enthusiastic admirer and imitator of Turner's work'.[6] Northcote in a reference to one of Callcott's marine works noted that 'Callcott had founded himself on Turner's manner, which several others had also adopted . . .'.[7] E.W.Cooke, who became one of the most respected artists of the Victorian era, was given a painting by Turner as a twenty-first birthday present from his father. Even an artist of Cotman's individuality found it hard to ignore his influence. In the British Museum are several of his copies of Turner's work including a detailed pencil study of *Dutch boats in a gale*.

There is a mass of literature available on Turner and to repeat the facts of his life here would clearly be unprofitable. On the other hand it is essential to establish the extent of his experience of the sea. What follows is a brief survey of his more important marine paintings together with some account of his contact with ships and coastal craft.

Turner's interest in marine subjects began early in his career and indeed his first exhibited oil painting was a sea-piece. Entitled *Fishermen at sea*, it was shown at the Royal Academy in 1796. A writer in the *Critical Guide* commented that 'the boats are buoyant and swim and the undulation of the element is admirably deceiving'.[8] Compared with his later work it is not particularly impressive, but it was followed in 1801 by *Dutch boats in a gale: fisherman endeavouring to put their fish on board*. This painting was commissioned by the Duke of Bridgewater as a companion piece to a painting by van de Velde the Younger and Turner inevitably saw the commission as an opportunity to challenge the mastery of the Dutchman in this sphere. The painting proved popular and was praised by artists with such differing views as Benjamin West, Fuseli and Constable. In this painting and *Ships bearing up for anchorage* ('The Egremont sea-piece') of the

following year, we can see the signs of Turner's break with the Dutch tradition and his particular contribution to marine art. Although the shipping in both paintings is accurately observed, it is clear that his dominant interest is the sea and the sky. The ships serve as a foil to the heaving waves and emphasize the frailty of man-made craft in the face of the forces of nature. Turner developed this theme further in later paintings. We have already noted something of this emphasis in the shipwreck paintings of de Loutherbourg, and it was to become a characteristic feature of many of the marine paintings of the Romantic period.

In the Royal Academy exhibition of 1802, Turner also exhibited *Fishermen on a lee shore* (pl. 64). This is not a large painting by his usual standards but it is one of the most successful of all his marine paintings. We find the original material for the picture in one of his sketchbooks. Indeed some of these sketches have a brilliance of execution which make them works of art in their own right. Turner used an interesting technique to facilitate on-the-spot recording. The stout, white paper of the sketchbook was previously prepared with a pale pink-brown wash. He was then able to produce highlights and the effect of foam simply by scratching the surface of the paper. The oil painting makes full use of his observations of fishermen struggling to launch their boats through the surf. The surging rise and fall of breaking waves and the glistening expanse of the foreshore is beautifully portrayed, and he pays scrupulous attention to the hull form and rigging of the three boats in the picture.

In July 1802 Turner set sail from Dover on the first stage of a tour of the Continent. The sea conditions were rough and the packet had to wait outside the harbour at Calais until the tide was high enough for them to cross the bar. Going ashore in the small boat proved a perilous undertaking, but Turner was able to make use of the experience in a large painting entitled *Calais Pier, with French poissards preparing for sea: an English packet arriving*. The painting was exhibited in 1803 and provoked an amazingly hostile reaction. The art critic of the *Sun* considered it 'a lamentable proof of genius losing itself in affectation' and Sir George Beaumont compared the foaming water to 'veins in a marble slab'.

Two years later Turner exhibited *The shipwreck: fishing boats endeavouring to rescue the crew* (pl. 65) in his newly-opened gallery at 64 Harley Street. Together with the *Fighting Temeraire* of 1838 it has become the most famous of all his marine paintings. In spite of the earlier criticism of *Calais Pier*, his depiction of the shipwreck was well received. Sir John Leicester bought it for 300 guineas on the opening day, and through the circulation of aquatint engravings of the picture it became familiar to a large section of the art world. T.S.R.Boase, writing in 1959, described it as 'the most awe-inspiring struggle of man and ocean that had yet been depicted'.[9] The stereotyped formulae so often used for portraying waves by earlier artists have been replaced by a searching analysis of the behaviour of water when stirred up by gale-force winds. We know that Turner witnessed a shipwreck because there are studies in two of his notebooks of a ship, viewed from several angles, which is in the course of breaking up. These sketches, and numerous studies of breaking waves in several sketchbooks between 1801 and 1805 provided him with the raw material for the scene.

In the autumn of 1806 Turner took up residence at 6 West End, Upper Mall, Hammersmith, and for the next few years the Thames was to be the chief source

of inspiration for his marine pictures. At this time the house stood open to the river and Thornbury learnt from the Rev. Mr Trimmer's son that, 'A garden ran down to the river, at the end of which was a summer house. Here, out in the open air, were painted some of Turner's best pictures.'[10] A group of oil sketches painted around this time depict scenes on the Thames from Abingdon down as far as Margate on the estuary. Most authorities believe the studies to have been made from a boat. Several finished oil paintings resulted from these trips, one of the most delightful being *Fishing upon the Blythe-sand, tide setting in*, also known as *Bligh Sands*. The area depicted is in fact Blyth Sand which is on the southern bank of the Thames opposite Canvey Island. The painting has an exhilarating atmosphere, full of breeze and sparkle, and has much in common with Constable's oil sketches of similar subjects. Turner gave up his house in Hammersmith in 1811, but he had a house built at Twickenham which was his base for some time, and much later in his life (in 1839 when he was aged sixty-four), he moved into a cottage in Cheyne Walk, Chelsea. Here he lived until his death. He was also, of course, born a few yards from the Thames, so it is hardly surprising that his observation of the river had such an influence on his art. Indeed its morning mists, its alternating moods of brilliant clarity and smoky murk had a profound effect on his landscape painting as well as his sea-pieces.

Evidence of Turner's first-hand observation of the sea is provided by a Devon journalist named Cyrus Redding. In 1852 he published his reminiscences of a coastal trip made in the summer of 1813, in a Dutch sea-going craft owned by Captain Nichols: 'Turner was invited to be of the party,' he writes. 'The coast scenery was just to his taste. He was an excellent sailor.' In a rising wind and with a heavy swell running, they ran eastwards along the Devon coast. Off Stoke's Point the sea rose higher, but Turner enjoyed the scene and was not affected by the motion. 'When we were on the crest of a wave, he now and then articulated to himself—for we were sitting side by side—"That's fine!—Fine!" Demararia was very ill and art driven out of his head. Turner sat watching the waves and the headlands, "like Atlas, unremoved".' Eventually they gained the shelter of Bur Island and apart from 'a little wetting' they landed safely.[11]

This trip was only one of a number of coastal passages made by Turner. He made a much more prolonged voyage in 1822 when he went to Scotland to record the King's visit to Edinburgh. He evidently sailed most of the way because his notebooks show views of Southwold, Yarmouth and other coastal towns, all viewed from the sea.

In 1818 Turner showed his command of 'the tranquil marine' in the painting *Dordrecht: the Dort packet-boat from Rotterdam becalmed* (pls. 68, 69 and jacket). The subject of the picture was inspired by a visit to Holland which he had made in August 1817. His 'Dort' sketchbook is filled with studies of Dutch craft and of the town of Dort and in some of these notes can be seen the seeds of this painting which became the most highly praised of all his marines. Constable, who was often critical of his rival's work, wrote to Leslie in 1832: 'I remember most of Turner's early works; amongst them was one of singular intricacy and beauty; it was a canal with numerous boats making thousands of beautiful shapes, and I think the most complete work of genius I ever saw.'[12]

Towards the end of 1823 Turner began work on a large painting of the battle of Trafalgar. It was commissioned by George IV as a companion work to de

Loutherbourg's painting of the *Battle of the Glorious First of June* (pl. 61) which was hanging in the State Room of St James's Palace. This was Turner's second picture of the battle. In 1806 he had exhibited *The Battle of Trafalgar as seen from the mizen starboard shrouds of the Victory* (pl. 66). This earlier painting had received a critical reception when it was first shown in an unfinished state at Turner's gallery. Farington thought it 'a very crude, unfinished performance, the figures miserably bad'.[13] Turner completed the work and showed it at the British Institute in 1808. It was again severely castigated and opinions have been divided on the matter ever since. Finberg considered that 'As a pictorial representation of a great naval engagement the picture is astonishingly successful.'[14] It is worth remembering that Turner went all over the *Victory* soon after she returned to the Medway and interviewed the crew. Two of his sketchbooks in the British Museum are filled with notes of uniforms and hull and rigging details.

For his 1823 painting of the battle Turner decided to obtain help from a professional marine artist. He wrote to Schetky at Portsmouth and asked him to make some drawings of the *Victory* for him. (This letter is quoted in full on page 137.) Turner's completed painting was hanging in the State Room of St James's Palace by May 1824. Although many people considered it to be superior to de Loutherbourg's picture, the sailors did not like it. According to George Jones, 'Turner was criticized and instructed daily by the naval men about the Court and during the eleven days he altered the rigging to suit the fancy of each seaman, and did it with the greatest good humour.'[15]

In 1827 Turner went to stay at East Cowes Castle, the home of the architect John Nash. While there he made numerous sketches of yachts racing off the Isle of Wight, which later formed the basis for a series of oil paintings. *East Cowes Castle: the regatta starting for their moorings* is perhaps the most satisfying of these. The various versions of *Yacht racing in the Solent* are perhaps less successful, although he has undoubtedly captured the movement and bustle of small craft in a stiff breeze.

During the 1830s his style underwent a considerable change. His Petworth studies as well as his marine subjects such as *Keelmen heaving coals by night*, of 1835, reveal a total preoccupation with the rendering of light. Forms and details are frequently dissolved into blurred shapes. His contemporaries were baffled by his work and perhaps their astonishment is not surprising when we compare a picture like *Rockets and blue lights (close at hand) to warn steam-boats of shoal water* (pl. 70), which was exhibited in 1840, with any of the paintings by Stanfield or Schetky who were enjoying popularity at this time. A seaman confronted with Stanfield's *On the Dogger Bank* (pl. 94) of 1846 and Turner's *Snowstorm: steam-boat off a harbour's mouth* of 1842 was almost bound to prefer Stanfield's literal depiction of storm conditions. And yet Turner's work was no figment of his imagination, for this picture was the result of the famous occasion when he had himself tied to a deck beam during a storm at sea so that he might observe the elements at first hand. It was left to later generations educated by Whistler, Monet, Sisley and Boudin to appreciate the qualities of this and other pictures of his later years.

In conclusion, I think it must be said that in spite of his experience of the sea, Turner approached it as a landsman. The majority of his studies were made

from the shore and although, as we have seen, he made numerous Channel crossings and several coastal passages, he was invariably an observer rather than a participant of nautical manœuvres. Although it is possible that he owned a boat at one time when he was living by the Thames, there is no evidence that he was a practical sailor like Cotman. (It is perhaps significant that, like Whistler, he employed the Greaves family to row him about the river in his later years at Chelsea.) He certainly had no experience of deep sea sailing and in this respect he was at a disadvantage when compared with men like Chambers and Stanfield who had been professional seamen.

This role as an observer explains certain discrepancies in his work. An example appears in *Spithead: two captured Danish ships entering Portsmouth Harbour, 1807* (pl. 67). Turner has admirably captured the mood of the occasion as the ships bear up for anchorage in a stiff breeze. The direction of the wind as shown by flags and billowing fore-topsail of the *Denmark*, the leading Danish ship, is from right to left across the picture; this is confirmed by the set of the sails of the second Danish ship and by the flags of the anchored ships in the distance. But the little gaff cutter speeding across the bows of the *Denmark* is shown running before a wind coming from the opposite direction—an impossibility with the wind force as it is shown. It is easy to see from a compositional point of view why Turner has depicted the cutter in this position, but a painter who had been a professional seaman would not have allowed this nautical inaccuracy.

On the other hand, if the behaviour of ships before the wind sometimes baffled him, he was at no such disadvantage when portraying ships at anchor, or shipwrecks seen from the shore. He showed an equal mastery in his depiction of calm and rough seas. When confronted with subjects he had himself observed he had no equal.

John Constable 1776–1837

Constable had no great love for the sea. He considered that pictures of boats were hackneyed and 'so little capable of the beautiful sentiment that belongs to landscape that they have done a great deal of harm'.[16] He was deeply upset when his second son Charles decided to become a sailor and felt that the boy was throwing away his talents on a life that was sad, melancholy and dirty. And yet in spite of this, and his constantly expressed belief in the superiority of landscapes over all other forms of painting, he produced a surprising number of sketches in oils and in watercolours of beach scenes and shipping. Most of these were studies which were never intended for exhibition, but they are as fresh and original as his studies of Dedham Vale and cannot be ignored in a survey of English marine painting. Nicholas Pocock and Dominic Serres, for all their years at sea, could never have produced a sketch like *Hove Beach*. Constable has captured the gleaming wetness of the surf and filled the picture with a brisk, salty breeze.

The facts of Constable's life have been recounted in many biographies and will not be repeated here, but it will perhaps be helpful to give some idea of the circumstances in which some of his marine pictures were painted.

One of the most interesting series of sketches was the result of a coastal voyage which Constable made in April 1803, at the age of twenty-six. He sailed from London to Deal in the East Indiaman *Coutts* with Captain Corin who was a friend of his father. During the course of the trip he made about 130 sketches (pl. 72), including some studies of HMS *Victory*. Many of the sketches were carried out in pencil with the addition of a grey wash and are so similar both in spirit and in technique to the lively shipping scenes of van de Velde the Younger (pl. 10) that we may assume he was emulating the Dutch painter whom he admired. He would have seen examples of van de Velde's work in the collection of Sir George Beaumont.

Constable described the voyage in a letter to John Dunthorne: 'I was near a month on board and was much employed in making drawings of ships in all situations. I saw all sorts of weather. Some of the most delightful, and some as melancholy. But such is the enviable state of the painter that he finds delight in every dress nature can possibly assume.' When they reached the naval base at Chatham he hired a boat, 'to see the men-of-war which are there in great numbers. I sketched the *Victory* in three views. She was the flower of the flock, a three decker of (some say) 112 guns. She looked very beautiful, fresh out of dock and newly painted. When I saw her they were bending the sails; which circumstance, added to a very fine evening, made a charming effect.'[17]

Three years later Constable made use of his sketches of Nelson's flagship, and exhibited a large watercolour of *His Majesty's Ship Victory in the Battle of Trafalgar between two French ships of the line*. According to Leslie, the subject was suggested to him by a Suffolk man who had been on board the *Victory* and described the battle to him. The picture, which is uncharacteristic of Constable, is carried out in shades of grey and brown and bears a resemblance to the work of Girtin. Constable never made a second attempt to paint a sea battle, and noted in his diary on 2 July 1824: 'There comes a letter from the Gallery to offer prizes for the best sketches and pictures of the Battles of the Nile and Trafalgar; it does not interest me much.'[18]

For one reason or another, however, Constable was constantly brought back to the coast, and wherever he went he made drawings or oil sketches. In June 1814 he stayed with his friend Mr Driffield, vicar of Feering in Essex. He made numerous sketches of the shore along the Thames Estuary and in a letter to his future wife commented: 'While Mr. D—— was engaged at his parish I walked upon the beach at South End. I was always delighted with the melancholy grandeur of a sea shore.'[19]

Two years later he was staying by the sea again, this time on the Dorset coast. Another ecclesiastical friend, John Fisher, invited Constable and his wife to spend their honeymoon at his vicarage at Osmington, overlooking Weymouth Bay. By chance the area had personal associations for Constable because his cousin had been shipwrecked and drowned on the Chesil Bank in the ship *Falconer*. The Paul Mellon Collection has a beautiful study of waves which may have been painted at Weymouth (pl. 71). The painting was in the Constable family for many years and by family tradition the floating piece of wreckage in

also brought him into regular contact with other painters and we know from the writings of Farington how much they all saw of each other. In 1827 Callcott married Maria Graham, the widow of a naval officer, and the same year the two of them set off on a leisurely tour of the Continent. On their return they settled down to life together in Kensington. Callcott's wife arranged regular gatherings of writers and artists at their house. Redgrave has recorded a delightful glimpse of these occasions:

'Vines were trained across and across the window, and through their leaves the rays of the setting sun came tempered and moderated into green coolness. Inside the room there was usually a small selection of rare plants in pots, and little bouquets of choice flowers on the tables. Two or three dogs formed part of the company . . . Lady Callcott mostly supported the conversation. She was somewhat imperious in her state-chamber; the painter being more of a silent listener until some incident of travel, some question of art, roused him up to earnest or wise remark. He was a kindly-hearted man, and always seemed interested in the progress of the young, being quite willing to communicate to them his art-lore, and to advise with them on the progress of their pictures.'[23]

An Academician who knew Callcott most of his life told Dafforne that the artist was devoted to his profession and to society, and that he lived a remarkably uneventful life: 'For years and years, and during the London Season, I should say that one day was as like another as possible; namely, breakfasting at eight o'clock, always getting into his painting room by half-past eight, and only leaving it in time to dress and go out to dinner.' But devotion to his art and a pleasant manner were not able to shield him from considerable criticism from some quarters, particularly from those who deplored his allegiance to Turner.

Constable referred to one of Callcott's paintings as 'too much of a work of art and labour, not an effusion'.[24] There is some truth in this. Callcott undoubtedly had great technical skill as a painter: his brushwork was fluid and inventive and he was a master of cloudy skies and effects of light and shade. But many of the pictures give the impression that he was striving too hard to emulate the compositions of Ruisdael and others and that he lacked the inner compulsion that brought to life the landscape and seashore scenes of Constable himself. Nevertheless, Callcott was able to break away from his masters on occasions and show his own considerable talent.

Among Callcott's most successful works are pictures with marine subjects, which is perhaps surprising as he had so little practical experience of ships and the sea. At Petworth there is a large picture of a Dutch boat and other shipping in a fresh breeze. Entitled simply *A sea-piece* (pl. 59), it is remarkable for its subtle colouring and exhilarating sense of movement; it is in no way put in the shade by Turner's famous 'Egremont Sea-piece' which hangs near by on the same wall.

Another fine marine painting by Callcott is *The Pool of London* (pl. 79) which was commissioned by the Marquess of Lansdowne and exhibited at the Royal Academy in 1816. This picture became celebrated in its day and we know that Callcott took great pains over its execution, even to the extent of having models of boats specially made so that he might render the details correctly. There is an interesting resemblance between the large Dutch boat in the foreground and the Dort packet boat shown from a similar viewpoint in Turner's *Dordrecht*

(pl. 68) which was exhibited two years later. It is possible that Turner was in this case influenced by his follower because one of Thornbury's anecdotes records his admiration for *The Pool of London*: 'Turner . . . on being told that Callcott had painted one of his finest scenes on the Thames for two hundred pounds, observed in the presence of several patrons of the fine arts, "Had I been deputed to set a value upon that picture I should have awarded a thousand guineas." '[25]

Redgrave observed that Callcott was particularly adept at 'representing with much refinement and poetry nature in her most placid and gentle moods'. A good example of this is *The Thames below Greenwich* which is now in the Soane Museum. Although the composition is extremely simple, Callcott has captured the peacefulness of a summer evening on the lower reaches of the estuary.[26] A marine painting of a very different nature is *A brisk gale: a Dutch East Indiaman landing passengers* (pl. 80) of 1830. The magnificent sky and the swirling green sea are handled with deceptive ease, and if his debt to the Dutch school is a little evident in the composition (the strongly shadowed foreground, the figures on the breakwaters, the grouping of the ships), he must be given full credit for the painterly quality of the brushwork.

Although there are a large number of marine subjects among Callcott's work he was nevertheless regarded by his contemporaries as a landscape painter and it seems likely that it was Turner's example that caused him to look to the sea for suitable subjects. Like Crome and Constable he approached the sea with a landsman's eye, but like them also he enriched the range of English marine painting.

Callcott died in his Kensington house on 25 November 1844, at the age of sixty-five. He had been suffering from ill health for some time and he outlived his wife by only two years.

John Sell Cotman 1782–1842

Cotman was primarily a landscape painter, but like his contemporaries Bonington and Constable, he produced a number of marine works of marked originality. Two sea-pieces, *The dismasted brig* and *The Needles* (pl. 75), are among the finest of all his watercolours and in addition to these he exhibited some forty pictures with marine subjects. He also filled many pages of his sketchbooks with drawings of ships and coastal scenes. For most of his life he lived in Norfolk, a county where the water is never far away, and he owned a small sailing boat in which he explored the east coast and the Thames Estuary. A letter that he wrote in 1838, towards the end of his life, shows his enthusiasm for life on the water:

'It seems that all my letters relate to my voyages up and down the Thames, breathing health and spirits. Today I took Alfred with me to Woolwich. It was such a glorious day, such clouds, such forms, such colouring. I was quite beside myself and everything appeared animated. This prosperous London and its

environs to me is everything—especially the Thames. Steamers in shoals cutting their rapid flight among ships of all nations. In short the whole day has been one of stupendous splendour. I think I never recollect such a day as it has been.'[27]

Cotman was born in Norwich in 1782 but went to London at the age of sixteen to study painting. It was not until 1806, when he returned to Norfolk, that marine subjects began to appear regularly among his landscapes and architectural compositions. He made several visits to the sea in the summers of 1807 and 1808 and painted coast scenes with shipping. One of these pictures is *The Mars riding at anchor off Cromer* (pl. 74), which was exhibited at the Norwich Society of Artists in 1808. This watercolour has all the characteristics of Cotman's finest work in this medium. It is beautifully composed with clouds and waves reduced to almost flat patterns. In 1812 Cotman moved to Yarmouth with his family and took up residence in a small house near the harbour. According to his biographer, Sidney Kitson, 'The shipping was a constant delight to him and he made innumerable notes of rig and structure, jotted down on any odd bit of paper that might be in his pocket at the time.'[28] When his sons were old enough he bought *The Jessie*, a boat with a covered cabin amidships, and together they explored the river and sailed inland to Breydon Water.

In 1817 Cotman set off for France in order to make first-hand studies for a series of etchings sponsored by Dawson Turner. His crossing of the Channel was delayed for a few days by a storm. In a letter home on 18 June he drew a picture at the top of the page showing a ship battered by waves on the beach. Underneath he wrote, 'This vessel was riding in great danger on the Friday I arrived at Brighton and on the Saturday morning she came on shore and in a few hours was dashed to pieces.'[29] He reached Dieppe safely however, and after sketching in the town he travelled via Rouen, Caen and Bayeux to Mont St Michel. With sketchbooks filled with drawings, he boarded the packet boat at Le Havre and sailed for Southampton. He evidently shared Turner's delight in rough sea conditions because in a letter[30] written to his wife on 11 August he said that 'though the passage was a most boisterous one, to me it was a new scene of grandeur and sublimity'. He described how 'at one time the vessel flew through the water with the lightness and swiftness of a swallow encompassed all around with the blazing sea that was perfectly luminous'. The wind dropped off the Isle of Wight and 'it fell a perfect calm' which delayed their arrival at Southampton for six hours. He took the opportunity to make a drawing which, on his return, he used as a basis for his famous watercolour of the Needles.

In spite of the patronage of Dawson Turner and others, Cotman was forced to spend much of his life teaching in order to support his family. He hated being what he called 'a mere drawing master', and so he must have been pleased to leave his pupils behind during the summer vacation of 1828. With his two eldest sons, Miles Edmund aged eighteen and John Joseph aged fourteen, he set off on a coastal voyage in *The Jessie*. They sailed from Norwich down the river to Yarmouth, and then along the coast via Lowestoft and Southwold to the Thames. Cotman sketched continuously and when they reached the Medway he recorded every type of vessel in view, from men-of-war to small fishing craft.

Cotman spent the Christmas of 1828 with his friend George Cooke at Hackney. Cooke (who was the father of E. W. Cooke, see page 167) was a most accomplished engraver and had engraved the work of such painters as Callcott, Stanfield, Prout and Cox. He was in financial difficulties at this time and Cotman made several drawings of London subjects and gave these to his friend as material for engravings. According to Kitson, two memorials of this visit were retained in the Cooke family for three generations. 'One is a water-colour drawing of shipping off a port, for the most part by young Edward Cooke, but Cotman has washed in a boat in the foreground which successfully pulls the composition together. The other drawing . . . is inscribed, "To George Cooke, with J. Cotman's best regards".'[31]

It seems probable that Cotman's skilled draughtsmanship had some influence on Edward Cooke's work. There is certainly a strong resemblance between Cooke's etchings for *Shipping and Craft*—which he was producing during the course of 1828 and 1829—and Cotman's own etchings.

In the summer of 1831 Cotman again sailed from Norwich to London, this time accompanied only by Miles Edmund. They moored the boat above London Bridge, and lived on board while they sketched in the neighbourhood. They then sailed to the Medway to make further drawings of the shipping in the estuary. With full sketchbooks they made their way back to Norwich by sea, and returned to their teaching.

The details of the remainder of Cotman's life need not concern us here, but it is worth noting that his marine paintings fared no better than his landscapes at the auction of twenty-six of his pictures at Christie's in 1836. *A view of Yarmouth with a lugger in a breeze* went for 10s. 6d., and the *Sea-piece, with dismasted brig* he bought himself for 17s. (This lovely watercolour is now in the Prints and Drawings Department of the British Museum.) Cotman died in London on 28 July 1842 at the age of sixty.

His finest marine pictures were all carried out in watercolours. The seascapes which he painted in oils are somewhat laboured and lack the sparkle and conviction of his work in the other medium. His method of working is well illustrated in *The Needles* (pl. 75). He has restricted the colour scheme to shades of blue, and has reduced the waves to broad, flat patterns. Actually this flatness is over-emphasized in reproductions of the picture, because a close examination of the paper shows that the area of the sea is made up of many layers of washes, which give a depth to the apparently flat areas. The shape of the white cliffs is dramatically repeated in the shape of the clouds overhead, and the placing of the shadows and the position of the tiny fishing luggers is carefully planned and exactly right. Martin Hardie has shown that most of Cotman's exhibited watercolours (as opposed to his sketchbook studies) were painted in his studio where he could use a table for laying down his washes, and where he could work unhurried by the necessity to capture a passing cloud effect.[32] The result was a marvellous series of cool, poetical compositions. They are typically English in their understatement and owe nothing to the Dutch marine school whose influence dominated so many marine artists of this period.

Miles Edmund Cotman 1810–1858

Cotman's eldest son, Miles Edmund, was his most talented pupil, and became his assistant. He was born in Norwich in 1810, but was brought up by the sea at Great Yarmouth when his father moved there in 1812 at the request of his friend and patron Dawson Turner. Miles Edmund benefited from his father's teaching early in his life and exhibited his first picture at the Norwich exhibition when he was thirteen. He continued to exhibit there regularly for the next ten years.

When Cotman sailed his boat to London in the summer of 1828, he was accompanied by Miles Edmund and his brother John Joseph. They spent much of their time sketching the shipping and coastal scenery of East Anglia and the Thames Estuary. The trip seems to have confirmed Miles Edmund's enthusiasm for marine subjects.

We have already seen that Cotman was a close friend of the engraver George Cooke and during the autumn and winter of 1828 their two families exchanged hospitality. In October, E.W.Cooke and his mother stayed at the Cotman's home in Norfolk. Cooke was then aged seventeen, a year younger than Miles Edmund, and from Cooke's diary we learn that the boys explored Norwich together and went sailing on the river near Thorpe.

In the summer of 1831 Cotman and his eldest son repeated the coastal voyage to London, and on their return they inserted an advertisement in the *Norwich Mercury*: 'J.S.Cotman & Son Resume their instructions in Drawing and Painting in Oil and Water-Colours on Monday August 1st, 1831.'[33] For the next three years they divided their attention between teaching local pupils and painting their own pictures. When Cotman took up his appointment as drawing master at King's College in 1834 he left his Norwich pupils in the care of his son, but he soon found he needed help with his unruly classes in London and he persuaded the college authorities to take on Miles Edmund as his assistant. In December 1836 Miles Edmund was given the official post of Assistant Drawing Master. When his father died in 1842 he took over his post and he continued to teach at King's College until he was compelled to resign through ill health. He returned to Norfolk and painted and taught at North Walsham for some years. He died on 23 January 1858.

It is often difficult to distinguish between the work of Miles Edmund Cotman and that of his father, and it is this lack of individuality which no doubt accounts for the neglect he has suffered until fairly recently. In the context of marine art he certainly deserves more attention than he has hitherto received. Between 1835 and 1856 he exhibited twenty-nine pictures at the British Institution and the Society of British Artists, and four pictures at the Royal Academy: all these were marines and although the subject matter was confined to two localities —the Medway and the area round Great Yarmouth—the pictures are worthy of more than local interest. His oil painting *Boats on the Medway* (pl. 78), for instance, which is now in Norwich Castle Museum, is a small masterpiece. Clear, sparkling colours, close observation of sunlight and shadow, and the skilful rendering of reflections contribute to a haunting impression of a calm day on

a river estuary. A drawing for this composition and an exquisite little water-colour of the same view are in the British Museum.

In contrast to his numerous tranquil scenes of Norfolk wherries and hay barges is his watercolour of *The squall* (pl. 77). In the manner of his father he has restricted his palette to blue-grey and green-grey for sky and sea, and sub-dued shades of buff and red ochre for the shipping. But he has his own way of portraying the scudding waves and makes skilful use of a sharp knife to suggest white foam.

C.F.Bell in *Walker's Quarterly* makes the interesting point that Miles Edmund Cotman had 'at his fingers' ends all the technical devices of water-colour painting of the Early Victorian period to a far greater degree than his father, whose method of work remained to the end very much that of Girtin and Turner in his early time'.[34] He suggests that he was particularly influenced by the work of W.J.Muller and Bonington. Bonington's work certainly made a deep impression on the young Edward Cooke, and during his teaching years in London Miles Edmund must have had ample opportunity to study Bonington's work. But the dominating influence on his painting must surely have been that of his father who was a critical and demanding teacher, and who had first introduced him to marine subjects.

A.V.Copley Fielding 1787–1855

For the first ten years of his working life as an artist Copley Fielding painted landscapes, and there seems no reason to suppose that he would ever have turned his hand to marine subjects if it had not been for the illness of his wife. He married Susannah Gisborne, the sister-in-law of John Varley, in 1813 and they moved into a house in Hampstead, but her health deteriorated and she was advised to go and live by the sea. They chose Sandgate, a small village between Hythe and Folkestone. Copley Fielding retained a studio in London but from 1817 onwards he spent much of his time on the Kent and Sussex coast, and painted a number of beach scenes and seascapes.

Anthony Vandyke Copley Fielding was born in 1787 at East Sowerby, near Halifax. He was the second son of Theodore Nathan Fielding, a portrait painter. His three brothers also became artists but Copley Fielding was by far the most successful of the family. Soon after his birth the family moved to London and when he was sixteen they moved to the Lake District. Under his father's tuition he went out every day and sketched from nature. By 1807 he was exhibiting his pictures at Liverpool.

In 1809 he travelled to London where he became the friend and pupil of John Varley. He decided to devote himself mainly to watercolours and evidently made good progress because in 1810 he was elected an associate of the Old Water-Colour Society. He subsequently showed large numbers of his pictures at the Society's exhibitions (327 pictures between 1813 and 1820 alone). He also exhibited seventeen pictures at the Royal Academy, three of which were

marines: *Fishing boats in a gale at Spithead*, *A seapiece* and *Scene on the sands at Shoreham Harbour*.

Although there is no record of his visiting the Continent, Copley Fielding travelled widely throughout the British Isles. In the latter part of his life he became a regular visitor to Brighton: from 1829 to 1847 he had houses there, first at 41 Regency Square and then at 2 Lansdowne Place. He died in Worthing on 3 March 1855 and was buried at Hove.

Ruskin was a great admirer of Copley Fielding's work. He devoted several pages to him in the section 'Of truth of water' in *Modern Painters*:

'Among those who most fully appreciate and render the qualities of space and surface in calm water perhaps Copley Fielding stands first. His expanses of windless lake are among the most perfect passages of his works; for he can give surface as well as depth, and make his lake look not only clear, but, which is far more difficult, lustrous.' Of rough water he wrote, 'No man has ever given, with the same flashing freedom, the race of a running tide under a stiff breeze; nor caught, with the same grace and precision, the curvature of the breaking wave, arrested or accelerated by the wind.'[35]

It is interesting to compare Ruskin's eulogy with a more recent judgement. In a searching analysis of Copley Fielding's watercolours written in 1925, S.C.Kaines Smith commented: 'His handling of wave-forms is superficially convincing but careful analysis reveals that it is wholly arbitrary . . . and it is only the sympathetic rendering of atmospheric effect, which does indeed approximate to truth, which redeems many of these drawings from the quality of mere hack work.'[36] This seems unduly harsh and modern opinion would probably place Copley Fielding's marine paintings half-way between these two extremes.

Bridlington Harbour (pl. 81) in the Wallace Collection is a typical seascape and portrays one of his favourite themes. The buoy in the foreground, the floating plank, the seagulls and the wave crests gleaming white against an area of dark sky, and the distant ship placed at right angles to the fishing smack are all common features of Copley Fielding's marines, but however well-worn the theme he has suggested the underlying movement of the waves and the wind on the surface with considerable skill. A dramatic picture in a similar vein is *Fishing smacks: storm coming on* (pl. 82).

A fine example of an estuary scene with shipping is *Plymouth Sound* which is in the Victoria and Albert Museum, and Manchester City Art Gallery has his *Loch Lomond*: a tranquil rendering of calm inland water.

R.P. Bonington 1802–1828

In his short life (he died a month before his twenty-sixth birthday) Bonington had little practical experience of the sea, but like so many of the artists of the Romantic movement, he constantly returned to the seashore as a source of inspiration. His technical facility and natural talent enabled him to develop a

fresh approach to marine painting. Apart from two months in Italy and three brief visits to England, his entire working life was spent in France. However, after his death, the pictures remaining in his studio were sold at five family sales in England where they were much admired by English collectors. Several marine painters bought his work and there is some evidence that he had a considerable influence on English marine art.

Bonington was born in Nottingham on 25 October 1802. In 1817 he emigrated to France with his family. For several months he was a pupil of F.L.T.Francia in Calais until his father put an end to his painting lessons. Bonington ran away from home and made his way to Paris. Here he met Delacroix who was to remain his friend for the next few years. In April 1819 he entered the Ecole des Beaux Arts and was for some time a pupil of the painter Baron Gros. Although he had by this date been re-united with his family, who had moved to Paris, Bonington was now sufficiently confident to set up his own studio. In 1822 his address was 27 rue Michel le Comte, and in 1824 he was at 16 rue des Mauvaises Paroles.

From his base in Paris, he made several tours of northern France to gather material for his pictures. The harbours of Dieppe, Boulogne and Calais, and the beaches of Normandy and Picardy provided him with a variety of subjects for both watercolours and oil paintings. In 1824 he sent five pictures to the Salon and won a gold medal (as did Constable and Copley Fielding on the same occasion). Three of these pictures were marines.

In 1825 he went to England and though little is known of his movements in this country we know that he spent some time sketching armour and monuments in London in the company of Delacroix. In May the following year Bonington was in Venice. Like so many other English artists he was deeply affected by the beauty of the city. His drawings and paintings of her palaces, canals and the lagoon are among the finest examples of his art.

Bonington's last two years were dominated by a mounting pressure of work and by his increasing lack of strength, which was to be diagnosed as tuberculosis, aggravated in the end by sunstroke. He made two further visits to London: the first was sometime in 1827 and we know that on this occasion one of his commissions was for the engraver W.S.Cooke (the uncle of E.W.Cooke). In the spring of 1828 he made a second visit to London and possibly brought with him his three exhibits for the Royal Academy.

His illness had now reached the point when his family decided to seek the advice of a London doctor. There was nothing anyone could do for him, however. He died on 23 September 1828. Several distinguished Academicians, including Sir Thomas Lawrence, attended his funeral, which is perhaps an indication of the reputation he had earned in his brief life.

Bonington's father, although of somewhat unreliable character, was evidently an opportunist and determined to capitalize on his son's talent. He formed a committee to help sell Bonington's pictures and was successful in enlisting the help of Clarkson Stanfield, Samuel Prout and two others. In 1829 the first sale of Bonington's work was held at Sotheby's, and realized the sum of £2,296 6s. 0d. Stanfield, who already owned one of his pictures, purchased three lots at this sale for a total of £10.

Among the English marine painters who were inspired by Bonington's work

were E.W.Cooke (page 167) and Charles Bentley (page 134). From Cooke's diary we learn that on 12 February 1834 (a week after he took his first lesson in oil painting) he went to the private view of an exhibition of Bonington's work in Regent Street: 'Beautiful pictures and drawings,' he wrote. Two months later he called on Mr Brown at the Prince of Wales Hotel to see his collection of Bonington's drawings, and recorded in his diary that they were 'truly splendid and surprising works of Art!! Nothing in Art so much affected me before.' It is possible to see traces of Bonington in a number of Cooke's marine subjects. His painting of *Brighton Sands*, for instance, in the Victoria and Albert Museum, bears a close resemblance to several of Bonington's coast scenes: the boat and figures are isolated on a great expanse of seashore and there is the same low horizon and effect of distance.

Charles Bentley had good reason to be affected by Bonington's style. During the period that he was apprenticed to the engraver Theodore Fielding, he was sent across to Paris to work, as an assistant, on engravings for a volume entitled *Excursion sur les Côtes et dans les Ports de Normandie*. It was published in 1823–4 and largely consisted of plates after watercolours by Bonington. As Martin Hardie points out, 'there is no doubt that this close study of Bonington's work, the engraver's careful copying of form and colour, influenced Bentley's own work when he became a watercolour painter'.[37] Many of Bentley's coast scenes capture the breadth and freedom of Bonington's style in a manner that usually eludes the more painstaking efforts of Cooke.

Bonington's marine paintings, even more than his landscapes, have a fragile and glittering brilliance. Skies of an intense, luminous blue shine between scudding clouds; cool green waves sparkle beneath the tan sails and black hulls of fishing craft. His marines also demonstrate the assurance of technique that Constable found disturbing in so young an artist.[38] His fluid brush strokes and his skilful rendering of that special quality of light associated with river and coastal scenery anticipated by many years the Thames paintings of Whistler and the beach scenes of Monet and Boudin. With deft horizontal strokes of the brush he could convey an extraordinary effect of recession towards the horizon. This, combined with his fondness for placing the horizon low in the composition and his restriction of vertical features, contributes to the illusion that the expanse of sky and seashore extends far beyond the limits of the framed canvas.

Many of Bonington's finest marine paintings are in private hands, but there are a few outstanding examples in public collections. *Fishing boats in a calm* (pl. 86) at Liverpool demonstrates his easy brushwork and his command of watery reflections. The well known *Sea-piece* in the Wallace Collection is a splendid portrayal of fishing boats splashing through choppy seas. One of his loveliest beach scenes is in the Ferens Art Gallery and is entitled *Coast scene in Picardy* (pl. 85). Dr Marion Spencer considers this to be the most outstanding of all his marine and coastal subjects. The atmosphere of a summer's day, and the jewel-like detail of the foreground details have been portrayed with an effortless brilliance that recalls the finest work of Turner.

Bonington's watercolour technique was, if anything, even more accomplished than his technique in oils, and it is hard to select isolated examples. In the collection of Mr and Mrs Paul Mellon are two fine examples of his mature

style: *A choppy sea* and the lively *Sea-scape*. And in Aberdeen Art Gallery is a watercolour which was painted in the last year of his life. It is entitled *Coast scene with shipping* (pl. 84) and demonstrates Bonington's deft use of the point of the brush to suggest details, and his command of broad, liquid washes for the cool blue sky and sand of the middle distance.

Charles Bentley 1805/6–1854

Charles Bentley was a watercolour artist with a vigorous style and a preference for coastal scenes. He appears to have had no more practical experience of the sea than Crome or Bonington but, like them, he was a keen observer of shipping and was skilful in depicting the atmosphere of the sea shore.

He was born in Tottenham Court Road in 1805 or 1806. His father was a builder and carpenter. He was apprenticed to Theodore Fielding (one of the brothers of A.V.Copley Fielding) and while working for him was sent to Paris to assist with the engravings for *Excursions sur les Côtes et dans les Ports de Normandie*. Many of the plates in this book were based on Bonington's watercolours and, as has already been noted, he was certainly influenced by this artist's style. William Callow was apprenticed to Fielding in 1823 and he and Bentley became friends. They went on sketching tours together, and visited Rouen and Le Havre in 1836, and Paris, Dieppe and Abbeville in 1841. Bentley also travelled widely throughout the British Isles. It is clear from his pictures that he visited many of the coastal areas of Britain and also the Channel Isles.

Although Bentley was a regular contributor to the exhibitions of the Old Water-Colour Society (he was elected an associate in 1834 on the same day as the marine artist George Chambers, and he became a full member in 1843) he does not appear to have made much money from his painting. When he died from cholera at 11 Mornington Place, Hampstead Road in 1854 the value of the possessions which he left to his widow was £300.

Bentley's pictures may lack the distinction of some of the great names of the English watercolour school, but they do have a freshness of their own. He had his own way of forging sea and sky into an atmospheric unity; and he combines an attractive roughness of texture with fine brush strokes for details. The Victoria and Albert Museum has some good examples of his work, notably *Fishing boats off the Isle of Wight* and *Harwich from the sea*. There are also examples of his work in several provincial English galleries: *Fécamp, Normandy* (pl. 83) in Brighton Art Gallery and Museum demonstrates his broad treatment of waves outside a harbour mouth; highlights are picked out by the restrained use of a sharp knife; and the colouring is in shades of grey-green and brown enlivened with two or three spots of red ochre.

5 THE VICTORIAN PERIOD

The subject matter of Victorian marine art was as varied as were the techniques of painting. The taste for storms and shipwrecks cultivated by the Romantic artists continued unabated. The sea itself became such an acceptable subject that human beings sometimes disappeared from the canvas altogether: Stanfield's famous picture *The abandoned* depicted a deserted hulk on an empty ocean, and John Brett and Henry Moore specialized in huge vistas of sea and sky. The fashion for the seaside holiday led to a great many views of such popular bathing places as Margate, Ramsgate and Brighton. Harbours and river estuaries continued to provide a variety of picturesque subjects. The century also saw the heyday of the ship portrait, epitomized by the work of W.J.Huggins, but also carried on by a number of local artists such as Samuel Walters of Liverpool and Joseph Walter of Bristol. And although Britain had long ago secured the mastery of the seas, naval battles continued to be a profitable source of commissions for marine artists.

This was a century that witnessed the transition from sail to steam and from timber to steel, that saw the abandonment of traditional methods of shipbuilding and experienced a boom in the shipping industry. Such changes were inevitably reflected in the paintings of the period. Many artists pursued a traditional course and continued to look back to the van de Veldes for inspiration, but the work of some artists became less assured and at the same time more exploratory. The seascapes of Whistler, McTaggart, and Wilson Steer might not please the lovers of conventional marine art but they expressed a new

approach to the sea. While links with artistic developments in France towards the close of the century marked an end of the dependence on the Dutch tradition in English marine art.

J. C. Schetky 1778–1874

Ninety Years of Work and Play is the title of a biography of John Christian Schetky written by his daughter. It is a lively account which includes quotations from her father's correspondence and that of his contemporaries, and it provides an interesting insight into the life of a successful marine artist in the nineteenth century. The fact that Schetky was an artist of no more than average ability does not lessen its value. He was well acquainted with Turner, Clarkson Stanfield and most of the established marine artists of the day and was on friendly terms with such exalted figures as Sir Walter Scott and Queen Victoria. According to his daughter he was a sociable and energetic man with a variety of accomplishments: he could play the flute, the guitar and the violoncello and was fond of singing Scottish ballads; he was a skilful amateur sailor; and he was an intelligent and popular teacher. His watercolours and oil paintings of shipping show that he was also a painstaking master of his art.

He was born in Edinburgh on 11 August 1778. His father, who came from an ancient Hungarian family, was a professional musician who had settled in Scotland in 1773 and married a Hungarian lady—who was herself an amateur musician and an artist. John Christian Schetky was the fourth son in a large family and was educated at the High School in Edinburgh. At an early age he tried, unsuccessfully, to persuade his parents to let him join the navy. His teaching career began when he was fifteen: he helped his mother with her drawing class of young ladies and on her death in 1795 he took up teaching in earnest.

In 1801 Schetky went on a Continental tour with two friends, and visited Paris, Geneva, Florence and Rome. On his return he settled in Oxford and stayed there for the next six years teaching drawing to the undergraduates. In the university vacations he returned to Scotland to visit his family and friends and went on several sketching tours.

In 1808 Schetky was made junior professor of civil drawing at the Royal Military College at Great Marlow and he retained this post until 1811 when he was appointed professor of drawing at the Royal Naval College at Portsmouth. He was in many ways ideally suited to the job and remained at Portsmouth for the next twenty-five years. Admiral Becher, who was one of his pupils, later recorded his impressions of Schetky's arrival at the college:

'He brought us a new state of things altogether. We were never allowed outside the dockyard gates before he came: but he looked up the college boat directly, and got permission to take us out sketching—and such jolly expeditions as we used to have all along the coast there! Ah! I remember his coming well! It must have been in the fall of the year 1811. A fine tall fellow he was, with all

the manners and appearance of a sailor—always dressed in navy-blue, and carried his *call*, and used to pipe us to weigh anchor, and so on, like any boatswain in the service.'[1]

Schetky became a familiar figure at Portsmouth and was often to be seen drawing ships in the harbour from his small boat, the *Wanderer*. Not long after his appointment at Portsmouth he established his first link with the Royal Family by being appointed 'Painter in Water Colours' to the Duke of Clarence. This was followed in 1820 by his appointment as 'Marine Painter in Ordinary' to George IV. In this capacity he accompanied the king on his visit to Ireland in 1821 and on his voyage to Scotland the following year.

An interesting correspondence between Turner and Schetky is recorded in *Ninety Years of Work and Play*, and it is a good example of the way in which artists in the marine field sometimes cooperated. On 3 December 1823, for instance, Turner wrote:

'Dear Sir,—I thank you for your kind offer of the Temeraire; but I can bring in little, if any, of her hull, because of the Redoubtable. If you will make me a sketch of the Victory (she is in Hayle Lake or Portsmouth Harbour) three-quarter bow on starboard side, or opposite the bow port, you will much oblige; and if you have a sketch of the Neptune, Captain Fremantle's ship, or know any particulars of Santissima Trinidada, or Redoubtable, any communication I will thank you much for. . . . Your most truly obliged, J.M.W.Turner. PS.—The Victory, I understand has undergone considerable alterations since the action, so that a slight sketch will do, having my own when she entered the Medway (with the body of Lord Nelson) and the Admiralty or Navy Office drawing.'[2]

Schetky duly sent the sketches, which were returned by the grateful Turner some nine months later.

At the age of forty-eight Schetky became engaged to Charlotte Trevenen, the sister of one of the friends he had made during his period at Oxford. They were married in April 1828, at St George's Church, Bloomsbury, and in spite of Schetky's many years as a bachelor, the marriage seems to have been a happy one.

In 1836 a threat by the Government to dissolve the Royal Naval College at Portsmouth caused him to look around for another job. Armed with testimonials from King William IV, as well as the Commander-in-Chief at Portsmouth and the President of the Royal Academy, this was presumably not too difficult a task. In March 1837 he and his wife moved to Waddon Lodge near Croydon and he took up the post of professor of drawing at the East India College at Addiscombe. Croydon's distance from the sea did not worry him unduly. He continued to visit his many friends on the south coast, and he also had a fifteen-foot model of a frigate specially built and fully rigged which he set up on his lawn to assist him when drawing ships.

Although he was now in his early sixties his life was as active as it had been at Portsmouth. In addition to his teaching duties, he continued to exhibit regularly at the Royal Academy. He also continued to travel widely. In 1842 he accompanied Lord Hardwicke (one of his patrons) to Hamburg, Berlin and Danzig. In 1843, after a short stay in Cowes, he visited Paris, Nantes, Tours and St Malo. Friendship with the Duke of Rutland resulted in visits to his home

in Derbyshire and cruises on board the Duke's yacht *The Resolution*: in 1846 they sailed to Brest; in the summer of 1848 they cruised to Belfast from Liverpool and then sailed round the Scottish Isles. Trips like these provided Schetky with plenty of material for his paintings. 'We got in again, though, this morning at grey dawn', he wrote to his daughter, 'and blowing *great guns*—enough to blow the horns off a bull! I was upon deck and enjoyed the grand sight, but it was very cold.'[3]

He was also regularly employed on commissions for royalty because his attachment to the Court was continued when he was appointed Marine Painter in Ordinary to Queen Victoria in 1844. On several occasions he travelled on board the royal yacht, and became well known to the Queen and Prince Consort. The Queen often used to make sketches of her own—at the inspection of the fleet at Spithead in 1846 we read of her impatiently sending for Schetky's drawings so that she might compare them with her own efforts.

After eighteen years at Addiscombe, Schetky retired in 1855. He and his family moved to London and from 1860 onwards his address was 11 Kent Terrace, Regent's Park. His maritime activities continued unabated, however. At the age of seventy-nine he was on board a yacht sailing round the Isle of Skye and was filling a sketchbook with notes. He died in London on 29th January 1874 following an attack of bronchitis. He was ninety-five.

Between the years 1805 and 1872 Schetky exhibited sixty-six works at the Royal Academy. Nearly all these were marines and most of them were either ship portraits or pictures of historic events—naval battles or royal occasions. Many of his oil paintings are somewhat pedestrian in composition and treatment; but as might be expected they show a professional approach to the subject: his ships are drawn with accuracy and sea conditions are carefully observed. *The Columbine with the Experimental Squadron off Lisbon* is a good example of his work and is full of light and movement. The *Loss of the Royal George* (pl. 90) is probably more typical: a lengthy subtitle to the picture explains the mass of detail with which he has recorded the notorious event. The painting was bought by Schetky's brother-in-law for £250 while it was still on the easel: 'Oh my dear wife,' Schetky wrote, 'why is there no post tomorrow that I might tell you in the shortest possible time that I have sold my half-finished picture of the Royal George for two hundred and fifty pounds!' Schetky was so determined to make the picture as perfect as possible that he persuaded Clarkson Stanfield to paint in the sky—another example of artistic collaboration.

In his watercolours Schetky demonstrates a lightness of touch and a delicacy that is often lacking in his oils. In his later years he made a speciality of pen and ink drawings. He used to employ a quill pen and his daughter recorded his method of working: 'By diluting some of the ink with water he produced various shades; and while the nib of his pen drew the outlines and rigging of his ships, the feather laid in the dark shadows and shaped clouds and waves. The effect thus produced proved very attractive.'[4] His fondness for brown ink earned him the nickname of 'Old Sepia' from his pupils at Addiscombe.

William John Huggins 1781–1845

The painting of ship portraits had its heyday in England during the nineteenth century and coincided with the boom in the shipping industry. William John Huggins was the best-known practitioner of the art during the 1820s and 1830s. His prolific output and the large number of his pictures which were published as aquatints were perhaps the main reasons for his fame, but he was also a skilful artist: his ships are accurately drawn and his best work is decorative and colourful.

In view of the popularity which he achieved in his lifetime it is curious that so little should be known about Huggins' early life. He was born in 1781 and we know that he spent some years at sea in the service of the East India Company. According to one source, 'During his voyage he made many drawings of ships and landscapes in China and elsewhere.'[5] When he was in his thirties, he retired from the sea and set himself up as an artist. He retained his links with the East India Company, however. He took a house in Leadenhall Street near East India House and he was regularly employed to paint pictures of the company's ships.

Huggins exhibited paintings at the Royal Academy and the British Institution, and was made marine painter to William IV in 1834. Among his royal commissions were three paintings of the Battle of Trafalgar which now hang in Hampton Court. His daughter married Edward Duncan, a talented watercolour artist and engraver, who engraved many of Huggins' marine paintings and sometimes acted as his assistant. The large oil painting *Indiamen in the China Seas* is signed by Huggins and Duncan. Huggins died in London in 1845.

Redgrave was a harsh critic of Huggins' work and considered that, 'His works are tame in design, skies bad in colour, seas thin and poor.'[6] Oliver Warner quotes Ruskin as saying that Huggins 'appeared to me to give no more idea of the look of a ship of the line going through the sea than might have been obtained by seeing one of the models floated in a fish-pond'.[7] Although he perhaps received more acclaim in his life than he deserved, it would not be fair to dismiss Huggins as a hack artist. He had a most individual style and his best work rises above the level of good craftsmanship.

Huggins' most characteristic paintings are his ship portraits of vessels in the service of the East India Company (pl. 87). These paintings invariably depict the ship broadside on, sailing in a fresh breeze, with a stretch of coastline in the distance. One must agree with Ruskin that the ships do sometimes have the appearance of toys, but with their colourful flags, bellying sails and the smart black and white hull markings, they make charming pictures. Huggins tended to use thin, clear colours and delighted in luminous blue skies, fluffy white clouds and turquoise seas. His waves were rendered in a curiously smooth manner, stylized in modelling, with white ripples trailed along the wave crests.

Huggins also painted other types of marine paintings and a good example is *First packet to Dublin: George IV on board* (pl. 91), which is in the National Maritime Museum. This again has a strongly decorative element, and the flat patterning of clouds, sails, funnels and hull shapes is entirely in the English tradition. Many other marine artists copied Huggins' style,[8] but they seldom achieved his fresh view of ships and the sea.

Joseph Walter 1783–1856

Joseph Walter was a talented artist living and working in the south-west of England during the early nineteenth century. Although the records of the Registrar's Office in Bristol describe him as 'Marine portrait painter' he painted a variety of subjects, most of them limited to the area of the Bristol Channel and the Avon.

He was born in 1783, but nothing is known of his background or artistic education. He lived at various addresses in Trinity Street, Bristol, and seems to have built up a considerable local reputation for himself. He was not entirely provincial because he did exhibit three pictures at the Royal Academy: *A sea-piece* in 1836, *Calm off port* in 1841 and *The fleet under Earl Howe in the armament of 1790* in 1847. He also showed two paintings at Suffolk Street. He died on 7 June 1856 and the *Bristol Gazette* recorded that he was 'much respected, especially in the parish of St Augustine, with which he was connected from his early boyhood'.

Joseph Walter's best paintings have an attractive, fluid style. The lively little picture *A brig entering the Bristol Avon* (pl. 92) is full of atmosphere and is painted in the predominantly grey palette which characterizes his work. It is one of three paintings by him at the National Maritime Museum. The others are *Shipping in the Bristol Channel*, which is well composed and dramatically lit, and a fine ship portrait, *West Indiaman Britannia*, showing the vessel in three positions. Bristol Art Gallery has ten of his paintings including the delightful *The Great Western off Portishead*, which is an unusually colourful picture for this artist.

Clarkson Stanfield 1793–1867

For most of his life Clarkson Stanfield was considered by his contemporaries to be the leading marine artist of the day. His background as a professional seaman gave an authenticity to his paintings of shipping; his affable manner and his friendship with the foremost writers and artists of his generation gave his patrons confidence and secured him many important commissions. In addition to this popularity he earned the praise of such widely differing critics as John Ruskin and Constable. Ruskin wrote at length about his marine pictures in *Modern Painters* and went so far as to say that 'one work of Stanfield alone presents us with as much concentrated knowledge of sea and sky, as diluted, would have lasted any one of the old masters his life'.[9] In a letter to Leslie written in 1832 Constable, in less effusive terms, said 'I have seen Stanfield and am much struck with him altogether as a sound fellow; he has great power.'[10]

In the tradition of earlier marine painters like Nicholas Pocock and Dominic Serres, Stanfield spent several years at sea before he showed his talent for painting. He was born at Sunderland on 3 December 1793 and was the son of James Field Stanfield, an Irish actor and author who had himself been at sea for a

time and served in a slave vessel. His experience of the slave trade had turned him into an ardent campaigner for its abolition and his son received his Christian name[11] as a tribute to Thomas Clarkson the great reformer and author of the *History of the abolition of the slave trade*.

At the age of twelve Stanfield was apprenticed to a heraldic painter in Edinburgh, but in 1808 he abandoned this career and joined the Merchant Navy. After several voyages he was pressed into the Royal Navy. In 1814, while serving on board HMS *Namur* he demonstrated his artistic talent for the first time by painting scenery for a play put on by the crew. Two years later he was injured by a fall and as a result he was retired from the Navy. He rejoined the Merchant Service, and his travels in the next two years included a visit to China. In 1818 he missed his ship through visiting his father and he decided to abandon his life at sea.

He was now aged twenty-five and secured himself a job as scene-painter at the old Royalty Theatre in Wellclose Square, Wapping. Around this time he also took up oil painting and by concentrating on pictures of ships he was able to use his specialized knowledge to good effect. He must have made rapid progress because in 1820 his drawings were included in a volume of engravings issued by George Cooke. Cooke advertised the volume as including 'drawings from the most eminent artists', and Callcott, Cotman, Cox, Prout and Crome were among their number.

After three years in London, Stanfield travelled to Scotland and took a job at the Edinburgh Pantheon under William Barrymore. David Roberts joined him there as a scene-painter and they began a friendship that was to last all their lives. After a short time in Edinburgh, Stanfield came south to London again and became a scene-painter at the Coburg Theatre—where he was rejoined by Roberts. In 1822 they moved together to Drury Lane and their stage sets soon acquired a considerable reputation.

However, his easel paintings were rapidly becoming more important to him than his scene painting, although the latter provided him with a good income. In the Victoria and Albert Museum there is an early painting by Stanfield entitled *On the Scheldt* (pl. 93). Although small in size it is an impressive picture, full of truthfully recorded detail and with a spirited rendering of sea and sky. It is easy to see how a painting like this would have appealed to the patrons of his day. There is none of the unfinished 'roughness' that they disliked in Constable's paintings or the somewhat overpowering rendering of natural effects typical of Turner's work.

In July 1824 he travelled to Paris with William Brockendon and it is possible that he met Bonington during this visit. He certainly became an admirer of his work because he not only bought three lots at the sale of Bonington's pictures following his death in 1828, but he also agreed to join Prout and two others to form a sort of committee to sell the remainder of his work on behalf of his family. On the death of George Chambers twelve years later, he made a similar gesture by completing an unfinished painting on Chambers' easel, for the benefit of his widow.

Meanwhile he was achieving official recognition for his work. In 1823 he exhibited at the Society of British Artists and in 1827 he exhibited at the Royal Academy for the first time. In 1831 he was elected an A.R.A. and in the same year

was commissioned by William IV to paint *Portsmouth Harbour* and the *Opening of New London Bridge*. By 1834 he had so many commissions for his easel paintings that he was able to give up scene-painting at Drury Lane—although he continued to paint sets for amateur occasions. Prominent among his friends now was Charles Dickens, and Stanfield frequently supplied scenery for Dickens' productions at Tavistock House. Later Dickens dedicated *Little Dorritt* to Stanfield. Much of the correspondence between the writer and the painter has been preserved. Dickens always began his letters 'My Dear Stanny' (David Roberts also called him by this nickname), and the letters, which are often composed in mocking nautical phrases, refer to their outings to Gravesend or appointments for tea or dinner up in Hampstead. In one of them Dickens says that he will not have the temerity to remind Stanfield that they agreed to meet at the Athenaeum on Monday, 'because none but a Mouldy Swab as never broke biscuit or lay out on the foc'sel yard arm in a gale of fair wind, ever forgot an appointment with a messmet'. In 1842 they made a tour of Cornwall, together with Maclise and Dickens' biographer Forster. There is a drawing by Stanfield in the Victoria and Albert Museum called *Logan Rock, Cornwall* in which the four of them are depicted. Many years later Dickens wrote an eloquent obituary in *All the year round* and referred to Stanfield as 'the soul of frankness, generosity and simplicity, the most loving and lovable of men'.[12]

In 1846 Stanfield exhibited a painting entitled *A Dutch Dogger carrying away her sprit* and usually referred to more simply as *On the Dogger Bank* (pl. 94). Although this is a small picture it is so powerful in its impact that the impression left in the mind's eye is of a six-foot canvas. It was well received by his fellow academicians and probably inspired one of Ruskin's most eloquent passages on Stanfield in *Modern Painters*:

'He will carry a mighty wave up against the sky and make its whole body dark and substantial against the distant light, using all the while nothing more than chaste and unexaggerated local colour to gain the relief. His surface is at once lustrous, transparent and accurate to a hair's-breadth in every curve; and he is entirely independent of dark skies, deep blues, driving spray, or any other means of concealing want of form or atoning for it.'[13]

Turner has always been credited with an unusually retentive visual memory, but Stanfield demonstrates in this painting that his own memory was equally astonishing. For whereas the painter of portraits or even of landscapes can return to his subject again and again and verify colour, tone and shape, the painter of a moving element like water is entirely dependent on his memory; even on a calm day the play of reflections on the water's surface can be baffling, but to record a moment in a storm at sea, particularly from as close quarters as Stanfield has taken this subject, demands an unusual degree of technical skill.

In 1847 he moved into a house in Hampstead called 'The Green-hill'. With his large family and his extensive circle of friends, the house must have been in a constant turmoil of activity. Regular visitors included Thackeray, Sir Edwin Landseer, Constable's biographer C.R.Leslie and of course Dickens and David Roberts. Meetings of the Sketching Society were also held in the house. His family did not tie him to his home, however, and although his travels were not so extensive as those of E.W.Cooke, he had paid a visit to Italy in 1839, and in 1851 he took his wife and daughters on a leisurely tour of southern France and

northern Spain. He received a number of foreign honours around this time, the most important being the award of a gold medal of the first class for three pictures which he sent to the Paris Exhibition of 1855. One of these pictures was *The Abandoned*, a dramatic presentation of a dismasted ship battered by stormy seas. Three years later he and David Roberts were made honorary members of the Scottish Academy, and travelled up to Edinburgh together to receive their diplomas. This honour from the city where he had begun work at the age of twelve and had later done a stint of scene-painting must have been particularly satisfying for him.

Stanfield died on 18 March 1867, aged seventy-four, and was buried in the Roman Catholic cemetery at Kensal Green. He was twice married and had twelve children in all, nine sons and three daughters. Only six of these survived but one of his sons, George Clarkson Stanfield, took up painting and achieved considerable success.

In spite of the popularity of his pictures, Stanfield's work was treated with a certain critical detachment by his contemporaries. The Redgraves, while admitting that 'He was a master of his art' pointed out that 'his art was too scenic and the influence of stage effects prevailed to the last'.[14] And Ruskin, who analysed his work with remarkable thoroughness, may have pointed out the weakness in Stanfield's painting when he wrote, 'We should like him to be less clever, and more affecting; less wonderful, and more terrible.'[15]

John Ward 1798–1849

John Ward was, in the best sense of the word, a local artist. He was born, lived and died in Hull and he painted the port and its shipping with a devoted attention to detail. He lacked the technical virtuosity which contact with London artists might have given him, but his best pictures have an unsophisticated charm and a sensitive use of colour.

He was born on 28 December 1798. His father was Captain Abraham Ward, the master of the brig *Nancy*. He was apprenticed to Thomas Meggitt, a house and ship painter, and in 1826 set himself up in the same trade. The following year he exhibited three pictures at the Hull and East Riding Institution Exhibition of Modern Art. The pictures, which were not offered for sale, were copies of paintings by William Anderson and were catalogued as such. The Scottish marine painter probably worked in Hull for a time and his pictures were popular additions to local art exhibitions. There is no record of Ward having met him, but it is generally assumed that he modelled his style on Anderson's work and among the effects which were sold after his death were three paintings by Anderson.

In 1838, Ward left the house and ship painting trade and set himself up as a marine artist and teacher. He inserted the following advertisement in the *Hull Advertiser*:

'John Ward, 23 North Street Charlotte Street, having arranged his DRAUGHTS and DRAWINGS OF SHIPPING, is desirous of giving INSTRUCTIONS in MARINE

DRAWINGS as applicable to MARINE PAINTING: and feels confident from his experience as a marine draughtsman, to impart such information as will ensure him the support of those anxious to obtain a knowledge thereof. Terms known on application, where specimens can be seen of PORTRAITS of vessels accurately DRAWN and PAINTED.'[16]

It is not known how successful his teaching practice became, but in the Hull Directory of 1839 he had added 'Marine Painter' to his trade description, and he still described himself as such in the 1848 Directory. He appears to have exhibited his paintings on only three occasions however. The first, as we have seen, was in 1827. The second occasion was in 1829 at the Second Exhibition of the Hull and East Riding Institution when six of his marine paintings were on show. The last occasion was in 1842 at the Art and Machinery Models Exhibition at Mechanics Institute where seventeen of his pictures were exhibited.

Some of Ward's work was engraved, and he himself issued sets of lithographs depicting naval and merchant vessels. He also published a book of lettering for sign-writers entitled 'The English Alphabet'.

In 1849 Hull was swept by a cholera epidemic which accounted for the lives of two thousand inhabitants. John Ward was one of the victims and he died on 28 September after a few hours' illness. The *Hull Advertiser* recorded that he was 'deeply lamented by a large circle of friends', and some years later referred to him as 'one of the first marine painters in the land'.[17]

The Ferens Art Gallery has a fine selection of Ward's work. *The return of the William Lee* (pl. 88) is perhaps his greatest achievement. The soft light, the long shadows on the calm, green water and the silent grandeur of the graceful ship approaching the harbour entrance make this a most haunting composition. Less poetic in treatment are two pictures which show in minute detail the shipping and riverside activities along the Humber: *The Forfarshire leaving Hull on her last voyage* and *Hull from the Humber c. 1837 with the pilot cutter Bee*. One of the most delightful features of all these pictures and very characteristic of Ward's style is the inclusion of groups of spectators or seamen leisurely rowing across the harbour in skiffs or aimlessly chatting. Another accomplished painting is the *P.S. Victoria off Hull* which is in the Collection of the Trustees of Trinity House.

Not all Ward's pictures were local views. He painted several pictures of whaling ships in the Arctic and the accuracy with which he depicted icebergs has given rise to the belief that he probably accompanied at least one whaling expedition to northern waters. Towards the end of his life he also travelled on the south and east coasts of England.

J.W. Carmichael 1800–1868

In his *Autobiographical Notes* W. Bell Scott tells how he once visited the studio of Carmichael and asked him why he always painted the same type of picture. Carmichael replied that 'ordinary people would only buy what they saw and enjoyed every day, or wanted to enjoy, the fresh sea, mid-day with blue streak

87 W. J. Huggins
The East Indiaman Atlas off Prince of Wales Island (Penang)
Oil on canvas, 32 × 48 in./81 × 122 cm. Signed and dated 1822
Private collection. Photo by courtesy of N. R. Omell

88 John Ward
The return of the William Lee
Oil on canvas, 24¼ × 36¼ in./62 × 92 cm.
Ferens Art Gallery, Kingston upon Hull. Photo by courtesy of the Medici Society Limited,
London

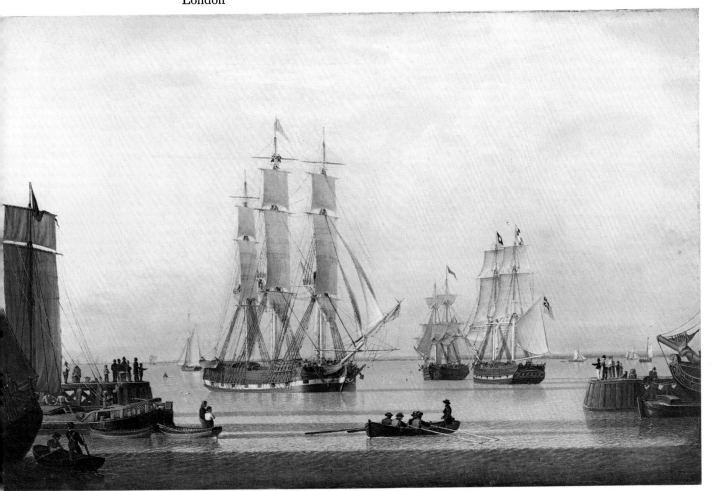

89　J. C. Schetky
　　Coastal colliers off Whitby, Yorkshire
　　Oil on copper panel, 10 × 14 in./ 25.5 × 35.5 cm. Signed and dated 1841
　　From the collection of Mr and Mrs F. B. Cockett, London

90　J. C. Schetky
　　Loss of the Royal George
　　Oil on canvas, 41½ × 71¼ in./105 × 182 cm. 1840
　　Tate Gallery, London

91 W. J. Huggins
First packet to Dublin:
George IV on board
Oil on canvas, 37 × 60 in./
94 × 152.5 cm.
National Maritime
Museum, London

92 Joseph Walter
A brig entering the Bristol Avon
Oil on canvas,
12 × 17½ in./
30.5 × 44.5 cm. Signed
and dated 1838
National Maritime
Museum, London

93 Clarkson Stanfield
On the Scheldt
Oil on panel, 32⅝ × 49 in./
83 × 24.5 cm. Signed and
dated 1821
Victoria and Albert
Museum, London

94 Clarkson Stanfield
On the Dogger Bank
Oil on canvas, 30 × 27½ in./76 × 70 cm. Signed and dated 1846
Victoria and Albert Museum, London

95 Clarkson Stanfield
Entrance to the Zuyder Zee, Texel Island
Oil on canvas, 39½ × 49½ in./100 × 125 cm. Exhibited Royal Academy 1844
Tate Gallery, London

96 Clarkson Stanfield
Sketch for the battle of Trafalgar, and the victory of Lord Nelson over the combined French and Spanish fleets, October 21, 1805
The action is shown at 2.30 p.m. The principal ships depicted are from left to right: *Royal Sovereign, Santa Anna, Temeraire, Redoubtable, Victory, Bucentaur* and *Santissima Trinidad*
Oil on wood, 15½ × 31½ in./39 × 80 cm. Painted 1833; sketch for large picture of 1836
Tate Gallery, London

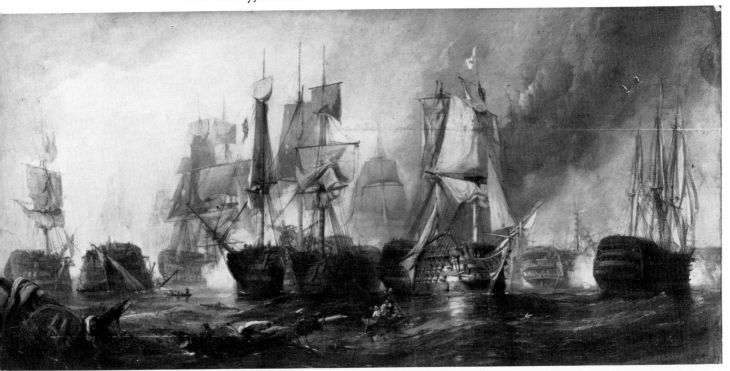

97 J. W. Carmichael
Hartlepool
Watercolour, 8¼ × 12¼ in./21 × 31 cm.
Laing Art Gallery and Museum, Newcastle upon Tyne

98 J. W. Carmichael
Coastal brigs and fishing vessels off the Bass Rock
Oil on canvas, 19½ × 29 in./49.5 × 73.5 cm. Signed and dated 1837
From the collection of Mr and Mrs F. B. Cockett, London

99 George Chambers
On the Thames
Watercolour, 8 × 11 in./20.5 × 28 cm. Signed and dated 1833
Victoria and Albert Museum, London

100 George Chambers
The Britannia entering Portsmouth
Oil on canvas, 22½ × 30½ in./57 × 77.5 cm. Signed and dated 1835
National Maritime Museum, London

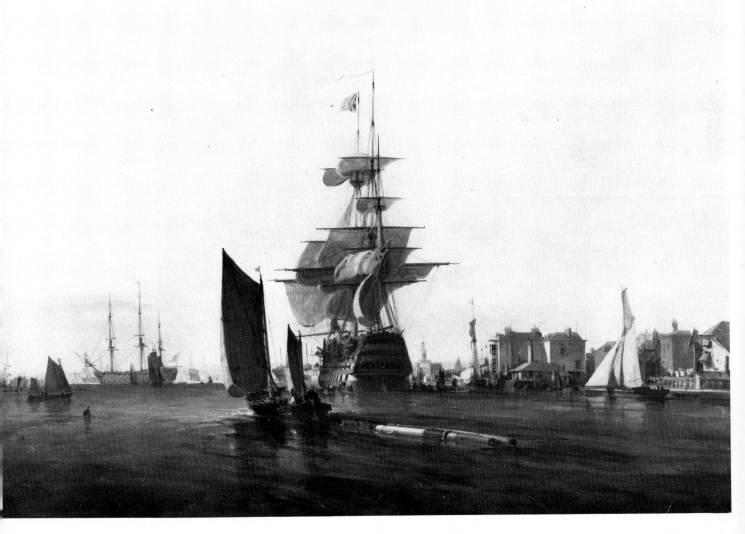

101 Edward Duncan
Greenwich from Blackwall
Pencil and sepia wash, 6 × 12 in./15 × 30.5 cm. Dated 1835
National Maritime Museum, London

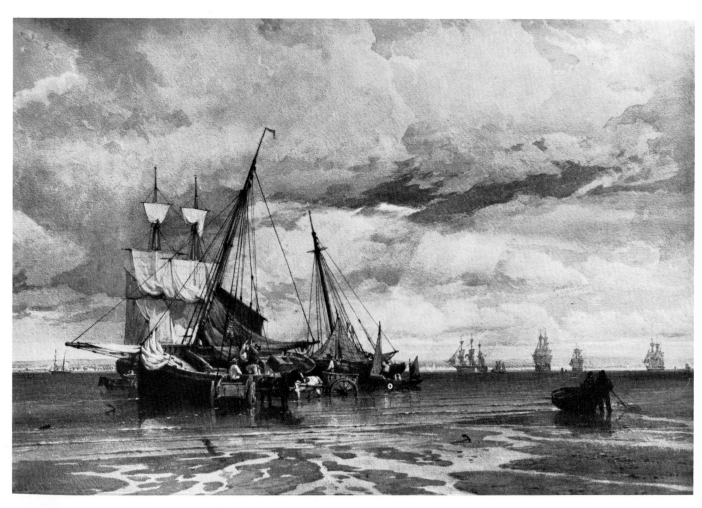

102 Edward Duncan
Spithead
Watercolour, 12¾ × 20¾ in./35 × 52.5 cm. Signed and dated 1855
Reproduced by permission of the Museum and Art Gallery, Birmingham

103 Samuel Walters
J. P. Smith, barque
Oil on canvas, 22½ × 35 in./57 × 89 cm.
National Maritime Museum, London

104 William Joy
Lifeboat going to a vessel in distress
Oil on canvas, 39¼ × 49¼ in./99.5 × 125 cm.
City of Norwich Museums

105 E. W. Cooke
Lugger & c. near the blockade station, Brighton
Etching, 7⅛ × 8⅝ in./18 × 22 cm. Signed with initials and dated May 1830
Art Gallery and Museums, Brighton

106 E. W. Cooke
The Ramsgate lifeboat and pilot boat going to the assistance of an East Indiaman foundering on the North Sand Head of the Goodwin Sands
Oil on canvas, 51 × 78 in./129.5 × 198 cm. Signed. Exhibited Royal Academy 1857
Private collection, USA. Photograph by courtesy of N. R. Omell

107 E. W. Cooke
Dutch boats in a calm
Oil on wood, 16½ × 27 in./
42 × 68 cm. Signed and
dated 1843
Tate Gallery, London

108 J. M. Whistler
Grey and silver: the angry sea
Oil on panel, 4⅞ × 8½ in./
12.5 × 22 cm. Butterfly
signature. 1880s
Smithsonian Institution
Freer Gallery of Art,
Washington D.C.

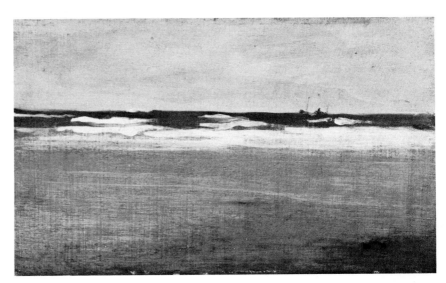

109 J. M. Whistler
Thames Police
One of the 'Thames Set'
which was published in 1871
Etching, 5⅞ × 8⅞ in./
15 × 22.5 cm. Signed and
dated 1859
National Maritime
Museum, London

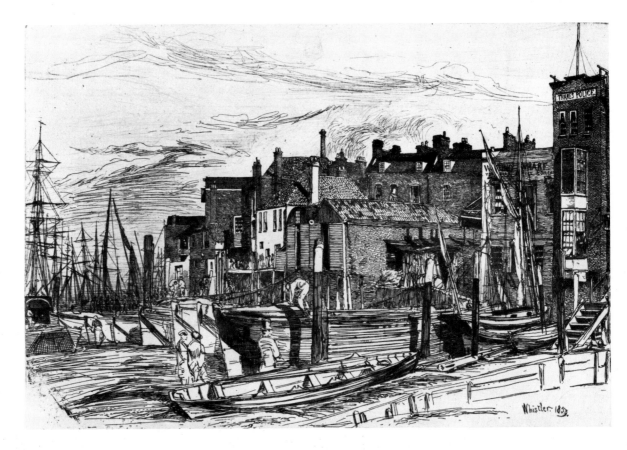

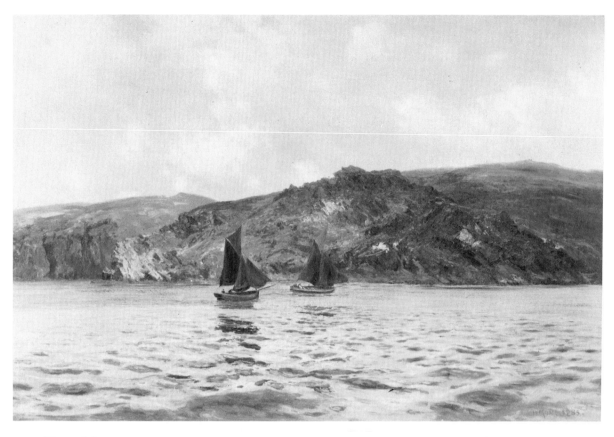

110 Henry Moore
 Catspaws off the land
 Oil on canvas, 35½ × 53½ in./90 × 136 cm. Signed and dated 1885
 Tate Gallery, London

111 Henry Moore
 Summer breeze in the Channel
 Oil on canvas, 23¾ × 39¾ in./ 60.5 × 101 cm. 1894
 Royal Academy of Arts, London

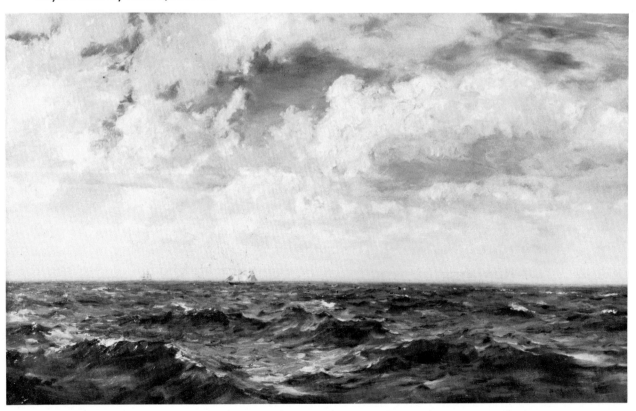

112 E. W. Cooke
Scheveling pinks running to anchor off Yarmouth
Oil on canvas, 35½ × 54 in./90 × 137 cm. Signed and dated 1864
Royal Academy of Arts, London

113 George Chambers
A Dutch boeier in a fresh breeze
Oil on canvas, 35 × 52 in./89 × 132 cm.
National Maritime Museum, London

114 William McTaggart
The emigrants
Oil on canvas, 37¼ × 55½ in./
94 × 141 cm. Signed. 1883-9
Tate Gallery, London

115 W. L. Wyllie
Toil, glitter, grime and wealth
on a flowing tide
The Thames below London
Bridge, with the Isle of Dogs
and Greenwich Hospital in the
distance
Oil on canvas, 44¾ × 65 in./
113 × 165 cm. Signed and
dated 1883
Tate Gallery, London

116 W. L. Wyllie
The Portsmouth fishing fleet
Oil on canvas, 24½ × 49½ in./
62 × 125.5 cm. Signed and
dated 1907
Royal Academy of Arts, London

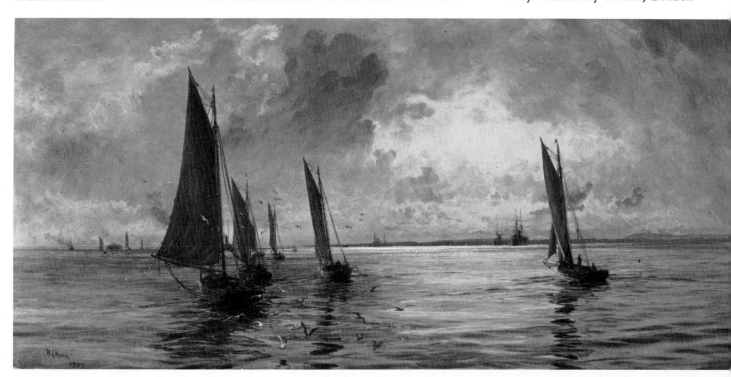

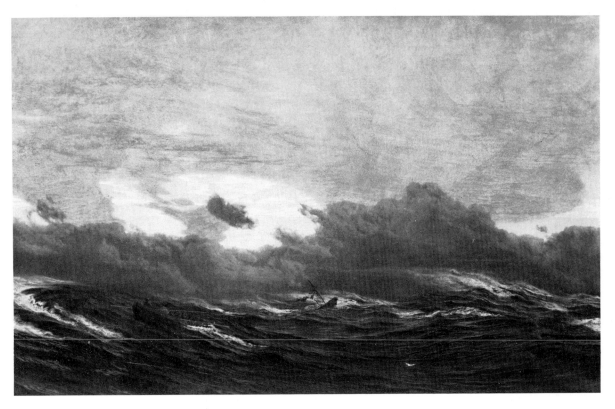

117 John Brett
The shipwreck
Oil on canvas, 60 × 96 in./152.5 × 244 cm.
Bournemouth Museums. Photograph by Harold Morris

118 Philip Wilson Steer
Three girls on a pier, Walberswick
Oil on canvas, 24 × 30 in./61 × 76 cm. Signed and dated 91.
Tate Gallery, London

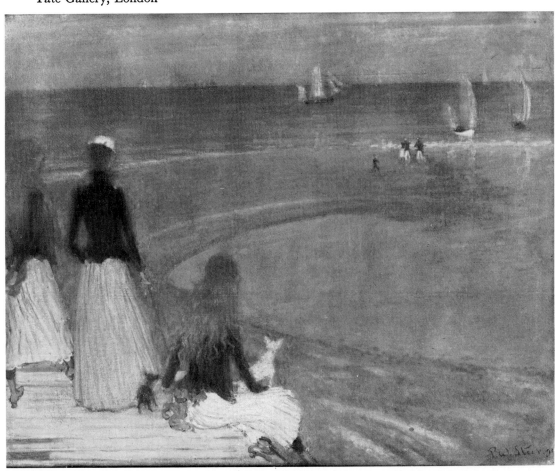

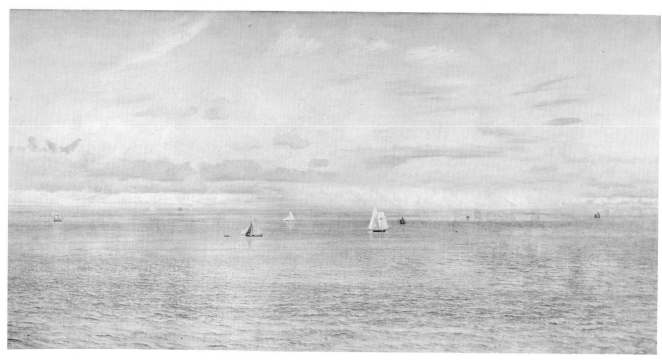

119 John Brett
Britannia's Realm
Oil on canvas, 41½ × 83½ in./105 × 211 cm. Signed and dated 1880
Tate Gallery, London

120 J. M. Whistler
Nocturne in black and gold: entrance to Southampton Water
Oil on canvas, 20 × 30 in./51 × 76 cm. *c.* 1872-4
Art Institute of Chicago

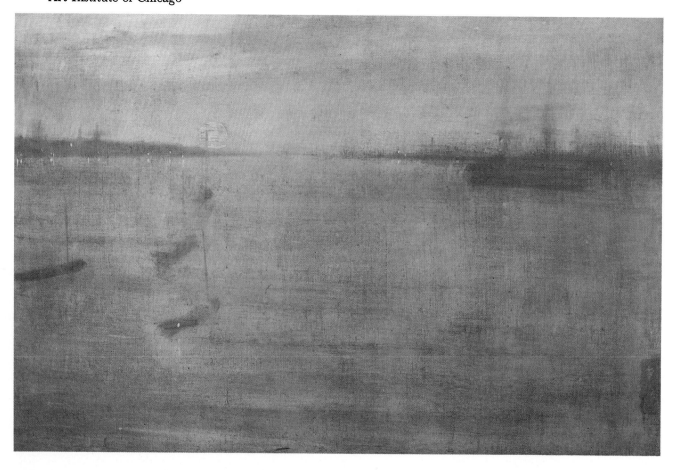

in the sky.'[18] Perhaps it was wise of Carmichael to concentrate on familiar subjects which he knew and which the public enjoyed, because he was at his best when portraying small craft sailing outside the mouth of a harbour, or two or three ships in a light breeze off a coast. When he attempted more ambitious subjects such as *Erebus and Terror off Victoria Land*, his work often lacked conviction.

John (or James) Wilson Carmichael was born in Newcastle upon Tyne on 8 January 1800, the son of a ship's carpenter. He was brought up near the Quayside and was himself apprenticed as a ship's carpenter. In 1823 he set up a studio in Newcastle and began to earn his living as a marine painter. He was a friend of Thomas Miles Richardson (1784–1848) and may have been his pupil for a time. In 1825 he exhibited two marine paintings at the Northumberland Institution, and gradually made a name for himself locally. In 1835 he exhibited at the Royal Academy. The picture, *Saving the crew of a wreck—scene, Scarborough Bay* was the first of twenty-one pictures which he exhibited at the Academy between 1835 and 1859.

He continued to live and work in Newcastle for several years—in 1828 he had established a studio next to the Northern Academy in Blackett Street, and it was not until around 1845 that he decided to move south and try his luck in London. He seems to have had no trouble in finding patrons, and soon after his arrival was commissioned to paint eight panels for the Duke of Devonshire. During the course of the Crimean War he spent three months with the fleet in the Baltic and made a series of pictures for the *Illustrated London News*. He was described by this journal in impressive terms in the issue of 2 June 1855:

'We have the satisfaction to announce that on Saturday last Mr. J.W. Carmichael, the celebrated marine-painter, formerly of Newcastle upon Tyne, sailed for the Baltic, to sketch the Events of the War for the ILLUSTRATED LONDON NEWS. The Sketches by this distinguished Artist, as they are received, will be engraved in our Journal, so as to present a Series of Illustrations of the coming Campaign in the Baltic.'[19]

Carmichael increased his fame by publishing two books. The first was entitled *The Art of Marine Painting in Watercolours* and was published in 1859, and he followed this up in 1865 with *The Art of Marine Painting in Oil-colours*. In 1862, following the death of his son, Carmichael and his family returned to the north of England and settled at Scarborough. There he died on 2 May 1868.

At his best, Carmichael demonstrated considerable powers as an artist. His work in both oils and watercolours showed an intimate knowledge of ships and he was expert at placing them in the water so that they seemed buoyant, and responsive to the movement of wind and waves. We see this clearly in his water-colour of *Hartlepool* (pl. 97) and in oil paintings such as *Sunderland* in the Sunderland Museum and *Kemp Town, Brighton, from the sea* which is in the Royal Pavilion at Brighton. His weakness was a lack of originality and a too obvious wish to please his clients. He frequently finished a picture in a day and seems to have had a no-nonsense approach to his art. He wrote in his diary 'I always find a pure thought of a picture fully carried out turns out better with me than making many alterations afterwards',[20] and hard work and honest craftmanship seems to have been the key to his success as a painter.

George Chambers 1803–1840

'Self-taught, relying upon himself, struggling with difficulties, he attained success.'[21] These words written by Redgrave in 1874 admirably sum up the course of George Chambers' life. Like Charles Brooking a century before him, his early years at sea appear to have permanently damaged his health and he died at the age of thirty-seven. But in a short working life, he emerged from a humble background, attracted the attention of influential patrons on the merits of his painting alone, and left behind him a remarkably high reputation among his fellow artists. Turner and Stanfield contributed to a fund for his widow, and Sydney Cooper wrote, 'Had he lived, I feel convinced that he would have become one of the greatest marine painters of his time, or indeed of any time.'[22] This claim goes too far, but there is certainly a case for considering him to be one of the finest marine painters of the Victorian period.

Chambers' miserable upbringing was typical of the poorer classes in England at the beginning of the nineteenth century. He was born at Whitby in 1803, and was the second son of a seaman. His mother let out lodgings. Their home was in a particularly squalid part of the town, and the parents were so poor that they could not afford to send George and his elder brother to school at the same time. They therefore took it in turns to attend school. When he was eight George's schooling ceased altogether and he was put to work on the coal sloops in the harbour; his job was to hold the coal sacks open while they were filled, for which he was paid two shillings a week. Two years later he was sent to sea in the Humber Keel *Experiment*, which was owned by his uncle.

At the age of twelve he was apprenticed to Captain Storr of the transport brig *Equity*. Being unusually small in stature Chambers was subjected to a good deal of bullying and his life appears to have been extremely harsh until it was discovered that he had a useful talent for decorating the ship's buckets and making sketches of passing vessels. The captain then began to boast of his artist cabin-boy and when his ship docked in London in 1820, he was persuaded by a fellow captain to set Chambers free from his apprenticeship. This was arranged, with the consent of the ship's owner.

Chambers was now seventeen. His education was minimal, his only trade was that of a seaman, which he had now abandoned, and he had a half-discovered talent for drawing. After working his way home to Whitby aboard a trading vessel, he took a job as a house and ship painter. He proved particularly expert at graining mantelpieces, carrying out lettering and marking whale boats. In his spare time he made small oil paintings for the captains of the ships engaged in the Greenland whale-fishery. After three years of this life he decided to return to London, and once again he worked his passage by boat, this time on board the *Valleyfield* with Captain Gray.

At the *Waterman's Arms* in Wapping, Chambers' life took a turn for the better. The owner of the pub was a certain Christopher Crawford who was usually to be found sitting in the bar smoking cigars and surrounded by parrots and other trophies supplied by passing seamen. He found a bed for the young artist and managed to secure him a few commissions.

Chambers was then engaged by Mr Horner, the proprietor of the Colosseum

in Regent's Park, to assist him in the painting of a panorama of London. This work took several years but when it was completed Chambers was able to take a job as scene-painter at the Pavilion Theatre.

Around 1830 Chambers began to emerge from obscurity. Admiral Capell saw his paintings in the window of a picture framer, sought him out and introduced him to two fellow admirals, Lord Mark Kerr and Admiral Mundy. They each commissioned paintings and also recommended him to their naval friends. Admiral Mundy was a critical patron and demanded the most exact portrayal of naval manœuvres, but Kerr was lavish in his praise: 'I am very much gratified by the painting you have done for me—it is full of genius. . . . The rain, the clouds, the light and shade are all executed in the most skilful manner.'[23] In September 1831 Kerr wrote to Chambers and asked him to send some paintings which he might submit to the King for his approval. William IV not only bought one of the paintings but summoned the artist to Windsor for an audience with Queen Adelaide and himself.

In 1832 Chambers returned to Whitby to stay with his relations for a while. It was on this visit that John Watkins first met him and began to gather material for the biography of the artist which he was to publish in 1841, a year after Chambers' death. Watkins became an ardent admirer and his writing is somewhat unbalanced by his constant praise of Chambers' merits, but the biography is nevertheless fascinating because it provides a first-hand account of the painter at work. They used to walk down to the pier together where Chambers would take out the small sketchbook which he always carried with him: 'I thought that a painter of his eminence would only take grand views', Watkins wrote, 'but he would stop and book an old buoy, a post, or a rock. He said these would all be of great service to him in the composition of a picture.'[24]

It is clear from the biography that Chambers was continually ill, and in 1833 he went on a tour of the south coast to seek recovery. He visited Lewes, Brighton and Shoreham. When he returned to London he took a cottage in Regent's Park 'which combined the advantage of a town residence with country air'. The address was 6 Park Village, West Albany Street. Watkins gives us a detailed description of how Chambers spent his working days in Regent's Park—a description which is worth quoting at some length:

'He painted in his drawing-room; but excepting the picture on the easel, there were no marks of its being a painting-room. His colours and brushes were kept in a mahogany case, designed by himself and having the appearance of a piece of drawing-room furniture. . . . He rose about eight, breakfasted, went into his painting-room, worked and received visitors while at work, dined late —for he wished to prolong his working hours until light failed—and when profitably engaged would disregard all calls to dinner. Tea followed shortly after dinner; and if he had had a successful day, but more commonly when unsuccessful, he would indulge himself in a visit to the theatre. His habits were very domestic. He loved to chat with his friends round his own fireside, smoking a cigar to a glass of white brandy.

'His method of painting a picture was first to chalk in the subject, then pencil it, washing out the chalk marks. He first rubbed in the sky, afterwards the more prominent parts of the picture, but not piece by piece—he generally had the whole of the picture equally advanced, for he could not finish bit by bit. His

method when at work was to paint a few strokes, then retire to see how they looked, return and rub them out with a cloth, or put in others, retire again and so on until he produced the effect which he saw in his "mind's eye". Sometimes he used his fingers and sometimes the stick end of his brush. His two boys drew in the same room while their father painted. His wife, like the dark-eyed Kate of Blake, cleaned his brushes for him and passed her opinion upon his performances.'[25]

Watkins tells us that Chambers usually had several pictures on the go at the same time and used to regret that he could not spend more time on each picture. 'He keenly felt his fate in being obliged to "paint for the pot" and yet he was a great advocate for submitting the feelings to the situation.'[26]

The only official recognition which Chambers ever achieved was for his water-colours. In 1834, he was able to write, 'I was last week elected an associate of the Old Water-Colour Society, which is almost as being a Royal Academician.'[27] He became a full member in the following year. The remaining five years of his life were uneventful and apart from his painting, were mainly taken up by travels to the coast in the hope that the changes of air would cure his ill health. He did make a couple of trips to Holland, however, and like all marine painters, found a variety of subjects for his pictures.

In the summer of 1840 he sailed to Madeira on the advice of his doctor, in the hope that the sun would cure his illness. He only stayed ten days on the island because he was no sooner there than he wished to return home to his family. Within weeks of his return he was even more seriously ill and he died at Brighton on 29 October 1840.

Chambers' work is well represented at the National Maritime Museum. *The Britannia entering Portsmouth* (pl. 100) is a peaceful harbour scene which illustrates his fluid brushwork: the building on the waterfront, the sheds, lines of washing and distant spires are suggested with a few deft strokes, and equally effective is the treatment of the calm water, ruffled only by the sprit-sailed ketch in the foreground. *The bombardment of Algiers* is a spirited reconstruction of one of Lord Exmouth's victories. One of his most successful paintings is *A Dutch boeier in a fresh breeze* (pl. 113), which depicts a small fishing craft splashing through choppy seas on one of those days when the sun shines fitfully through overcast skies.

Edward Duncan 1803–1882

Edward Duncan appears to have had no particular interest in the sea until he met William John Huggins. But around 1826 he began engraving Huggins' sea-pieces (he subsequently married Huggins' daughter, Bertha), and from this time onwards, marine subjects began to appear among his work. Although he was a skilful watercolour artist and acquired a considerable knowledge of ships, his pictures are essentially in the tradition of artists like Cox, De Wint and Prout who occasionally turned aside from landscapes to paint coastal scenes and ships

in harbours. However, Duncan made something of a name for himself in the marine sphere because he illustrated three titles in Vere Foster's series of practical painting books: *Simple Lessons on Marine Painting*, *British Landscape and Coast Scenery* and *Advanced Studies in Marine Painting*. The illustrations are pleasant enough and mostly depict coastal craft.

Duncan was born in Hampstead on 20 October 1803. He was apprenticed to Robert Havell and from him learnt the art of engraving in aquatint. For a time he was employed by Fores of Piccadilly, but he soon began to paint landscapes of his own. It seems that he was considerably influenced by the style of Robert Havell's brother, William. After his meeting with Huggins, Duncan increasingly devoted himself to pictures of ships and the sea. His experience of the sea, however, limited to a voyage across to Holland and travels around the English coast during the summer months. He was particularly fond of the Thames and it is clear from his notebooks that he spent much time on the river or drawing scenes along the banks. *Greenwich from Blackwall* (pl. 101) is a delightful pen and wash drawing which is typical of the sketches he made of this area.

In 1833 Duncan became a member of the New Society of Painters in Water Colour. From 1843 onwards he often supplied pictures for the *Illustrated London News*. These illustrations were nearly all of marine subjects and included dramatic portrayals of fishermen battling against heavy weather. Good examples are *Oyster dredging in Whitstable Bay*[28] and *Dutch boats riding out a gale off the Dogger Bank*.[29] Towards the end of his life Duncan made a single journey to Italy. He died in Hampstead on 11 April 1882. He left behind him a large collection of ship models and a collection of paintings by other artists including work by van de Velde, Copley Fielding, Chambers and E.W.Cooke.

Duncan's watercolours are not inspired but they demonstrate an accomplished technique and considerable powers of draughtsmanship. *Spithead* (pl. 102) is a fine example of his work in this medium. It is well composed and has something of Bonington's breadth of treatment. Duncan also worked in oils and there are several of his paintings in the Victoria and Albert Museum, and the National Maritime Museum.

William Joy 1803–1867
John Cantiloe Joy 1806–1866

Two members of the Norwich school who concentrated on marine painting were the brothers William Joy (1803–67) and John Cantiloe Joy (1806–66). William worked in both oils and watercolours and was fond of stormy scenes. John preferred more tranquil subjects and usually painted in watercolours. However they frequently worked together on the same painting and when they did so they simply signed themselves 'Joy', or left the work unsigned.

The brothers were brought up in Yarmouth. Their father was the guard on

the Ipswich Mail Coach. When they were still in their teens they were fortunate to find a friend in Captain Charles Manby who allowed them to use a room in the Royal Hospital, Yarmouth, as a studio, and encouraged them to copy the paintings in his collection. Manby had made his name establishing life-saving stations around the coast. (His apparatus for firing a rope by mortar was first used in 1808.) He was also a patron of the arts and owned work by Pocock, Powell and F.L.T.Francia.

From 1819 onwards, pictures by the Joy brothers appeared at the exhibitions of the Norwich Society of Artists and other local shows. William Joy later exhibited two paintings at the Royal Academy, first in 1824 and then in 1832. The second of these paintings was a good advertisement for his patron's invention. It was entitled *Forcing a boat from a flat beach in a heavy gale by the plan brought into use by Captain Manby for affording assistance at a distance from land with facility and certainty*. The Joys spent some period in their lives at Portsmouth where they were employed as Government draughtsmen. They then moved on to Chichester and later to London.

Although their work never approached the heights of the more famous names of the Norwich school, the Joys were nevertheless accomplished marine artists. Their drawing of ships shows a sound knowledge of hull construction and rig. The subject matter of their pictures would seem to indicate, however, that they had little experience of deep-sea sailing and made most of their studies from the beach or the quayside. The paintings of William Joy are usually full of movement and are vigorous in execution. *Lifeboat going to a vessel in distress* (pl. 104) is a good example. The fishermen on the shore in the foreground are a typical feature of his compositions.

The British Museum has a pair of watercolours by John Cantiloe Joy. One is a peaceful scene of boats at anchor and the other is a lively depiction of boats in a fresh breeze. There is a beautiful watercolour by him in the National Maritime Museum: *A two-decker furling sails*. It is signed 'J. Joy' and dated 1855. The best-known joint production of the brothers is *King George IV passing Great Ormesby, Yarmouth on his return from Edinburgh, 1822*, which is in the Victoria and Albert Museum.

Samuel Walters 1811–1882

Samuel Walters worked in Liverpool at a time when the British shipping industry was flourishing, and he painted many of the merchant vessels using the busy port. He was not an inspired artist but he carried out his commissions with sound craftsmanship and an expert knowledge of ships. No doubt the shipowners were delighted with the results.

He had an auspicious start for a marine painter. His grandfather was a boatbuilder in Devon; his father, Miles Walters, became a marine artist; and Samuel Walters himself was born at sea on 1 November 1811 on a coastal passage from Bideford to London. His father settled in Liverpool during the 1820s

and Samuel began by assisting him with the painting of ship portraits. In 1830, however, he exhibited a picture of his own, *Dutch boats in a fresh breeze*, at the Liverpool Academy Annual Exhibition, and from this date onwards he began to exhibit his own work regularly in Liverpool.

In 1835 Samuel Walters married, and he spent much of the next five years travelling round the coasts of England. In 1845 he decided to try his luck as an artist in London and he moved there with his family. The experiment was not a success, however, and after two years he moved back to Stanhope Street in Liverpool. He retained his links with London though, and exhibited fourteen pictures at the Royal Academy between 1842 and 1861. The subjects of these paintings included *Prussian brig in a light breeze*, *Hay barge on the Thames, near Gravesend* and *Scheveling Beach—low water*.

During the 1850s and 1860s Walters built up such a thriving practice in ship portraits that he was able to move out of Liverpool and take a house in Bootle—an area much favoured by the city's prosperous businessmen. In 1873 he had two houses built in Bootle and he occupied one of these, 76 Merton Road, with his large family. In rural surroundings, close to the river, he lived and painted for the rest of his days. He died on 5 March 1882 at the age of seventy. He named two of his sons after famous marine painters. His eldest son, George Stanfield Walters, followed in his footsteps and became a marine artist. After serving as his father's assistant for some years he moved to the south of England and exhibited regularly at the Royal Academy. His third son was named Samuel Vandervelde Walters.

Liverpool City Museum and the Walker Art Gallery have many examples of Walters' work. *The Port of Liverpool* in the Walker Art Gallery shows the sweep of the waterfront in meticulous detail but is more interesting as a historical record than as a work of art. The National Maritime Museum has some typical ship portraits by him. *J.P.Smith, barque* (pl. 103) is characteristic: attention is focused on the boat, her rig, and details such as the flags, the figurehead and the number of reef-points in the sails. In this painting as in most of his other ship portraits, the ship fills most of the canvas and is depicted in profile. The sea is portrayed in a conventional manner, and it would seem from Walters' ship portraits and those of artists like Huggins, that a choppy sea and a fresh breeze was the favourite setting for the vessels of the captains and shipowners who commissioned the paintings.

E.W.Cooke 1811–1880

Edward William Cooke was trained as an engraver and developed a meticulously accurate technique from an early age. His observation of sea conditions, of craft and of gear, was all-embracing and his work offers a wealth of information for the marine historian.

He was born on 27 March 1811 at Pentonville, the second son of George Cooke, a skilled engraver who numbered Callcott, Cotman and Stanfield among

his friends. Edward showed his gifts as a draughtsman at an early age and was given every encouragement by his father. At the age of nine he made drawings for Loudon's *Encyclopaedia of Plants* and helped his father in the preparation of plates for one of his publications—his job was to reduce the drawings and trace them on to the plates. At the age of fourteen he was making drawings of various subjects for Stanfield. And by the age of sixteen he was an accomplished draughtsman, as a drawing of Southwark Iron Bridge, dated August 1827, clearly shows. In addition to the help he must have received from his father's friends, it is recorded that he also studied perspective for a brief period under Augustus Pugin, and received some instruction in nautical matters from Captain Burton of the West Indiaman *Thetis*.

Cooke's early exercises culminated in the publication of 'Fifty Plates of Shipping and Craft'. Published in twelve instalments, the first four plates appeared on 1 March 1828. It is an amazing achievement for one so young, and yet we have the evidence of his diary, which he began in 1828, that he chose the subjects, made the drawings and engraved the plates himself. The engravings compare favourably with those of Cotman. Each scene is beautifully composed, and his command of areas of space is as impressive as the delicacy with which he suggests the texture of oak planks or the movement of waves (pl. 105). The subjects include every type of vessel from the tiny Peter Boats of the Thames to a Seventy-four on the Medway.

The similarity of Cooke's engraving technique to that of Cotman was in fact no coincidence, for the two families were friends of long standing. In October 1828, for instance, Cooke journeyed to Norwich and stayed with the Cotmans. He went round the city with Cotman's eldest son, Miles Edmund, and had tea with James Stark. Later in the holiday they took a sailing boat down the river to Thorpe, and Cooke briefly noted in his diary, 'Wind blowing very hard, two hours and a half coming back as we had to beat all the way, got home at 9.'[30] While in Norfolk he made a number of drawings including some sketches of cobles on the beach near Yarmouth.

A diary entry on 27 December underlines the extent to which the young artist was mixing with other painters: 'Went with Father and Mr Cotman to Town, first to Crosby Hall, then took Brixton coach and called on Prout, saw glorious sketches, returned to Mr Cox's, saw more beautiful drawings, then to Mr. Hixon's where Father bought two beautiful drawings by Cox. Next called at Roberts's in Abingdon Street, Westminster and had another treat of Works of Art and after calling on Stanfield, (who was out) returned home about 11 p.m.'

In 1829 the Cooke family moved to Barnes, and Edward devoted a lot of time to sketching on the Thames, seeking subjects for 'Shipping and Craft' the last four plates of which were published in December.

Cooke took up oil painting in 1834, and recorded, 'On the sixth February went to Mr. Stark's (Chelsea) and he gave me my first lesson in painting (on a small coast scene) in evening bought colours & etc., and the next morning commenced my career with the brush upon two little subjects.' From now on painting was to be his livelihood, and following the death of his father he travelled widely in search of marine subjects. Of the many countries he visited, the most significant was Holland. Its boats and its shores furnished him with

innumerable subjects for pictures and he visited the country sixteen times altogether. The shore at Scheveningen particularly impressed him, and during the course of a visit in 1837 he wrote, 'Heavy sea on beach, eighty boats hanging by their anchors, just afloat, having come in, in consequence of the brisk breeze during the night. . . . The beach in a tremendous bustle all day, the fleet of herring boats going off, it blew half a gale from the S.W. and the flood tide rolled in very heavily. At 4 o'clock the whole 45 boats got clear away and stood to the Nor'ad.'[31] The large painting in the National Maritime Museum, *Beaching a pink, Scheveningen*, depicts one of the scenes he witnessed. It is a dramatic work and indicates that he experienced no difficulty in turning from engraving to the medium of oil paint. Particularly effective is his rendering of the short, steep waves so characteristic of shallow water, and the flicks of spray whipped off the surface by the on-shore wind. It is interesting to compare this picture with Turner's *Fishermen on a lee shore* (pl. 64). Cooke had, incidentally, been given a painting by Turner for his twenty-first birthday.

In 1840 Cooke married Jane Loddige. He had known her for many years because her father, who was a nurseryman, had commissioned Edward to illustrate *The Botanical Cabinet* when the two families were neighbours at Hackney. The couple went abroad for their honeymoon. They travelled through Belgium and Germany and returned via Paris. The marriage, a happy one, was sadly cut short when Jane died in childbirth in 1844.

In 1851 Cooke helped in the arrangement of exhibits for the Great Exhibition, and in the same year he was elected an A.R.A. His paintings were fetching good prices and in 1854 he took a house in fashionable Hyde Park Gate.

In 1856 Cooke was at Yarmouth where he made sketches of the wreck of an East Indiaman on the beach. The scene appears to have inspired him to gather material for a large shipwreck painting. The result was *The Ramsgate life-boat going to the rescue of an East Indiaman* (pl. 106), a dramatic presentation of an actual historical event. It was exhibited at the Royal Academy in 1857, and was highly praised by John Ruskin.

Cooke was elected R.A. in the year 1864 and for his Diploma work painted *Scheveling pinks running to anchor off Yarmouth* (pl. 112). This vigorous painting is typical of many of his marine paintings and places him firmly in the tradition started in England by the younger van de Velde and continued by Scott, Brooking and Pocock. In contrast to Turner's sea paintings in which dramatic effects of sea and sky dominate the shipping, Cooke has made the Dutch boat the focal point of the composition and has lovingly delineated every detail of rigging and fishing gear. The brig on the horizon and the distant glimpses of buildings on the shore are also traditional features in seascapes and appear in the pictures of such widely differing artists as Cotman and Stanfield. A comparison of Cooke's painting with van de Velde's *A small Dutch vessel close-hauled in a strong breeze* (pl. 1) shows how little this branch of painting had changed in two hundred years.

By 1868 Cooke was sufficiently affluent to commission Norman Shaw to design him a new home, at Groombridge, Kent, where he entertained a host of distinguished friends. His travels abroad continued, however, and we know that he was in Egypt in 1873. His last years were spent at his home where he devoted his time to painting and pursuing his other life-long interests in archaeology and botany. He died on 4 January 1880.

John Brett 1830–1902

A few days after the death of John Brett at his home in Putney, a lengthy obituary appeared in *The Times*. Although it is couched in the polite tones expected from such obituaries, it nevertheless provides a sensitive appraisal of the artist's work. The writer recalled how several of Brett's studies of sea and rocks were to be found on the walls of Burlington House every year and mentioned that his favourite haunts were Cornwall and the Channel Islands: 'Wherever he could find calm seas and sunny skies and seaweedy rocks and cliffs sloping to the strand, there he was content to pitch his easel and to produce the vivid, luminous renderings of such scenes which gained him so many admirers.'[32]

The obituary mentions the strong influence of the Pre-Raphaelite Brotherhood on Brett's work, and makes the point that he continued to paint with elaborate fidelity to nature long after his early enthusiasm for the movement had died away. Indeed Brett seems to have been a man of unusual fixity of purpose. Although he had many interests (his home was full of scientific instruments and mechanical gadgets) he devoted most of his energy in the latter half of his life to recording various aspects of the sea and the sea shore with an exactitude which has seldom been achieved before or since. His approach seems to have been scientific rather than artistic and it is not surprising to learn that he used photography as an aid to his work. Nevertheless, as F.Gordon Roe has pointed out, both Brett and Henry Moore 'occupy a very significant position in the history of British marine painting' because they showed that 'the sea itself could be the be-all and end-all of thematic necessity'.[33]

John Brett was born in 1830 at Bletchingley, Surrey, the son of an army captain. He entered the Royal Academy Schools in 1853, and soon came under the influence of the Pre-Raphaelites. In 1858 he sent *The stonebreaker* to the Royal Academy. The painting was acclaimed by John Ruskin. The following year Brett travelled in Italy with Ruskin, and as a result of the tour exhibited at the Royal Academy the *Val d'Aosta*, which repeated the brilliant and detailed observation of nature which characterized the earlier work. Ruskin was again extravagant in his praise, and wrote, 'Here for the first time in history we have, by help of art, the power of visiting a place, reasoning about it, and knowing it, just as if we were there.'[34] Encouraged by Ruskin, Brett developed a passionate interest in botany and geology.

Around 1870 Brett turned to the sea as a source of inspiration for his paintings. *From the Dorsetshire cliffs* (in the Tate Gallery) was painted in 1871 and is typical of one type of painting which made his name. The canvas is three and a half feet high and seven feet long and depicts a vast expanse of calm sea, viewed from a height. Four or five tiny ships can just be made out in the distance but the main interest is the sky and the sea and the pattern of sunlight across the surface of the water.

As might be expected from his paintings, Brett was thorough in his method of working. We know that he had a yacht of his own and that he spent most of the summer months sailing in the Channel and elsewhere looking for suitable subjects. In 1886 he exhibited in the rooms of the Fine Art Society 'an average

summer's work out of doors'. The exhibition consisted of forty-six sketches and three small pictures which had been painted between the months of June and September. Brett wrote an introduction to the exhibition catalogue in which he explained his approach to his work in scientific and philosophical terms. It would appear that, 'He believed in sketching only for its use to fix certain scenes on the mind, and considered a sketch to be useless if the picture could not be afterwards produced by the aid of the memory alone.'

However, it seems that Brett did not rely solely on his memory because there is a fascinating entry in Beatrix Potter's diary for 9 February 1884 which tells how he went 'sailing about the West Coast of Scotland in his sailing yacht in the summer, making oil sketches which he uses for the colour in his pictures which he paints in the winter months chiefly from memory, though also assisted by photographs, for he is a successful photographer'.[35]

In 1880 Brett exhibited his most celebrated open-sea painting, *Britannia's Realm* (pl. 119), at the Royal Academy and in the same year it was bought for the Tate Gallery (under the terms of the Chantrey bequest). The following year he was elected an A.R.A. In spite of the championship of Ruskin and the popularity of his work he was never made a full Royal Academician, however.

In addition to his painting, Brett continued to pursue his scientific interests— he resembled E.W. Cooke in this respect. In 1871 he was elected a fellow of the Royal Astronomical Society, and when he had a house built for himself in Keswick Road, Putney, it was designed to accommodate an observatory as well as a studio. Brett died in January 1902.

Broadly speaking, Brett's marine paintings fall into two categories: pictures of rocky seashores, and pictures of the open sea. A good example of the former type is *Echoes of a far-off storm* which is in the Guildhall Art Gallery. The rocks and the ripples in the sand are depicted with his usual accuracy and although there are no people to be seen (they rarely appear in his marines) he has enlivened the middle distance by a group of plover. *Britannia's Realm* is a fine example of the second category and in its single-minded attention to the open sea it must, like *From the Dorsetshire cliffs*, be considered something of a *tour de force*. Looking at it one understands the significance of Ruskin's remark about Brett giving us the power of visiting a place, 'and knowing it, just as if we were there'.

Not all Brett's open sea paintings were of calm scenes. *North-west gale off the Longships* in Birmingham Art Gallery portrays a desolate stretch of rough water with an ominous group of rocks surmounted by a lighthouse in the distance. And in Bournemouth Museum is the very large painting entitled *The shipwreck* (pl. 117) which depicts a tiny rowing boat, a wreck and a surging mass of huge waves.

It has frequently been said that Brett cared more for scientific truth in his pictures than for the creation of beauty, and of course there is more to a work of art than the exact observation of every ripple and every pebble. But I believe that he had a personal vision of the sea. His close observation of cloud forms and the light on the waves are in the same tradition as Constable's scientific observations of nature, and the brilliant blues and greens of his paintings and his panoramic view of the sea are something of a revelation.

Henry Moore 1831–1895

It is usual to link Henry Moore with John Brett. They were born within a few months of each other and both spent most of their working lives painting pictures of the open sea. But despite their similarity of subject matter the style of their work was very different. It is true that Moore was, like Brett, influenced by the Pre-Raphaelites and many of his early works share their detailed exactitude, but his mature work is much closer in character to the marine paintings of McTaggart or Whistler. Indeed his best work has more in common with the marine paintings of Monet and Boudin than with the other marine artists working in England at the time. This is confirmed by the enthusiasm with which his seascapes were received in France. When his work was first shown in Paris, French critics coined the phrase 'la note bleue de Moore', and at the Paris Exposition Universelle of 1889 he received the Grand Prix and was later decorated with the cross of the Legion of Honour.

Moore came from a family of painters. His father was a portrait painter and four of his brothers, Albert, Edwin, John and William, became artists. Henry was born at York on 7 March 1831. At the age of twenty he entered the York School of Design. In 1853 he came south to London and went to stay with his brother John in Newman Street. The same year he exhibited his first picture, a landscape, at the Royal Academy, and in December 1853 he joined the Royal Academy Schools. However he seems to have had little use for the teaching because after a few sessions he ceased to attend. He spent the next few years travelling, around Britain and on the Continent.

It is often stated that Moore began painting the sea in 1857 but this is not strictly true. He painted his first sea-piece before he was in his teens and the pictures he painted on family holidays to the Yorkshire coast inspired his father to say to him, 'Whatever else you paint, you must paint the sea.'[36] However the fact remains that the fourteen pictures which he exhibited at the Royal Academy between 1853 and 1858 were all landscapes and it was a visit to Clovelly in 1857 which really seems to have set him on the path which he was to follow for the rest of his life. On 16 May 1857 he wrote in his diary 'There is one thing respecting the sea I never saw truly given in a painting—viz, its size and extent as seen from high cliffs—it is truly wonderful.'[37]

He now began to exhibit marine paintings at the Royal Academy, the British Institution and the Society of British Artists. An early landmark was *Winter gale in the Channel* which was shown at the Royal Academy in 1872. He had spent five hours on the beach at Hastings during a storm making a study for this painting. The surging movement of the waves is wonderfully portrayed, while the lowering clouds and the salty atmosphere recall Constable's oil sketches of similar scenes on the beaches at Brighton and Hove.

In 1873 Moore was invited to watch a naval review at Spithead aboard the yacht of Mr Burnett. From this date onwards they frequently went cruising together and Moore was able to study the sea from the deck of a boat instead of from the shore. Mr Burnett's yacht *Dawn* was an eighty-ton yawl (he later exchanged her for a smaller cutter) and their cruises, which usually lasted from two to six weeks during the summer months, covered the length of the Channel

from Dover to Cornwall and included the Channel Islands. Moore also cruised aboard the hundred-ton schooner owned by Mr Gossage of Liverpool, and in this vessel he sailed along the Irish coast and the west coast of Scotland.

During the winter of 1873–4, Moore travelled to Egypt and was able to make some memorable studies of the Mediterranean on the voyage across. The ship ran into a storm off Alexandria and he took the opportunity to make a study for the painting *Rough seas: Mediterranean* which was subsequently exhibited at the Royal Academy and praised by Lord Leighton. We are fortunate in having a description of the manner in which Moore made his study:

'The canvas and chair were secured to the rail of the bridge, where Moore, with the captain's sanction, went to obtain a clear view; and there a "weather-cloth" was also erected, behind which the artist and his friend (who held the box of colours) ducked whenever a very heavy shower of spray swept over the vessel. In this somewhat perilous eyrie Moore painted with all his might.'[38]

By 1870 Moore had virtually abandoned landscapes and his paintings concentrated on the sea and sky in differing weather conditions. Human beings were usually eliminated from the composition and if a ship was introduced it merely served to give a sense of scale and emphasized the vastness of the ocean. His regular cruises in his friends' yachts provided him with an endless variety of subjects and while on board he painted and sketched at a feverish pace: 'on one memorable cruise lasting about a month, he executed no fewer than fourteen oil studies and forty or fifty in pencil or water-colour'.[39]

Catspaws off the land (pl. 110) in the Tate Gallery is a fine example of one of the paintings resulting from these cruises. While sailing off Fowey in Cornwall during July 1883, the *Dawn* was overtaken by two of the local fishing craft, and Moore made a study of them from the deck. The painting was exhibited in 1885 and bought for the nation under the terms of the Chantrey Bequest. The price paid was £350. In the same year Moore exhibited *The Newhaven packet*. This lively painting with its vigorous brushwork and breezy atmosphere is now in Birmingham Art Gallery.

In 1893 he was elected a full Academician and his diploma picture *A summer breeze in the Channel* (pl. 111) was one of his most characteristic paintings. In spite of failing health he went on a short cruise in July 1894 with his daughter and his friend Mr Gossage. They sailed in the lower Clyde and explored many of the lochs. The next summer he was down in Margate with his brother, Robert, and there he died on 22 June at the age of sixty-three.

Unlike John Brett who retained a passion for painting every wave and ripple with faithful realism, Moore developed a fluid style with open brushwork and an obvious delight in the medium of oil paint. The habit of detailed observation which he had developed in the days when he was under the Pre-Raphaelite influence remained with him, but as Martin Hardie observed, he was able to adjust 'his earlier analytical habit and love of minuteness to a wider and more persuasive conception of atmospheric conditions'.[40] He was a fine colourist and was equally adept at suggesting the vibrant blues and greens of summer and at portraying the steely grey tones of winter.

James McNeill Whistler 1834–1903

Whistler did not settle in England until he was twenty-five. He was born in Lowell, Massachusetts, on 10 July 1834 and was educated at West Point Military Academy, and then in Paris where he attended the Ecole Imperiale et Spéciale de Dessin and the Académie Gleyre. He took up residence in London in 1859 and rapidly established himself in the artistic life of the city. Pictures of marine subjects were of course only a small part of his work, but he brought an entirely fresh approach to the depiction of the sea and the rendering of reflections on calm waters. Although his work was frequently castigated he was to have a considerable influence on later generations of English marine painters.

Whistler was evidently attracted to the Thames from the moment he arrived, because he immediately set to work on a series of sixteen etchings depicting scenes along the river. An impression of the 'Thames Set', as it was called, was exhibited at the Royal Academy in 1860. The engravings are remarkable for their bold command of space as well as for their beautifully observed detail (pl. 109). They provide a fascinating record of the wharves and shipping of mid-nineteenth-century London, and it is interesting to compare them with earlier pictures of the river—notably the engravings of Wenceslaus Hollar in the seventeenth century and the paintings of Canaletto and John Cleveley the Elder in the eighteenth century.

For much of his life in England Whistler lived in Chelsea, and during the 1860s and 1870s his home was in Lindsey Row (now Cheyne Walk) overlooking the Thames. His neighbours included the brothers Walter and Harry Greaves who belonged to a family of boatbuilders. Walter Greaves was also an amateur painter and soon became an admirer and earnest student of Whistler. He told Joseph and Elizabeth Pennell (Whistler's biographers), 'We taught him to row and he taught us to paint', and he described how they used to get up at five o'clock in the morning and row as far as Putney.[41] Sometimes Whistler would stay out on the river all night when he was seeking inspiration for his moonlight subjects.

Greaves also mentioned that his father used to row Turner up and down the river during the later years of the artist's life when he was living at Chelsea with Mrs Booth. Curiously enough Whistler always despised Turner (who had died only nine years before Whistler's arrival in London) and he made several contemptuous remarks about his work.

Though London remained his home, Whistler did a considerable amount of travelling during the 1860s. He paid a number of visits to the coast and paintings of the sea appear with increasing frequency among his other work. In September 1861 he went to Brittany where he painted *Coast of Brittany*. Its detailed realism is very different from the suggestive treatment of his later seascapes. The following autumn he was at Guéthary overlooking the Bay of Biscay. Here he painted *The blue wave: Biarritz*. In 1865 he went to stay in Trouville where his friend Courbet was living. *Grey and green: the silver sea* and *Harmony in blue and silver: Trouville* were among several attractive seascapes painted during his two month stay. In February 1866 he set off for South America and spent some nine

months in Chile. The Pacific Coast provided him with subjects for several pictures of the sea with shipping. One of these, *Crepuscule in flesh colour and green: Valparaiso* is in the Tate Gallery. Another, *Symphony in grey and green: the ocean* is in the Frick Collection, and is one of the most beautiful of all his seascapes.

During the course of the 1870s Whistler painted the majority of his famous 'Nocturnes'. The subjects of this series of night scenes varied from firework displays to Chelsea streets under snow. There were also numerous studies of the Thames and a few pictures of coastal waters. Walter Greaves provided the Pennells with valuable information about Whistler's method of painting these pictures. From them we learn that the pictures were invariably painted from memory; but although they sometimes seem to have been dashed off in a matter of hours, they were the result of much painstaking preparation. Whistler considered that any appearance of labour was a mark of failure and he would destroy his efforts if he was not satisfied. 'No one knew the hard work that produced the simplicity,'[42] wrote the Pennells.

Working with very liquid paint and frequently using a wide house-painter's brush, he achieved some astonishing results. His rendering of colour and tone is so accurate that an apparently flat area of blue-green canvas can convey the appearance of a calm expanse of water stretching to the horizon and merging into the night sky, as in *Nocturne: the Solent*. In the *Nocturne in black and gold: entrance to Southampton Water* (pl. 120) he suggests the insubstantial forms of ships and small craft with a few smudged brush strokes, and with the most subtle changes of tone gives slight movement to the surface of the water in the foreground. Reflections and distant lights are always conveyed with masterly assurance and never more so than in his paintings of the river along Battersea Reach. *Nocturne in blue and green: Chelsea* is a good example of this beautiful series which captures the river in so many moods.

In 1879, following his libel action against Ruskin and his subsequent bankruptcy, Whistler retreated to Venice. He stayed there fourteen months and spent much of his time working on pastel drawings and on etchings. When he returned to London, the Fine Art Society published twelve of the forty or so etchings which he carried out, and they became known as 'The First Venice Set'. They helped to confirm his reputation as one of the great masters of etchings. He also painted a few magnificent canvases including the *Nocturne in blue and gold: the lagoon, Venice.*

In 1883 Whistler paid another visit to the sea shore, this time to Cornwall. From St Ives he wrote to Godwin: 'The country you know never lasts me long and if it had not been for the sea I should have been back before now.'[43] It was possibly around this time that he began a series of small oil sketches, most of them painted in the open air. They include landscapes, some street scenes and a brilliant series of seascapes. Sickert, who was a close friend of Whistler, believed that these small pictures expressed the essence of his talent:

'He will give you in a space nine inches by four,' he wrote, 'an angry sea, piled up and running in as no painter ever did before. The extraordinary beauty and truth of the relative colours, and the exquisite precision of the spaces, have compelled infinity and movement into an architectural formula of eternal beauty.'[44] Many of these sketches, such as *Green and gold: the great sea* and *Grey*

175

and silver: the angry sea (pl. 108) are in the Freer Gallery in Washington. Their sparkling brilliance inevitably recalls the Brighton Beach oil sketches of Constable. They convey the atmosphere of the sea shore with the same assurance and economy of means, and were also painted in the open air on panels.

Whistler's feeling for the sea is one of the most attractive sides of his character and is in marked contrast to the image which he presented to the world. The gallery-going public knew him for his portraits and figure studies, for his controversial writings and his eloquent comments on the art of his day. A caricature by Spy published in *Vanity Fair* depicted him in a swaggering pose, elegantly attired in frock coat and wide-brimmed hat, with a monocle in his eye and a cane in his hand. How different from this picture was the Whistler who spent so much of his time on lonely beaches recording the distant waves. His visits to the sea continued up to the end of his life. In 1899 he spent the summer at Pourville, and in 1900 he took a cottage on a remote strip of land overlooking Dublin Bay. Here he painted one of his last seascapes, an evocative sketch entitled *Grey and gold: the Golden Bay, Ireland*. He died three years later in Chelsea, on 17 July 1903.

William McTaggart 1835–1910

Obviously McTaggart should not be included in a book on marine art in England. He was of Highland origin, he was born in a croft at Aros, near Machrihanish on the west coast of Scotland, he received his artistic education at the Trustees Academy in Edinburgh, and he spent all his life painting the scenery of his home land. But Scottish readers will appreciate that it was impossible to exclude an artist who painted some of the most original and beautiful seascapes in the history of marine art. As so often with late-nineteenth century paintings, black and white reproductions can give little idea of the effect of McTaggart's canvases on the spectator. Anyone who has stood in front of his paintings in the National Gallery in Edinburgh will remember the brilliance of their colour and the swirling vigour of the brushwork.

William McTaggart was born on 25 October 1835 and was brought up within sight and sound of the Atlantic. It was not until around 1870, however, that he began to concentrate on pictures of fishermen and the sea. His early paintings were landscape and genre subjects and were in a meticulous Pre-Raphaelite style, very different from his later work. According to J.L.Caw it was in his watercolours that McTaggart first began to break away from precise realism and acquire 'the sparkle and flicker of light, the purity and brilliance of colour, and the dancing and rhythmical motion, which mark all the work of his prime'.[45] His watercolours were usually painted on a rough surface Whatman paper. Transparent washes were laid on with a fully loaded brush and the texture of the paper provided white highlights. McTaggart often painted a picture with a single large brush, and worked in a direct manner allowing no time for second thoughts.

Around 1870 McTaggart spent the first of many summers at Tarbert on Loch Fyne. Here and also by the sea at Machrihanish, Carradale and Carnoustie he found the inspiration for a wonderful series of coast scenes and seascapes. *Young fishers*, a tranquil scene painted in 1875, depicts three boys trailing lines over the side of a rowing boat. The shimmering water and the light reflected off the surface on to the boys' faces is wonderfully portrayed. Gradually McTaggart's style acquired a looser brushwork and his forms began to dissolve into fragments of vibrant colour. The subject matter of his pictures always retained a warm humanity, however, and he never abandoned himself to the empty vistas of sea favoured by Henry Moore and John Brett. Children nearly always appeared in his beach scenes. We see them in the foreground of *The emigrants* (pl. 114) for instance. On the right of this picture are the characteristic double-ended open boats of the Scottish coast, with their masts sharply raked aft. On the distant blue sea a ship is anchored, waiting to take the emigrants away.

In 1890 McTaggart painted one of his most powerful marine paintings, *The storm*, depicting foaming green seas breaking on a beach beneath a dark blue-grey sky. With a swift lightness of touch he conjured up a wild, windy day. As always, he included a group of women and children standing among the heather and gorse on the cliffs watching the fishermen heaving at the boats on the sand below.

Although McTaggart was in Paris in 1860 and 1880 it was apparently not until the 1890s that he saw his first Monet. It seems that he arrived at his impressionistic renderings of light and atmosphere without any knowledge of the French artist's work. McTaggart's home for the last twenty years of his life was the village of Broomieknowe near Edinburgh. He died in 1910.

W.L.Wyllie 1851–1931

William Lionel Wyllie was a professional marine artist in the same tradition as E.W.Cooke. His style of painting was very different but like Cooke he devoted his life to painting, drawing and making etchings of marine subjects. By his eightieth year he had recorded on paper or canvas nearly every type of vessel afloat in British waters. He painted rowing boats, sailing dinghies, Thames barges, steam tugs, fishing boats, submarines, destroyers and battle cruisers.

Wyllie's father and brother were artists, and he was trained at the Royal Academy Schools. He first exhibited at the Royal Academy in 1868, was made an A.R.A. in 1889 and a full Academician in 1907. His knowledge of ships was based on a lifetime of close contact with them. He owned and sailed a variety of vessels, he was with the Royal Navy during World War I, and he lived by the water most of his life: from 1885 to 1907 he had a house overlooking the Medway; and from 1907 until his death in 1931 he lived in Tower House at the entrance to Portsmouth Harbour.

Wyllie's oil painting technique was vigorous and accomplished. He employed loose, open brushwork and was particularly adept at suggesting liquid reflections. The drawing of his ships was always accurate but at the same time retained a freedom of line. His work is well represented in public collections. The Tate Gallery has a dramatic *Battle of the Nile*, and his *Toil, glitter, grime and wealth on a flowing tide* (pl. 115) of 1883. In Bournemouth Museum there is a painting of fishing boats entitled *Ave Maria* and a desolate portrayal of a half-submerged wreck, *The Goodwin Sands*, which was exhibited at the Royal Academy in 1874. The Royal Academy has his Diploma work, *The Portsmouth fishing fleet* (pl. 116), an atmospheric rendering of a scene which he must often have witnessed from the windows of his house.

Philip Wilson Steer 1860–1942

Philip Wilson Steer was not a marine artist and he did not share Wyllie's life-long interest in ships. But between the years 1885 and 1894 he painted a memorable series of beach scenes. Most of these pictures depict young girls in white dresses and sun-hats running along the sands, paddling in the surf or standing on the pier at Walberswick looking out to sea. The intensity of light and the sparkling colour of summer days by the seaside are captured with an extraordinary brilliance. To the same period belong a number of harbour scenes, and pictures of the open sea. A good example of the former is *Poole Harbour* in Leeds City Art Gallery.

In some of Steer's paintings of the open sea, such as *Surf* of 1885 and *The open sea, Walberswick* of 1886, can be seen echoes of Whistler's marine studies. Other subjects such as *Sunrise on the sea, Walberswick*, painted around 1889, recall the paintings of Henry Moore. The beach scenes, however, are closest in spirit and in technique to the work of the French Impressionists. In fact Steer received part of his artistic education in France (he entered the Académie Julian, Paris, in 1882, after studying at Gloucester School of Art), and he spent several summers painting on the French coast. He was in Etaples in 1887, Montreuil-sur-Mer in 1889 and Boulogne in 1894. Although he was certainly influenced by both Manet and Monet, and by the *pointilliste* style of Seurat,[46] he retained an entirely personal vision in his best paintings of this period. These include two pictures in the Tate Gallery, *The bridge* of 1887, *Three girls on a pier, Walberswick* (pl. 118), painted between 1888 and 1891, and the glittering summer scene, *Children paddling, Walberswick* which is in the Fitzwilliam Museum, Cambridge. These are not marine paintings in the strict sense but they do capture the elusive quality of light by the sea.

In addition to the paintings of the sands at Walberswick and in France, Steer painted some delightful pictures of yachts. He spent the summers of 1888 and 1892 at Cowes. (In the Victoria and Albert Museum are three of his sketchbooks

filled with drawings of yachts racing, and of the waterfront at Cowes.) Manchester City Art Gallery has a small painting *Summer at Cowes* and in the Tate Gallery is the well-known *A procession of yachts, Cowes*. Few of Steer's paintings of boats would satisfy a marine historian because the chief delight of these pictures is their colour and their sunny atmosphere rather than their drawing. They are a reminder, however, that there is more to marine art than the accurate depiction of wave-forms and rigging. Indeed it is a strange contradiction that some of the most vivid portrayals of the sea have been painted by gifted artists who seldom went to sea.

APPENDIX

Nicholas Pocock Esquire　　　　　　　　Leicester Fields, May 4th 1780
Dear Sir,

　Your picture came too late for the exhibition. It is much beyond what I expected from a first essay in oil colours; all the parts separately are extremely well painted; but there wants a harmony in the whole together; there is no union between the clouds, the sea, and the sails.

　Though the sea appears sometimes as green as you have painted it, yet it is a choice very [un]favourable to the art: it seems to me absolutely necessary in order to produce harmony, and that the picture should appear to be painted, as the phrase is, from one palette, that those three great objects of ship-painting should be very much of the same colour as was the practice of Van Der Velde and he seems to be driven to this conduct by necessity. Whatever colour predominates in a picture, that colour must be introduced in other parts; but no green colour, such as you have given to the sea, can make a part of a sky. I believe the truth is, that, however the sea may appear green, when you are looking down on it, and it is very near—at such a distance as your ships are supposed to be, it assumes the colour of the sky.

　I would recommend to you, above all things, to paint from nature instead of drawing; to carry your palette and pencils to the water side. This was the practice of Vernet, whom I knew in Rome; he then shewed me his studies in colours, which struck me very much, for that truth which those works only have which are produced while the impression is warm from nature; at that time he was a

181

perfect master of the character of water, if I may use the expression, he is now reduced to a mere mannerist, and no longer to be recommended for imitation, except you would imitate him by uniting landscape to ship-painting, which certainly makes a more pleasing composition than either alone.

I am with great respect, Your most humble and obedient servant,

JOSHUA REYNOLDS

BIBLIOGRAPHY
AND NOTES

The following books and other sources have been consulted in most cases and are therefore not repeated in the lists of specialist works on individual artists.

Archibald, E.H.H. 'The English School of Shipping Painters of the Eighteenth and Early Nineteeth Centuries' in *The Concise Encyclopaedia of Antiques* London 1961

Baldry, A.L. *British Marine Painting* special number of the *Studio* London 1919

Binyon, L. *Catalogue of drawings by British Artists in the British Museum* London 1898–1907

Chatterton, E.Keble *Old Sea Paintings* London 1928

Dictionary of National Biography London 1885–1900

Farington, Joseph *The Farington Diary 1793–1821* ed. Grieg, London 1922–8

Graves, A. *A Dictionary of Artists 1760–1893* London 1901

Graves, A. *Royal Academy Exhibitors 1769–1904* (8 vols) London 1905–6

Hardie, Martin *Watercolour Painting in Britain* (3 vols) London 1967–9

Mariner's Mirror, The (journal of the Society for Nautical Research) from 1911

National Maritime Museum, Greenwich *Concise Catalogue of Oil Paintings* London 1958

National Maritime Museum, Greenwich: information on many marine artists stored in the files of the Department of Pictures

Redgrave, S. *Dictionary of Artists of the English School* London 1874

Robinson, M.S. *The Macpherson Collection of maritime prints and drawings in the National Maritime Museum, Greenwich* London 1950

Roe, F. Gordon *Sea Painters of Britain* vol. I 'Van de Velde to Turner', vol. II 'Constable to Brangwyn' Leigh-on-Sea 1947

Tate Gallery *Catalogue of the British School* London 1947

Taylor, Basil *Painting in England 1700–1850* Collection of Mr and Mrs Paul Mellon, Catalogue of exhibition held at Virginia Museum of Fine Arts (2 vols) Richmond, Virginia 1963

Thieme-Becker *Allgemeines Lexikon der Bildenden Künstler* Leipzig 1907–47

Victoria and Albert Museum *Catalogue of Watercolour Paintings* London 1927 (supplement 1951)

Warner, Oliver *An Introduction to British Marine Painting* London 1948

Williams, Iolo *Early English Watercolours* London 1952

Wilson, Arnold *A Dictionary of British Marine Painters* Leigh-on-Sea 1967

1 INTRODUCTION

Books

Clowes, G.S. Laird *Sailing Ships: their history and development* London 1932

Murray, K.M.E. chapter in 'Shipping', vol. 1 of *Medieval England* Oxford 1958

Rickert, M. *Painting in Britain: the Middle Ages* London 1954

Ruskin, John *Modern Painters* London 1843 (cited: 1903 Library edition, ed. Cook and Wedderburn)

Serres, Dominic and John Thomas *Liber Nauticus, and Instructor in the Art of Marine Drawing* London 1805

Notes

1 Watkins, John *Life and Career of George Chambers* London 1841, 39

2 Serres *Liber Nauticus* part I 'Studies for Water'

3 Ruskin *Modern Painters* vol. I, part II, section V, 500

4 Robinson, M.S. *Van de Velde Drawings in the National Maritime Museum* Cambridge 1958, 22

5 Emanuel, Frank *Walker's Quarterly* October 1923, 30

6 Kitson, S. *Life of John Sell Cotman* 316

7 Farington *Diary* 8 November 1815

8 Schetky *Ninety Years of Work and Play: sketches from the public and private career of John Christian Schetky* by his daughter, London 1877, 189

9 M.S.Cott *Augustus I* i ff. 22–3 (illustrated Murray, *Medieval England* vol. I, pl.17)

2 THE INSPIRATION OF HOLLAND

Books

Arts Council Exhibition *Shock of recognition: the landscape of English Romanticism and the Dutch seventeenth-century school* London 1971

Maclaren, Neil *National Gallery Catalogue: the Dutch School* London 1960

Millar, Oliver *Dutch Pictures from the Royal Collection* catalogue of exhibition held at the Queen's Gallery, Buckingham Palace, London 1971

Robinson, M.S. *Van de Velde Drawings in the National Maritime Museum* Cambridge 1958

Rosenberg, J., Slive, S., ter Kuile, E.H., *Dutch Art and Architecture 1600–1800* London 1966

Stechow, W. *Dutch Landscape Painting of the Seventeenth Century* (2nd edition) London 1968

Notes

1 *Shock of recognition* Introduction
2 See Appendix
3 Farington *Diary* 18 May 1818
4 *Shock of recognition* notes to no. 101
5 Finberg, H. *Burlington Magazine* August 1942, 201
6 Gilpin, Rev. William *Three Essays on Picturesque Beauty* London 1792, 27
7 Thornbury, Walter *The Life and Correspondence of J.M.W.Turner* London 1862, 8
8 *Shock of recognition* notes to no. 55
9 *Ibid* notes to no. 55
10 Leslie, C.R. *Memoirs of the Life of John Constable* London 1843, 318
11 Farington *Diary* 5 April 1806
12 Robinson *Van de Velde Drawings* 15

3 THE EIGHTEENTH CENTURY

Books
General works on this period
Dayes, Edward *Professional Sketches* London 1805
Edwards, Edward *Anecdotes of Painters* London 1808
Walpole, Horace *Anecdotes of Painting in England* London 1765–71
Waterhouse, E.K. *Painting in Britain 1530–1790* London 1953
Whitley, William *Artists and their Friends in England 1700–1799* London 1928

Selected works on individual artists
W.ANDERSON
Mariner's Mirror vol IV 1914, 266–74; vol XII 1926, 226
S.ATKINS
Malcolm Henderson Gallery *Marine Paintings, Drawings and Watercolours* Catalogue of exhibition, London 1972
C.BROOKING
Sorensen, Colin *Charles Brooking 1723–1759 Paintings, Drawings and Engravings* Catalogue of exhibition, Aldeburgh 1966
T.BUTTERSWORTH
Wilmerding, John *A History of American Marine Painting* Boston 1968

J.CLEVELEY THE ELDER
Apollo August 1949, 54

T.LUNY
Dymond, Robert *Report and Transactions of the Devonshire Association* vol.
 XVIII 1886, 442
Country Life April 1961

P.MONAMY
Vertue, George *Vertue Notebooks* Walpole Society, vol. XXII London 1933–4,
 145

N.POCOCK
Brighten, Claude Biographical article (in Greenwich files)
Dunman, W.H. Catalogue of exhibition, Bristol Museum 1940

I. SAILMAKER
Vertue, George *Vertue Notebooks*, Walpole Society, vol. XVIII London 1929–30,
 74

R.SALMON
Wilmerding, John *Robert Salmon, Painter of Ship and Shore* Boston 1971
Wilmerding, John *A History of American Marine Painting* Boston 1968

S.SCOTT
Sharpe, K. and Kingzett, R. *Samuel Scott Bicentenary* catalogue of exhibition,
 Guildhall Art Gallery, London 1972 (contains comprehensive bibliography)

D. AND J.T. SERRES
The Connoisseur vol. 50, 1918, 234; vol. 62, 1922, 174
Sandby, William *Thomas and Paul Sandby* London 1892
Memoir of John Thomas Serres by a friend, London 1826

Notes

1 Vertue *Notebooks* Walpole Society, vol. XVIII, 74
2 *Ibid*, vol. XXII, 145
3 From Greenwich files
4 *Ibid*
5 *Ibid*
6 Walpole 671
7 Farington *Diary* 31 July 1796
8 Whitley *Artists and their Friends* vol. 1, 204
9 Farington *Diary* 8 February 1797
10 *Ibid*
11 Records of Shipwrights Company, vol. 1, 43
12 Dayes *Professional Sketches* 322
13 Farington *Diary* 8 February 1797
14 Dayes *Professional Sketches* 322
15 Catalogue of Brooking Exhibition 1966 (introduction)
16 Edwards *Anecdotes* 5
17 Warner *British Marine Painting* 16
18 Edwards *Anecdotes* 5
19 Burlington Fine Arts Club, catalogue of an exhibition of marine art, 1929.
 See also Nicholson, B. *The Treasures of the Foundling Hospital* Oxford 1972, 61
20 *Dictionary of National Biography*

21 Redgrave *Dictionary*
22 Sandby *Thomas and Paul Sandby* 167
23 Redgrave *Dictionary*
24 *Memoir of John Thomas Serres* 12
25 B.M. no. 1885–5–9–1647
26 Redgrave *Dictionary*
27 Roe, F. Gordon *Sea Painters of Britain* vol. 1, 36
28 Graves *Royal Academy Exhibitors*
29 Brighten, article in Greenwich files
30 Dayes *Professional Sketches*
31 Ferens Art Gallery *Early Marine Painters* 1951, 21–2
32 *Mariner's Mirror* vol. XII 1926, 226
33 Williams *Early English Watercolours* 201
34 Hardie *Watercolour Painting in Britain* vol. 1, 236
35 *Report . . . Devonshire Association* 443
36 *Ibid* 445
37 *Literary Gazette and Journal* 24 June 1837, 403
38 O.J.Prattent *Country Life* 27 April 1961
39 See book list above
40 Hardie *Watercolour Painting in Britain* vol. 1, 236
41 Wilmerding *History of American Marine Painting* 119
42 *Ibid* 205

4 THE ROMANTIC MOVEMENT

Books

General works on the period

Boase, T.S.R. 'Shipwrecks in English Romantic Painting' *Journal of the Warburg and Cortauld Institutes* vol. XXII 1959, 337

Clarke, Kenneth *Landscape into Art* London 1949

Day, Harold A.E. *East Anglian Painters* Eastbourne 3 vols 1967–8

Gilpin, Rev. William *Three Essays on Picturesque Beauty* London 1792

Selected works on individual artists

C.BENTLEY

Roe, F.Gordon *Walker's Quarterly* no. 3 April 1921

R.P. BONINGTON

Dubuisson, A. and Hughes, C.E. *Richard Parkes Bonington: his life and work* 1924

Shirley, Hon A. *Bonington* London 1940

A.W.CALLCOTT

Dafforne, James *Pictures by Sir A.W.Callcott R.A.* London 1875

J.CONSTABLE

Leslie, C.R. *Memoirs of the Life of John Constable* London 1843 (cited 1951 edition, ed. J.Mayne)

Reynolds, Graham *Constable: the Natural Painter* London 1965

J.S.COTMAN

Kitson, Sydney *The Life of John Sell Cotman* London 1937

Reinacker, Victor *John Sell Cotman, 1782–1842* Leigh-on-Sea 1953

M.E.COTMAN
Bell, C.F. *Walker's Quarterly* no. 21, 1926–7
W.DANIELL
Sutton, Thomas *The Daniells: Artists and Travellers* London 1954
A.V.COPLEY FIELDING
Kaines Smith, S.C. *Old Watercolour Society's Club* vol. III 1925–6, 8–30
P.J.DE LOUTHERBOURG
Joppien, Rüdiger *Philippe Jacques de Loutherbourg R.A. 1740–1812* Catalogue of exhibition, Kenwood 1973
Parker, Harry *Mariner's Mirror* vol. III 1913, 40–42
J.M.W.TURNER
Finberg, A.J. *The Life of J.M.W.Turner R.A.* London 1939 (2nd edition 1961)
Rothenstein, J. and Butlin, M. *Turner* 1964
Thornbury, Walter *The Life and Correspondence of J.M.W.Turner* London 1862 (revised edition 1877)

Notes

1 Waterhouse *Painting in Britain* 223
2 *Mariner's Mirror* vol. III 1913, 40–42
3 Farington *Diary* 1 June 1807
4 Dutton *The Daniells* 88
5 Hardie *Watercolour Painting in Britain* vol. III, 46
6 Farington *Diary* 28 March 1804
7 *Ibid* 6 May 1806
8 Finberg 33
9 Boase 'Shipwrecks in English Romantic Painting' 337
10 Thornbury 116
11 Finberg 198
12 Leslie *Memoirs* 202–3
13 Finberg 142
14 *Ibid* 142
15 *Ibid* 283
16 Leslie *Memoirs* 124
17 *Ibid* 16
18 Reynolds *Catalogue of the Constable Collection* V. and A. 1960, cat. no. 65
19 *Ibid* cat. no. 91
20 Taylor *Painting in England* 1700–1850, catalogue of Mellon Collection, vol. I, 75
21 Leslie *Memoirs* 123
22 Dafforne *Pictures by Sir A.W.Callcott* 35
23 *Ibid* 22
24 Farington *Diary* 1 April 1806
25 Thornbury 275
26 Redgrave *Dictionary*
27 Kitson *Life of John Sell Cotman* 338
28 *Ibid* 165
29 Cotman letters (in the B.M.)
30 *Ibid*

31 Kitson 283
32 Hardie *Watercolour Painting in Britain* vol. II, 73
33 Kitson 289
34 *Walker's Quarterly* no. 21, 1926–27, 11–12
35 Ruskin *Modern Painters* vol. I, part II, section V, chap II, 532
36 Kaines Smith *O.W.S.C.* 1925–6, 8–30
37 Hardie vol. III, 77
38 Leslie *Memoirs*

5 THE VICTORIAN PERIOD

Books
General works on the period
Boase, T.S.R. *English Art, 1800–1870* Oxford History of Art, vol. X 1959
Maas, Jeremy *Victorian Painters* London 1969
Reynolds, Graham *Painters of the Victorian Scene* London 1953
Ruskin, John *Academy Notes 1855–59* London 1875
Wood, Christopher *Dictionary of Victorian Painters* London 1971

Selected works on individual artists
J.BRETT
Art Journal 1882, 57 and 1902, 87
J.W.CARMICHAEL
Laing Art Gallery *John Wilson Carmichael* centenary exhibition 1968
GEORGE CHAMBERS
Watkins, John *Life and Career of George Chambers* London 1841
E.W.COOKE
Guildhall Art Gallery *Edward William Cooke* catalogue of exhibition 1970
E.DUNCAN
Emanuel, Frank *Walker's Quarterly* October 1923
National Maritime Museum *Two Victorian Marine Painters: E.Duncan and T.S. Robins* catalogue of exhibition 1971
W.MCTAGGART
Caw, Sir J.L. *Scottish Painting: Past and Present* Edinburgh and London 1908
H.MOORE
Maclean, Frank *Henry Moore R.A.* London 1905
J.C.SCHETKY
Ninety Years of Work and Play: sketches from the public and private career of John Christian Schetky by his daughter, London 1877
P.WILSON STEER
Laughton, Bruce *Philip Wilson Steer* Oxford 1971
C.STANFIELD
Dafforne, James *Pictures by Clarkson Stanfield R.A.* London 1874
Guildhall Art Gallery *David Roberts and Clarkson Stanfield* catalogue of exhibition 1967

S.WALTERS
Bootle Art Gallery *Samuel Walters: marine painter* catalogue of exhibition 1959
J.WARD
Ferens Art Gallery *Early Marine Paintings* catalogue of exhibition 1951
J.M.WHISTLER
Sutton, Denys *Nocturne: the Art of James McNeill Whistler* London 1963
Holden, Donald *Whistler Landscapes and Seascapes* London 1969
Pennell, E.R. and J. *The Whistler Journal* Philadelphia 1921
W.L.WYLLIE
Wyllie, M.A. *We were one. Life of W.L.Wyllie* 1935
Malcolm Henderson Gallery *W.L.Wyllie R.A.* catalogue of exhibition 1972

Notes

1 *Ninety Years of Work and Play* 93
2 *Ibid* 129
3 *Ibid* 226
4 *Ibid* 267
5 *Dictionary of National Biography*
6 Redgrave *Dictionary*
7 Warner *British Marine Painting* 37
8 He was sometimes assisted in his work by his son, J.M.Huggins, whose work is almost identical.
9 Ruskin *Modern Painters* vol. I, part II, section V, 535
10 Leslie *Memoirs* 204
11 See Guildhall Art Gallery catalogue, 3. Many authorities continue to refer to this artist as William Clarkson Stanfield. This is incorrect: see title page of *Stanfield's Coast Scenery* London 1836; Dafforne; artist's signatures on authenticated paintings, etc.
12 Hardie *Watercolour Painting in Britain* vol. III, 70
13 Ruskin *Modern Painters* vol. I, part II, section V, 535
14 Redgrave *Dictionary*
15 Ruskin *Modern Painters* vol. I, part II, section V, 535
16 Ferens Art Gallery catalogue, 19
17 *Ibid* 17
18 Laing Art Gallery catalogue, 5
19 *Ibid* 5
20 *Ibid* 6
21 Redgrave *Dictionary*
22 Cooper, T.S. *My Life* London 1891, 141
23 Watkins *Life and Career of George Chambers* 39
24 *Ibid* 52
25 *Ibid* 82
26 *Ibid* 83
27 *Ibid* 74
28 *I.L.N.* 7 August 1847, 93
29 *I.L.N.* 9 June 1855, 580
30 Cooke *Diary* October 1828
31 *Ibid* 1837

32 *The Times* obituary 9 January 1902
33 Roe, F.Gordon *Sea Painters of Britain* vol. II, 33
34 *Art Journal* 1902, 87
35 Maas *Victorian Painters* 193
36 Maclean *Henry Moore R.A.* 24
37 *Ibid* 33
38 *Ibid* 61
39 *Ibid* 76
40 Hardie *Watercolour Painting in Britain* vol. III, 81
41 Pennells *The Whistler Journal* 117
42 Holden *Whistler Landscapes and Seascapes* 52
43 Sutton *Nocturne* 105
44 *Ibid* 105
45 Caw *Scottish Painting* 249
46 Laughton *Philip Wilson Steer* 10, 15

LIST OF ILLUSTRATIONS

Figures in bold refer to plate numbers

INDEX

N.B. Numbers in italics refer to plate numbers.

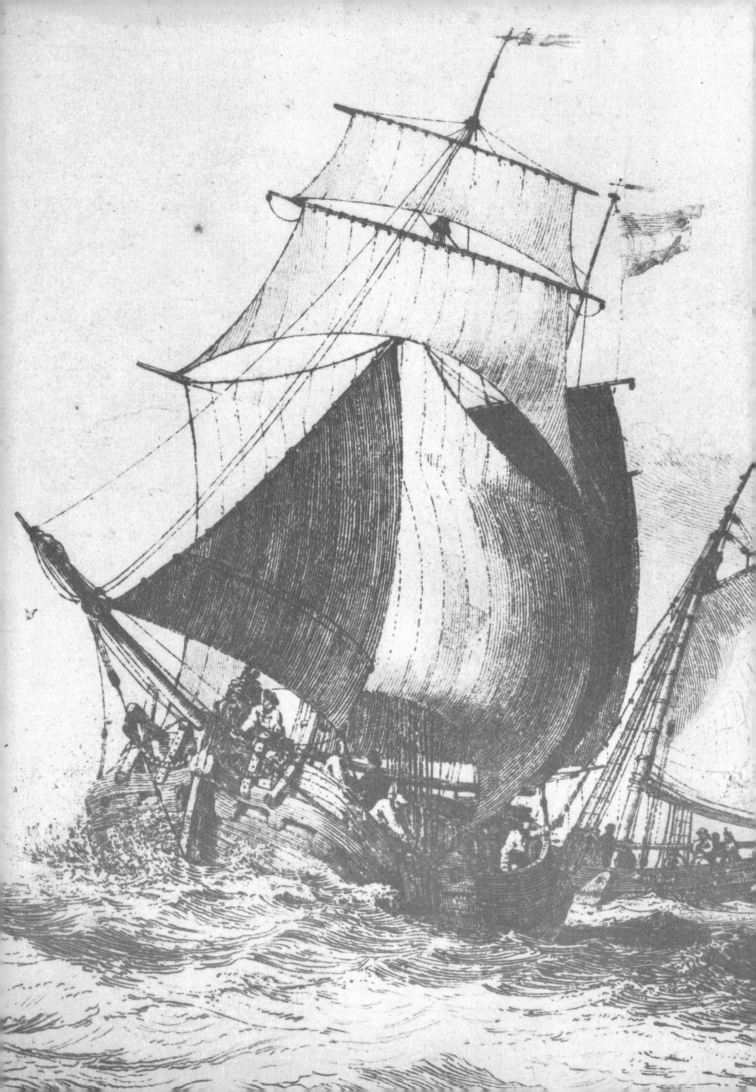